Fnb

Get **more** out of libraries

Please return or renew this item by the last date shown.

You can renew online at www.hants.gov.uk/library

Or by phoning 0845 603 5631

Hampshire
County Council

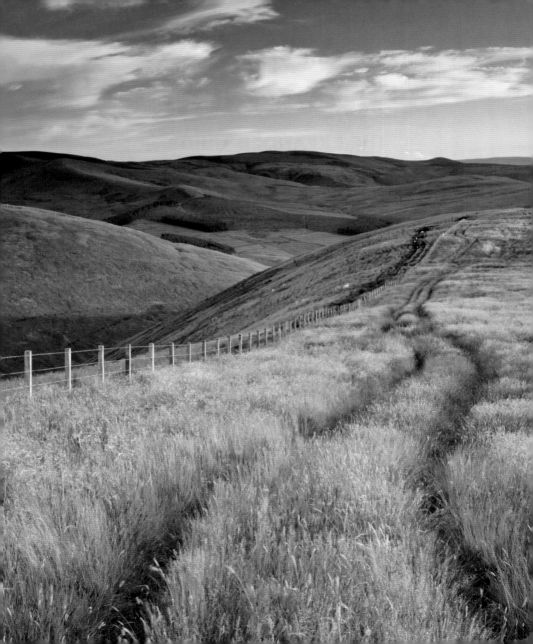

SONY
A500 & A550
THE EXPANDED GUIDE

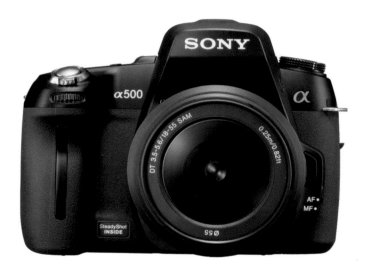

David Taylor

AMMONITE
PRESS

ISBN 978-1-906672-782

British Library Cataloging in Publication Data: A catalog record of this book is available from the British Library.

Editor: Ian Penberthy
Series Editor: Richard Wiles
Design: Richard Dewing Associates

Typefaces: Giacomo
Color reproduction by GMC Reprographics
Printed and bound in China by Hung Hing Printing Co. Ltd

« PREVIOUS PAGE
Path to the Bowmont Valley along Auchope Rig at the northern end of the Cheviot Hills in the Scottish Borders.

» CONTENTS

Chapter 1
OVERVIEW

1 OVERVIEW

The A500 and A550 are recent additions to the rapidly evolving range of digital SLRs (DSLRs) by the Japanese electronics giant, Sony.

Sony was originally called the Tokyo Tsushin Kogyo (Tokyo Telecommunications Engineering Company) and was founded in 1946 by Masaru Ibuka and Akio Morita. Initially the two entrepreneurs made a living repairing radio sets and manufacturing voltmeters.

TTK did not become the Sony Corporation until 1958, when the need for a short, snappy, yet internationally inclusive, company name was deemed necessary. By the end of the century, the

Sony A100
Building on the camera heritage of Konica Minolta, the A100 was Sony's first entry into the DSLR market.

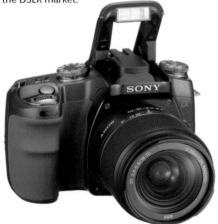

Sony Corporation had created a number of innovative and successful electronic products, such as the Walkman music player and Playstation games console. By the year 2000, Sony also had a range of digital compact cameras available, the Mavica and Cyber-shot models.

› Evolution of the Sony A500 and A550

It wasn't until July 2006 that Sony introduced its first DSLR camera, the A100. Although this date may give the impression that the company was late in coming to the DSLR market, the lineage of the A100 has deep roots that stretch as far back as the mid-1980s.

The A100 was based extensively on technology developed by the camera manufacturer Konica Minolta. Features such as antishake and eye-start had all appeared previously on Konica Minolta's 5D and 7D DSLR cameras, which were released two years before the A100.

Although regarded as an innovative film camera company, Konica Minolta had lost market share to rivals after the release of the first affordable DSLR, the revolutionary Nikon D1, in 1999. Sony acquired the assets

of Konica Minolta in 2006, allowing the company to enter the DSLR market with a mature system already in place.

Lens system

A DSLR is only as good as the lenses that are available for the system. The lens mounts of the A100 and all subsequent Sony DSLRs are compatible with the system introduced by Minolta in 1985. Marketed as the Maxxum in the United States, Dynax in Europe, and Alpha α in Japan, the Minolta autofocus and lens mount system was the first to use a motor inside the camera to focus the lens.

By acquiring the rights to a preexisting camera system, Sony was able to utilize the large range of lenses produced by Minolta (Konica Minolta after a merger in 2003) since 1985. Many of the lenses now branded as Sony were designed originally by Minolta for its line of film-based SLRs.

The advantage for the Sony DSLR user is that lenses designed over two decades will still be compatible with their state-of-the-art camera. The only lenses from Minolta that are not compatible with Sony DSLRs are manual-focus lenses that predate the introduction of autofocus cameras.

Once Sony had acquired the rights to Konica Minolta, the different names for the AF lens mount were rationalized. The names Dynax and Maxxum were dropped,

and α became the worldwide designation for the system. Since the introduction of the A100, Sony has produced cameras for each type of photographer. Professionals are catered for with the A900 and A850 full-frame cameras. To match the needs of such demanding cameras and their users, the German lens manufacturer Carl Zeiss produces a growing number of prime and zoom lenses for the Sony α lens mount

This willingness of Sony to produce cameras for the professional market means there is a clear upgrade path for anyone with a consumer-oriented Sony DSLR.

Sony A900 & 70–400mm G LENS ⩔
With a 24.6mp, full-frame sensor, the A900 is proof that Sony is serious about catering to professional photographers.

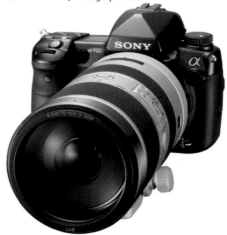

› The A500 & A550 Released

The A500 and A550 were announced on August 27th, 2009. The two cameras share a common body and control system, so a user of one camera would immediately be familiar with the other. The two main differences between the A500 and the A550 are the specifications of the Exmor CMOS image sensor and the LCD monitor. The A500 image sensor has 12.3 effective megapixels, the A550 14.2. The resolution of the LCD monitor is also higher on the A550 at 921,600 pixels as opposed to the A500's 230,400.

The two cameras share features that, at the time of writing, are unique in the Sony DSLR range. Live View mode now sports a Face Detection function that can recognize up to eight human faces and prepare the camera by prioritizing the exposure and autofocus system to successfully record those faces. Closely related to Face Detection is Smile Shutter, another Live View option that automatically fires the shutter when a person smiles. When the shutter fires is determined by an adjustable "smile sensitivity" scale. An in-camera High Dynamic Range (HDR) option is also unique in the Sony range and not commonly found on other manufacturers' DSLRs.

Both the A500 and A550 can be bought as bodies only or with either one or two standard kit lenses. The first of the kit lenses is the DT 18–55mm f/3.5–5.6 lens, which has a useful wide to short telephoto range. The second kit lens is the DT 55–200mm f/4–5.6, which fills the need for a short to long telephoto lens. Both lenses were designed specifically for APS-C cameras such as the A500 and A550, and feature refinements such as spherical and Extra low Dispersion (ED) glass elements for improved image quality.

‹‹ Sony A500
Using Live View and the hinged LCD screen, it is now easier to shoot low to the ground or holding the camera above head height.

» MAIN FEATURES OF THE A500 & A550

THE A500

Body

Dimensions: 5½ x 4⅛ x 3⅜in (137 x 104 x 84mm)
Weight: 1lb 5.1oz (597g)—body only without battery.

Sensor & processor

12.3 effective megapixels on an RGB CMOS sensor measuring 23.5 x 15.6mm (APS-C format). Uses revised Exmor and Bionz processors for fast analog-to-digital (A/D) conversion.

File types and sizes

JPEG file sizes range from 4272 x 2848 pixels in 3:2 aspect ratio and 4272 x 2576 pixels at the large setting in 16:9 aspect ratio, and 2128 x 1416 pixels in 3:2 aspect ratio and 2128 x 1192 pixels at the small setting in 16:9 aspect ratio. RAW files (.arw) are recorded as 4272 x 2848 pixels in 3:2 aspect ratio and 4272 x 2576 pixels in 16:9 aspect ratio.

LCD monitor

The monitor on the rear of the A500 is a 3in (7.5cm) TFT LCD with a resolution of 230,400 dots. It has an anti-reflective coating with 100% frame coverage (using manual focus check in Live View mode). Brightness can be set to change automatically depending on surrounding lighting conditions. The monitor is used for all menu functions, image review, and for composition of the image in Live View mode. To assist using the camera at low angles, the monitor can be tilted.

THE A550

Body

Dimensions: 5½ x 4⅛ x 3⅜in (137 x 104 x 84mm)
Weight: 1lb 5.1oz (597g)—body only without battery.

Sensor & processor

14.2 effective megapixels on an RGB CMOS sensor measuring 23.4 x 15.6mm (APS-C format). Uses revised Exmor and Bionz processors for fast analog-to-digital (A/D) conversion.

File types and sizes

JPEG file sizes range from 4592 x 3056 pixels in 3:2 aspect ratio and 4592 x 2576 pixels at the large setting in 16:9 aspect ratio, and 2288 x 1520 pixels in 3:2 aspect ratio and 2288 x 1280 pixels at the small setting in 16:9 aspect ratio. RAW files (.arw) are recorded as 4592 x 3056 pixels in 3:2 aspect ratio and 4592 x 2576 pixels in 16:9 aspect ratio.

LCD monitor

The monitor on the rear of the A550 is a 3in (7.5cm) TFT LCD with a resolution of 921,600 dots. It has an anti-reflective coating with 100% frame coverage (using manual focus check in Live View mode). Brightness can be set to change automatically depending on surrounding lighting conditions. The monitor is used for all menu functions, image review, and for composition of the image in Live View mode. To assist using the camera at low angles the monitor can be tilted.

» SHARED FEATURES OF THE A500 & A550

Body

Lens Mount: Compatible with Konica Minolta Maxxum/Dynax/Alpha and Sony Lens mounts.

Viewfinder

Fixed eye-level pentamirror with 95% field-of-view and magnification of 0.80x with 50mm lens at infinity, -1m^{-1} (diopter). Eye relief approximately 19mm from the eyepiece, 15mm from the eyepiece frame at -1 m^{-1}. The diopter of the viewfinder can be adjusted between -2.5 and +1m^{-1}.

Focus

The autofocus is TTL phase-detection system using 9 points (8 lines with center crosshair sensor). Choice of three different AF modes to suit static or moving subjects: Single-shot, Automatic, and Continuous. Both automatic and manual selection of the nine AF points are available in Exposure mode. In Scene Selection the focus points are selected automatically. The AF working sensitivity range is from EV 0–18 at ISO 100 equivalent. AF lock is possible in Single-shot mode and subject dependent in Automatic mode. Manual focus check is available in Live View using the LCD.

Exposure

The 40-segment honeycomb pattern photocell sensor has three full aperture metering modes: Multi-Segment, Center-Weighted, and Spot. The metering range is 2–20 EV (4–20 EV with Spot metering) at ISO 100 conversion with an f/1.4 lens (OVF) or 1–17 EV (Live View) with an f/1.4 lens. Exposure compensation up to +/-2 stops and automatic three-frame auto-exposure bracketing up to +/-0.7 stops. Manual and automatic ISO settings from 200 to 12800 in 1-stop increments.

Shutter

The A500 and A550 use an electronically controlled focal-plane shutter, with a speed range from 1/4000 sec. to 30 sec. and bulb, selectable in EV ⅓-step intervals. Drive options include Single-shot, Continuous (up to 7 frames per second in speed priority continuous mode, A550 only), a 10-second self-timer, a 2-second self-timer, exposure and white balance bracket, and multi-shot HDR.

Flash

The built-in flash has a guide number (GN) of 12 (meters) at ISO 100 with a shutter sync speed of 1/160 sec. Depending on shooting mode, flash can be set to: off, automatic, fill-flash, slow synchronization, rear synchronization, red-eye reduction, or flash exposure compensation. Wireless and high-speed sync available with compatible external flash unit.

Memory Card

Switchable between Sony's proprietary Memory Stick PRO/PRO-HG Duo media and SD/SDHC memory cards.

Software

Image Data Converter SR, Image Data Lightbox SR, Picture Motion Browser.

1 » FULL FEATURES AND CAMERA LAYOUT

FRONT OF CAMERA

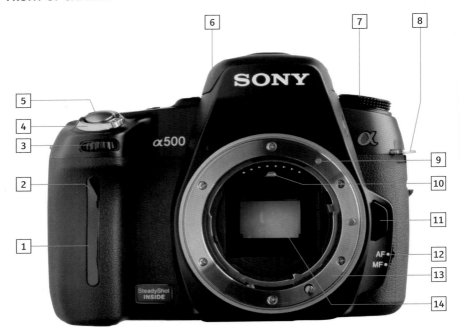

1	Remote sensor	8	Camera strap eyelet
2	Self-timer lamp	9	Lens mount index
3	Control dial	10	Lens contacts
4	Power switch	11	Lens release button
5	Shutter release	12	Focus mode switch
6	Built-in flash	13	Lens mount
7	Mode dial	14	Reflex mirror

BACK OF CAMERA

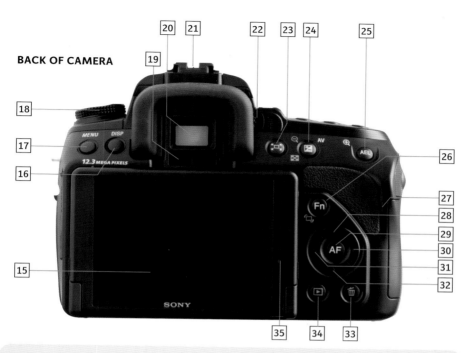

15	LCD monitor	25	AEL (exposure lock) button/zoom in
16	DISP (display) button	26	Fn (Function)/rotate image
17	MENU button	27	Access lamp
18	Mode dial	28	Control up
19	Eyepiece sensors	29	AF/Enter button (controller)
20	Viewfinder	30	Control right
21	Accessory shoe	31	Control left
22	Diopter-adjustment dial	32	Control down
23	Smart teleconverter	33	Delete button
24	Exposure compensation/Image index/zoom out	34	Playback
		35	Light sensor

1 » FULL FEATURES AND CAMERA LAYOUT

TOP OF CAMERA **LEFT SIDE**

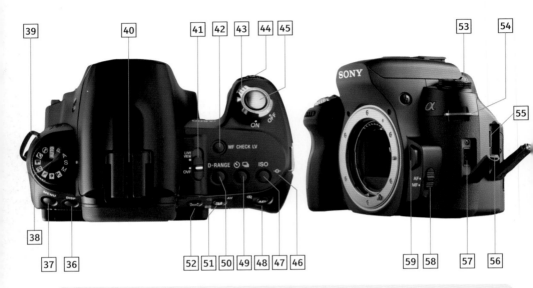

36	DISP (display) button	**45**	Shutter release	**52**	Smart teleconverter button
37	MENU button	**46**	Focal plane mark		
38	Mode Dial	**47**	ISO	**53**	Mode dial
39	Camera strap eyelet	**48**	AEL (exposure lock)	**54**	Camera strap eyelet
40	Accessory shoe		button/zoom in	**55**	USB terminal
41	Live View/OVF switch	**49**	Self-timer/Drive mode	**56**	HDMI terminal
42	MF Check LV (manual	**50**	D-RangeOptimizer	**57**	Remote terminal
	focus check) button	**51**	Exposure compensation/	**58**	Focus mode switch
43	Power switch		Image index/zoom out	**59**	Lens release button
44	Control dial				

RIGHT SIDE

BOTTOM OF CAMERA

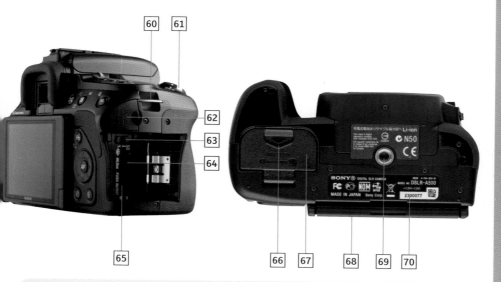

60	Camera strap eyelet	66	Battery cover lock
61	Power switch	67	Battery cover
62	DC IN terminal	68	LCD monitor
63	Memory card switch	69	Tripod socket (¼ inch)
64	SD memory card slot	70	Serial number
65	Memory Stick PRO Duo slot		

1 » FULL FEATURES AND CAMERA LAYOUT

VIEWFINDER DISPLAY

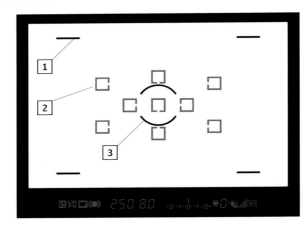

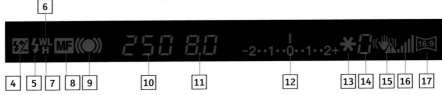

1 Shooting area for 16:9 aspect ratio	**10** Shutter speed
2 AF area	**11** Aperture
3 Spot metering area	**12** EV scale
4 Flash compensation	**13** AE lock
5 Flash charging	**14** Shooting unavailable warning
6 Wireless flash	**15** Camera shake warning
7 High-speed sync	**16** SteadyShot scale
8 Manual focus indicator	**17** Aspect ratio 16:9
9 Focus	

1 » MENU DISPLAYS

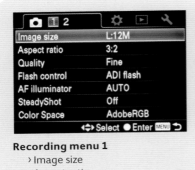

Recording menu 1
> Image size
> Aspect ratio
> Quality
> Flash control
> AF illuminator
> SteadyShot
> Color Space

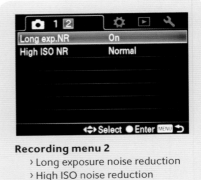

Recording menu 2
> Long exposure noise reduction
> High ISO noise reduction

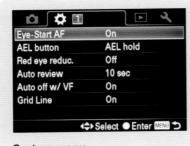

Custom menu
> Eye-Start AF
> AEL button
> Red eye reduction
> Auto review
> Automatic LCD switch off
> Grid Line

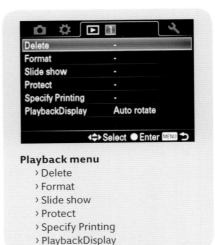

Playback menu
> Delete
> Format
> Slide show
> Protect
> Specify Printing
> PlaybackDisplay

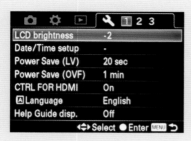

Setup menu 1
> › LCD brightness
> › Date/Time setup
> › Power Save (Live View)
> › Power Save (Optical View Finder)
> › Control for HDMI
> › Language
> › Help Guide display

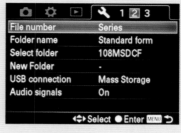

Setup menu 2
> › File number
> › Folder name
> › Select folder
> › New Folder
> › USB connection
> › Audio signals

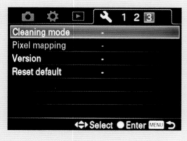

Setup menu 3
> › Cleaning mode
> › Pixel mapping
> › Version
> › Reset default

Chapter 2
FUNCTIONS

2 FUNCTIONS

Using your first DSLR can be a daunting business. Fortunately, Sony has made both the A500 and A550 as user friendly as possible, but with a variety of innovative features not currently found on DSLRs by other manufacturers. The button layout is subtly different to previous Sony Alpha range cameras, though not to the extent of confusing someone used to Sony's design philosophy.

Both cameras have scene selection modes that quickly set the controls appropriately for particular situations. Once you are more familiar with and confident in using your camera, you can use the wide range of manual settings for greater creative choice. This chapter will explore what is available on the A500 and A550, starting with basic information about preparing your camera before moving on to the more complex aspect of using it as a creative tool.

SONY A500
With a built-in flash and the option of full manual control as well as a range of automatic scene modes, the Sony A500 and A550 are both excellent first DSLRs.

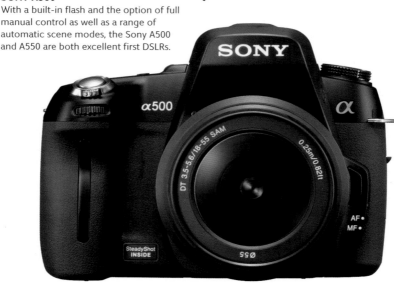

» CAMERA PREPARATION

The more familiar you are with how your camera operates, the better you will cope in photographic situations where you may not have time to think. It is worthwhile practicing the procedure of changing lenses and selecting the various shooting modes until the use of your camera becomes second nature.

› Attaching the strap

There is no sound worse than your new camera hitting the floor after slipping through your fingers! For this reason, it is recommended that you attach the strap that comes with your camera.

To attach the strap, feed one end through either the right or left eyelet on the top of the camera. Then pass the end of the strap under the length of strap that has already passed through the buckle. Allow at least 2in (5cm) of strap to extend beyond the buckle to avoid the risk of it being pulled back through. Repeat this for the opposite side of the camera. Adjust the length of the strap as required, then pull firmly on the end of the strap to fix it firmly within the buckle.

› Adjusting the diopter

The A500 and A550 allow changes to the focus (or diopter) of the viewfinder to compensate for individual variations in eyesight. The adjustment range is -2.5 and +1 m^{-1}. The diopter control dial is just to the right of the viewfinder eyepiece. With the camera switched on, look through the viewfinder and turn the dial toward the + symbol to adjust for longsightedness, or toward the - symbol for shortsightedness. Use the numbers at the bottom of the display to judge whether the viewfinder is focused correctly. If you have a lens attached when adjusting the diopter, bear in mind that the lens itself may not be focused, so do not use the scene as a guide to the sharpness of the viewfinder.

› Using the eyepiece cover

During a long exposure, light may leak into the camera through the viewfinder and affect the final exposure. The A500 and A550 come with a plastic eyepiece cover that masks the viewfinder to prevent this. Once the eyepiece cover is in place, it is impossible to see through the viewfinder, so it is important to mount the camera on a tripod and compose the image first. To use the eyepiece cover, first tilt the LCD screen forward. Remove the eyecup by placing your thumbs at the bottom and pushing gently upward. The eyepiece cover can now be slid down into place.

> **Note:**
> Fixing the cover may activate **Eye-Start** *(see page 102)*, causing an error in focusing or making the LCD flash. Switch off **Eye-Start** and **Auto off w/VF** *(see page 104)*.

› Fitting or removing a lens

Switch off the camera before attaching or removing a lens. Remove the body cap (or other lens if one is already mounted on the camera) by pressing the lens release button and turning the cap or lens counterclockwise (as it is facing you). To attach a lens, align the orange index marks on the lens and the camera body, and insert the lens carefully into the camera. Turn the lens clockwise until it firmly clicks into place. Do not force the lens if it is not turning correctly. If it is correctly aligned, it should turn smoothly. Before using the camera, check that the AF/MF switch on the lens is set to the desired position.

Common errors

Dust getting onto the camera's sensor is the bane of the digital photographer's life. Although Sony cameras have an excellent sensor cleaning system, it is still worth taking care when changing lenses. Avoid removing a lens outdoors on a windy day, or shelter the camera with your body if this is unavoidable. Take care when changing lenses—the consequences of dropping a lens just aren't worth thinking about.

› Inserting the battery

Sony uses a Lithium Ion (Li-Ion) NP-FM500H battery for both the A500 and A550. The NP-FM500H is an "infoLITHIUM" battery that exchanges information with the camera related to operating conditions. Unlike older Ni-Cad batteries, Li-Ions do not have a "memory" effect and can be recharged at any point without potentially reducing the life of the battery. Before using a new battery, it will need to be charged fully using the supplied BC-VM10 charger.

Before inserting the battery, ensure that the camera is switched off. Turn the camera upside down and locate the

INSERT THE BATTERY ⌄
Push the battery into the battery compartment while pressing against the blue lock lever until it clicks into place.

battery cover at the base of the handgrip. Slide the battery cover lever across to release the catch and gently open the battery cover door. Push the battery firmly into the battery compartment, with the tip of the battery pressing the blue lock lever as you do so. Once the battery has clicked into place, close the battery cover. A fully charged battery will be confirmed by ▊⚼⚼⚼ on the detailed shooting mode screen. When a battery is exhausted, ◀▊◢◣ will be displayed and it will need to be recharged before further use.

To remove the battery, again with the camera switched off, open the battery cover as before. Push the blue lock lever toward the end of the camera. The battery should then spring out slightly. Pull the battery out completely and close the cover again.

› Internal rechargeable battery

Both cameras have an internal battery that maintains the date, time, and other settings, even when the camera is switched off and the main battery is not inserted. When the camera is in use, this internal battery is charged by the NP-FM500H battery.

If you do not use your camera for long periods, the internal battery will gradually discharge. If the battery is entirely depleted, the camera can still be used, but will not record the date and the time. To

recharge this battery, insert a fully charged NP-FM500H battery and leave for 24 hours with the camera switched off. If the camera consistently reverts to the default settings, the internal battery may need to be replaced by a Sony dealer.

› Battery charging

Each camera is supplied with a BC-VM10 battery charger. Slide the battery onto the charger, with the terminals facing the contacts on the charger, until the battery clicks into place. Connect the battery charge to an AC power cord and insert the plug into the wall receptacle. The charge lamp will glow until the battery is normally charged. One hour after the lamp has gone out, full battery charge will be completed. A normal charge for a fully depleted battery will take approximately 175 minutes, and for a full charge, approximately 235 minutes.

If the charge lamp begins to flash, a fault has been detected by the battery charger. A fast flash (once every 0.15 second) indicates that the battery is defective in some way or that the wrong sort of battery has been placed in the charger. A slow flash (once every 1.5 seconds) indicates that the battery charger has stopped charging the battery temporarily. This is likely to occur if the

operating temperature (between 10 and 30°C or 50 and 86°F) of the battery charger has been exceeded.

› Battery life

Li-Ion batteries are small and lightweight, yet they have a large power capacity for their size. Inevitably, however, they will discharge with use. To prolong the use you will get from one charge, there are several ways you can save power. Using the LCD frequently (particularly in Live View) will quickly deplete the battery. The battery will also discharge gradually when left in the camera. If you don't use the camera for a long period, remove the battery.

Using AC electricity

The Sony A500 and A550 can also be powered by an ACPW10AM AC adapter (sold separately). To use the adapter, turn the camera off, then plug the connector of the adapter to the DC IN terminal on the side of the camera.

> **Tip**
>
> *The battery charger can be used overseas (100–240v AC 50/60hz) with a suitable plug adapter and does not require a voltage transformer.*

» BASIC CAMERA FUNCTIONS

Set to automatic, the Sony A500 and A550 cameras are both easy to pick up and use quickly, but they also feature a range of options and modes that allow for a more creative approach to photography. Both cameras have a large rear LCD screen that shows the selected mode clearly, with useful explanatory text detailing how the use of that particular mode will affect the final image.

To set the various shooting and playback options, the A500 and A550 use a combination of buttons for specific camera functions, two menu buttons, four control buttons arranged in a circular "joypad," a confirmation enter button, and a control dial. You will need to know the location of these controls on your camera to make the best possible use of it. It is worth taking time now to memorize these controls and the symbols that represent them.

Throughout the rest of this book, the main menu button will be referred to as **MENU** and the secondary Function button as **Fn**. The control buttons will be shown as ◄ / ▲ / ► / ▼. These buttons are arranged around the confirmation enter button, referred to as the controller in Sony's manual, and in this book as **AF/Enter**. Finally, the control dial below the On/Off switch will be referred to as ![dial icon].

› Switching the camera on

The power switch surrounds the shutter button. Switched off, the camera is entirely inactive. Switched on, the camera will operate normally.

› Cycling through the screens

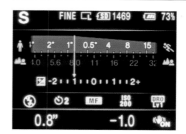

Pressing the **DISP** button when in shooting mode will cycle through a series of screens displaying different levels of information. There are three levels of information displayed when the **OVF/Live View** switch is set to **OVF**: a blank screen and two different summaries of the currently selected creative modes. See page 39 for information about Live View.

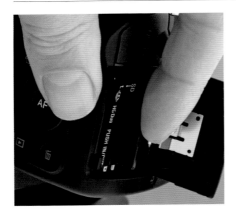

INSERT THE MEMORY CARD ⌃
With the SD/SDHC Duo label facing toward the front of the camera, push the card gently into the slot until it clicks into place.

Both cameras allow you to choose between using Sony's proprietary Memory Stick PRO/PRO-HG Duo media and the more universally available SD/SDHC memory cards.

1) Ensure that the camera is switched off and the small red access lamp to the left of the LCD screen is unlit.

2) Slide the memory card cover on the right side of the camera toward you until the cover swings freely open.

3) Looking directly at the memory card slots, the Memory Stick PRO Duo slot is on the left, the SH/SDHC on the right. Do not try to insert the wrong card into the wrong slot.

4) To insert an SD/SDHC memory card, ensure that the label side is facing toward the front of the camera and the metal contacts on the card edge face toward the slot. Push the card gently into the slot until you feel a slight resistance. Push more firmly, but not excessively, until the card clicks into place. Never force the memory card if there is undue resistance, since it may not be aligned in the slot correctly. Close the memory card cover.

5) The procedure for inserting the Memory Stick PRO/PRO-HG Duo is similar, although the label on the card should face the rear of the camera.

6) Select the type of memory card you are using by setting the memory card switch to the correct position. It is possible to have both types of memory card installed in the camera, but only one can be used at a time.

7) To remove the memory card, push it gently farther into the memory card slot

until you hear a click. You should now be able to pull it free from the slot.

8) Once you insert a memory card into the camera and turn the camera on, the number of images that can be fitted onto the card is displayed on the LCD screen. This figure will vary when you change the image quality and image size *(see pages 96–7)*.

Common errors

When the red access lamp is lit, the camera is either reading, writing, or erasing image data on the memory card. Do not remove the card or the battery when the lamp is lit, since this will corrupt the image data or even potentially damage the camera.

If there is no memory card in the camera, a yellow NO CARD warning will flash on the LCD screen. The shooting functions will be disabled.

› Formatting a memory card

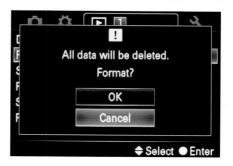

It is a good idea to format a memory card before using it for the first time or if it has been used in another camera previously. Formatting will remove all the data on the card, including images that have been protected from erasure. If there are any images already saved to the card, it is important to copy them to a PC or other storage device before formatting.

To format a memory card, press the **MENU** button, then use the ► button to select ▶ **Playback**. Press ▼ to highlight **Format**. Press **AF/Enter** to select **Format**. Press ▲ and **AF/Enter** to select **OK**.

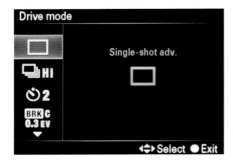

The A500 and A550 have three frame advance modes: two self-timer settings, exposure and white balance bracketing, and an option for using a wireless remote commander (available separately). The shooting mode you use determines which of the frame advance modes are available.

Set to Continuous Hi-Speed Advance, the A500 and A550 can shoot at a maximum of five frames per second (employing the optical viewfinder; four if using Live View). However, this figure will be dependent on shooting conditions, the quality and speed

Note:
The A550 can shoot up to seven frames per second using Speed Priority Continuous advance. Focus and exposure are set on the first shot and used on subsequent frames until the shutter button is released.

of your memory card, and the type of file selected. As you shoot, images are transferred from a frame buffer in the camera to the memory card. When 0 flashes in the viewfinder, you will not be able to shoot any more images until the frame buffer is sufficiently clear and the processed files written to the memory card.

The drive mode is selected automatically in Scene Selection (although self-timer modes are still available). To adjust the drive mode setting in Exposure mode, select the required option on the **Fn** menu screen, or press the ☉/⊡ button.

Drive mode options

Mode	Setting
Single-shot advance	☐
Continuous advance—Lo	⊡Lo
Continuous advance—Hi	⊡Hi
Continuous advance—Speed priority (A550 only)	⒮⊡
Self-timer, with 2- or 10-second delay	☉
Continuous advance bracket	BRK c
White balance bracket	BRK WB
Wireless remote commander	📱

› Mode dial

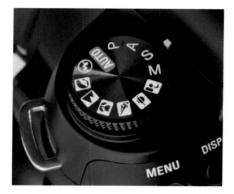

The mode dial has 12 settings, *(see table, right)*, each of which will be covered in detail later in this chapter. The mode settings are grouped into two types: Scene Selection and Exposure. Scene Selections are automated, the camera selecting the appropriate settings for the situation. Exposure mode allows you to choose between various options, giving you greater creative control over the final image. To select the desired mode, turn the dial until its icon is aligned with the white mark next to the dial.

Mode dial options

Scene Selection	Setting
Night Portrait/View	![]
Sunset	![]
Sports Action	![]
Macro	![]
Landscape	![]
Portrait	![]
No flash	![]
Auto	**AUTO**

Exposure	Setting
Program	**P**
Aperture Priority	**A**
Shutter Priority	**S**
Manual	**M**

› Operating the shutter button

The shutter button has two stages. Pressing lightly down halfway will activate the autofocus and camera metering. Playback mode will also be canceled automatically.

In Single-shot AF mode, the camera will focus, and both the exposure and the focus point will be locked until either the shutter button is released or the photograph taken by pressing down fully on the shutter button. In Continuous AF mode, neither the exposure nor focus is locked until the shutter is depressed fully and the photograph taken.

When Single-shot advance is selected, only one photograph will be taken when the shutter button is fully depressed. The shutter button must be released before the

camera can be used to take another photograph. In Continuous advance mode, the camera will continue to shoot at a maximum rate of seven frames per second (on the A550, using Speed Priority Continuous advance) until either the memory card or the camera's image buffer is full, or you stop pressing down on the shutter button.

› Operating the control dial

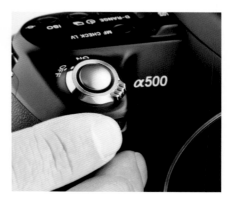

The 🌣 control dial next to the shutter button is used to set the aperture value and shutter speed in the Exposure modes, aperture priority and shutter priority. In manual exposure mode, turning the dial changes the shutter speed. Turning the dial at the same time as pressing down on the 🔲 button changes the aperture value.

› Focusing

Both cameras accept all the lenses in the current Sony lineup. The A500 and A550, and most, but not all, lenses are equipped with an AF/MF switch for selecting auto or manual focus mode. You may find that changing to manual focus may be necessary in certain situations. Autofocus is generally accurate, but when light levels are low or you are trying to focus on something with insufficient contrast, autofocus can start to "hunt" and be unable to achieve focus lock. If the lens has an AF/MF switch, use this to select manual focus. If the lens does not have an AF/MF switch, operate the one on the camera. The A500 and A550 have nine AF points that can act as a group or be selected singly (see page 18).

› Manual focus

When the lens is set to manual focus, **MF** will be displayed in the viewfinder and on the detailed information Live View screen. Rotate the focusing ring on the lens to focus. When your subject is in focus, the green ● confirmation light is displayed in the viewfinder or on the LCD (if in Live View). When Wide AF is selected, the center focus point is used to confirm manual focus. When Local AF is chosen, the focus point selected by the control buttons is used (see page 74).

Tip

The A500 and A550 have Eye-Start. Bringing the camera to your eye switches on autofocus automatically (assuming the AF/MF switch is set to AF). To deactivate Eye-Start, press **MENU***, select the* ⚙ *Custom menu, and highlight the Eye-Start AF option. Press the* **AF/Enter** *button and highlight* **Off** *using the* ▼ *control button. Press* **AF/Enter** *again.*

› Single-shot mode

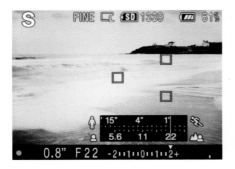

Single-shot mode is appropriate for subjects that don't move. Partially depress the shutter button (or fully depress **AF/Enter**) to lock autofocus. The camera will not try to refocus until you release pressure on the shutter button (or **AF/Enter**). When focus is locked, the green ● confirmation light and the red active focus point(s) will be visible in the viewfinder. This information will also be displayed on the LCD screen when using Live View, although the active focus point(s) will now be highlighted by a green box. Focus lock will also be confirmed by a beep, unless this has been deactivated on 🔧 2. Holding the shutter button partially depressed will keep the focus locked and you can recompose the photograph.

› Continuous AF

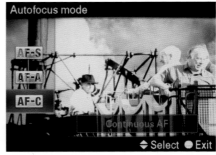

Continuous AF mode is the best choice for subjects that have directional movement. Focusing will start once Eye-Start has been activated or when the shutter button has been partially depressed. When the AF system starts to track a subject, the (◉) confirmation light and the red active focus point(s) will be visible in the viewfinder. This information will also be displayed on the LCD screen when using Live View, though the active focus point(s) will now be highlighted by a green box. The camera will continue to focus until the moment the shutter button is fully depressed. Focus lock will not be confirmed by a beep in Continuous AF mode.

› Automatic AF

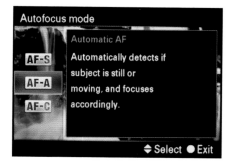

Automatic AF is a hybrid of the Single-shot and Continuous modes, and will switch between the two depending on the subject. If the subject is motionless, depressing the shutter button will lock the focus; if the subject moves, the AF system will continue to focus until the moment the shutter button is fully depressed.

> ### Tip
>
> When the A500 and A550 are still focusing, (()) will be displayed in the viewfinder. If focus cannot be achieved, the [●] focus indicator will flash and you will not be able to press the shutter button to take the shot.

Notes:
Automatic AF will be selected when the exposure mode is set to **AUTO** or one of the following four Scene Selection modes:

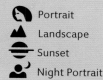 Portrait

Landscape

Sunset

Night Portrait

Single-shot AF is selected when the exposure mode is set to Macro in Scene Selection.

Continuous AF will be selected when the exposure mode is set to Sports Action in Scene Selection.

Continuous AF is selected when the Smile Shutter function is used *(see page 41)*.

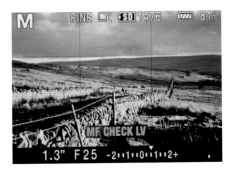

Focus can be checked by pressing the **MF CHECK LV** button. The reflex mirror is raised inside the camera and the image from the main image sensor displayed on the LCD monitor. The exposure settings chosen before entering MF CHECK LV are displayed at the bottom of the LCD. It is possible to change exposure at this point, but these changes will not affect the image displayed on the LCD, although will affect the exposed image if you press the shutter button during MF CHECK LV.

1) Press the **MF CHECK LV** button.

2) Press the **AEL** button to magnify the image on the LCD. Pressing **AEL** repeatedly magnifies the image further to a maximum of 14x. Use the ◀ / ▲ / ▶ / ▼ buttons to pan around the image.

3) Pressing the **AF/Enter** button will activate autofocus. If AF area is set to

Local, using the ◀ / ▲ / ▶ / ▼ buttons will activate AF for the selected AF point. **MF CHECK LV** will be briefly interrupted while the camera focuses. Manual focus can be used, but no focus confirmation points will be displayed.

4) Press the **MF CHECK LV** button again to exit and return to normal shooting mode. After pressing the shutter button in **MF CHECK LV**, the camera will return to normal shooting mode once the image data has been written to the memory card and displayed in Playback.

Notes:
A grid line can be displayed over the image in **MF CHECK LV** as an aid to composition *(see page 104)*.

The viewfinder is disabled during **MF CHECK LV.**

When [|▲] is displayed on the LCD, the camera temperature is too high.

Warning!

Running the main image sensor continuously generates a lot of excess heat. Turn off **MF CHECK LV** and return to normal shooting mode.

› Live View

With the A500 and A550, you have the choice of using either the optical viewfinder (OVF) or the LCD monitor in Live View mode. Live View employs a separate sensor to the main image sensor used to record the final image, so there are no temperature issues as seen with MF CHECK LV. To use Live View, move the switch to the right of the viewfinder from OVF to Live View. The OVF will be masked off and the scene will be displayed on the LCD screen, along with relevant shooting information and battery status.

Press the **DISP** button to change the level of shooting information that is displayed. There are four levels of information, from a simple screen with only basic exposure information to a detailed summary of the currently selected creative modes. To return to using the optical viewfinder, set the mode switch back to OVF.

› Smart Teleconverter

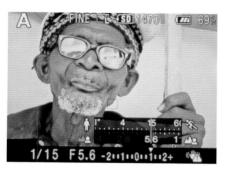

With Live View activated, you can zoom into the center of your image and record just that section using Smart Teleconverter.

1) Switch the camera to **Live View** and press 🔲 once to zoom in 1.4x.

2) Press the shutter button to record the image or press 🔲 again to zoom in 2x before taking the shot. Pressing 🔲 a third time without pressing the shutter button returns the camera to standard Live View.

3) Once a shot has been taken, the camera returns to standard Live View.

The recorded image size at 1.4x zoom is equivalent to medium image size, while at 2x zoom it is equivalent to small image size. This is regardless of the image size set on the 📷 Recording menu screen (*see pages 96–101*).

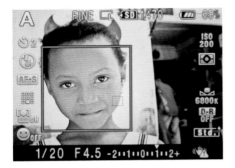

Face Detection

There are two modes, only available in Live View—Face Detection, and Smile Shutter—that will help you create satisfying portraits of people. When Face Detection is activated, the A500 and A550 will automatically detect up to eight faces that are within your composition. The camera then adjusts the focus, exposure, flash settings, and image processing parameters as necessary.

When a face is detected, a white box is drawn around it. If autofocus is possible (e.g., if the face is within your lens' focus range), the box will turn orange. When you press the shutter button to take the shot, the box turns green. If there is no face present in the picture, the normal AF points will be displayed and will turn green when focus is achieved.

If there are several faces in your composition, the camera draws a white box around each of them except one. This face is selected as the "priority" face. The box around this face turns orange if autofocus is possible.

> **Notes:**
> Face Detection is set to on as the default. To switch off Face Detection, press **Fn**. Highlight [●]ON press **AF/ Enter**. Highlight [●]OFF and press **AF/ Enter**.
>
> Face Detection cannot be used with the manual focus check function (see page 35).
>
> Smart Teleconverter is unavailable when using **MF CHECK LV** or Smile Shutter, or when the image quality is set to RAW or RAW+JPEG.
>
> When Smart Teleconverter is used, the AF area is set to spot and metering is set to multi-segment (see page 75).
>
> Face detection works best when your subject's face is free from obstruction, such as drooping hair covering the eyes, or a hat casting a shadow.

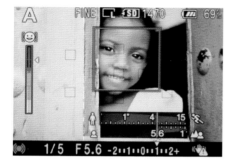

Smile Shutter

For DSLR users, capturing the moment a person smiled was once a matter of careful timing and the occasional missed opportunity. Now, with the A500 and A550, the precise moment a person smiles can be captured automatically using Smile Shutter.

1) Set the camera to **Live View** mode.

2) Press the **Fn** button and use ▲ / ▼ to highlight **Smile Shutter** at the bottom left of the screen 😊ON. Press **AF/Enter**.

3) Highlight **On** and use ▶ / ◀ to change the Smile Shutter sensitivity. This can be set to Slight Smile 😊ON, Normal Smile 😊ON, or Big Smile 😊ON. Slight is the most sensitive setting, and Big the least sensitive.

4) Press **AF/Enter** to exit and return to shooting mode.

5) A Smile Detection Sensitivity indicator is displayed on the LCD.

When the camera detects a face, an orange Face Detection frame is displayed around it, turning green when focus is confirmed. If your subject is smiling, the image is shot automatically when the Smile Detection Sensitivity level exceeds the ◁ point on the indicator. The bigger the smile, the higher the Smile Detection Sensitivity indicator rises.

To exit Smile Shutter mode, repeat stages 2 to 4, selecting **Smile Shutter Off**, switching back to **OVF**, or turning your camera off.

Tip

As with Face Detection, keep the facial features of your subject as clear from obstruction as possible.

2

› Built-in flash

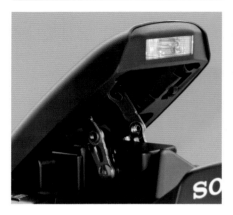

The built-in flash can be set to on or off in both Scene Selection and Exposure modes, with the exception of the Scene Selection mode ⚡ No Flash. In Scene Selection, the flash will pop up automatically if activated. In Exposure, the flash must be raised manually by pressing the ⚡ button. When the flash is active and charged, the ⚡ flash will be displayed in the viewfinder and in the bottom left of the LCD screen.

› ISO setting

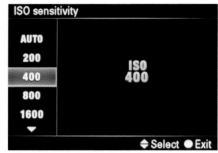

The ISO value regulates how sensitive the sensor is to light. This directly affects the combined exposure values of aperture and shutter speed. The higher the ISO value, the faster the shutter speed or the smaller the aperture you will be able to use. In low light this would mean you could more successfully handhold the camera without the risk of camera shake. However, using a higher ISO value introduces "noise" into the image. This gives the image a gritty, grainy appearance that reduces fine detail. Using a low ISO value will give you a crisper image with more detail.

In Scene Selection modes, the ISO is automatically selected for you between ISO 200 and 1600, depending on light levels, and cannot be altered. In the Exposure modes **P/A/S**, ISO can be set

manually in the range ISO 200–12,800, or to **Auto ISO**. In the Exposure mode **M**, ISO can only be set manually. If **Auto ISO** was previously selected, the camera will default to ISO 200.

To set the ISO value in Exposure mode, press the ISO button (or **Fn**, highlight ISO, and press **AF/Enter**) and use ▲ / ▼ to highlight the desired ISO value. Press **AF/Enter** to set the ISO value. The ISO setting is shown on the LCD screen.

> ### *Tips*
>
> *Doubling the ISO value is equivalent to a 1-stop increase in the sensitivity of the sensor; halving the ISO value decreases sensor sensitivity by 1 stop.*
>
> *Increasing the ISO value increases the effective range of the built-in and external flash.*
>
> *With High ISO noise reduction enabled, the camera will attempt to reduce the "noise" in the image when the ISO is set to ISO 1600 or higher.*

NOISE ⌃
The high level of "noise" has drastically reduced the level of fine detail in this image. However, the image does have a soft, "painterly" feel that may suit a different subject.

2 » IMAGE PLAYBACK

After taking a shot, the camera will automatically display the image. The length of time the image is displayed can be changed on the ⚙ Custom menu between four settings: 2, 5, and 10 seconds, or off entirely.

If automatic review is disabled, pressing the ▶ playback button will display the last image shot. Pressing ◀ in playback will skip back through the images on the card; pressing ▶ will jump forward.

Pressing the **DISP** button in playback mode toggles the image display style between image with shooting data, image with shooting data and an RGB histogram, and finally image only.

› Magnify images

The images in playback mode can be magnified up to x14 (A550) or x13.4 (A500) of the screen size, which is useful for checking focus after creating an image. To magnify an image in playback mode, press the **AEL** / ⊕ button. Continue to press the button to zoom into the image or press the ⊟ / ⊖ button to zoom out.

To pan around the zoomed image, use the ▲ / ▶ / ▼ / ◀ control buttons.

Pressing the ▶ playback button again will restore the image to normal size.

› Rotating images

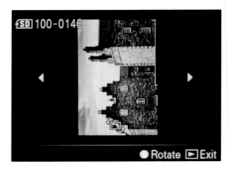

In playback mode, press the **Fn** / 🔲, button and press **AF/Enter** to rotate the current image 90° counterclockwise. Pressing the **AF/Enter** button a further three times will return the image to its original orientation. Once you are happy with the image orientation, press the ▶ playback button to exit, or press either ◀ or ▶ to review and rotate more images.

› Image index

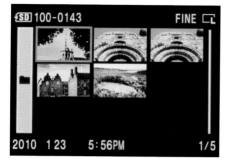

In playback mode, press the ▓ / ▓ button. Either 4 or 9 images can be displayed on screen at any one time using **Image Index**. To toggle between these two options press the **DISP** button. Note, however, that the greater the number of images displayed, the smaller will be the size of the thumbnail. The current image selected is highlighted in orange. Use either the ▲ / ► / ▼ / ◄ control buttons or left and right with the ▓ control dial to navigate around the image thumbnails. Press ▓ / ▓ again to select an image and show it at the normal size.

The A500 and A550 can save images to different folders on your memory card. To navigate between the different folders on the card, use the ◄ / ► control buttons to move to the folder bar on the left of the image index screen. Press the **AF/Enter** button then use ▲ / ▼ and **AF/Enter** to select the desired folder.

› Slide Show

Press the **MENU** button, navigate to ▶ Playback 1 and select **Slide show**. On the slide show options screen, the time each image will be displayed can be changed, and **repeat slide show** switched on or off. Select **OK** at the bottom of the screen to start the slide show. During the slide show, pressing ◄ / ► will skip backward or forward between images. To pause and then restart the slide show, press the **AF/Enter** button. Press **DISP** during the slide show to toggle between displaying the image only and the image with shooting information overlaid.

To exit the slide show before the end, press the ▶ Playback button, whereupon the camera will revert to standard playback mode.

> **Note:**
> The A500 and A550 will play all the images on the memory card at user-selectable intervals of 1, 3, 5, 10, or 30 seconds.

2 » DELETING IMAGES

In Playback, images can be deleted by pressing either the 🗑 button or by selecting the delete option after pressing the MENU button. Once an image has been deleted, it cannot be recovered.

› Single image delete

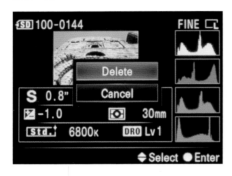

After shooting an image, that image can be deleted immediately in image review. Press the 🗑 button, highlight **Delete**, and press **AF/Enter** to confirm. Alternatively, highlight **Cancel** and press **AF/Enter** to return to Playback mode. You will not be able to delete the image until all the image data has been successfully written to the memory card.

In normal playback, to delete the currently displayed image, press the 🗑 button, highlight **Delete**, and press

AF/Enter to confirm. Alternatively, highlight **Cancel** and press **AF/Enter** to return to Playback mode.

› Multiple image delete

To delete a range of images or all images, press **MENU** during image playback and select **Delete**.

To choose specific images to delete, select **Marked images**. Use the ◄ / ► buttons to move through the images on your memory card. Press the **AF/Enter** button to mark the displayed image for deletion. A green 🗑 symbol will appear in the center of the image. When you have marked the full range of images you wish to delete, press the **MENU** button. Highlight **Delete** and press **AF/Enter** to confirm. Alternatively, highlight **Cancel** and press **AF/Enter** to continue with image marking. Press the ▶ button to exit delete images and return to Playback.

To delete all the images on the memory card, select **All images** and then **Delete** to confirm. Alternatively, highlight **Cancel** and press **AF/Enter** to return to the delete images screen. Press the ▶ button to exit delete images and return to Playback.

› Folder delete

Images can be stored in a number of different folders on your memory card (*see page 112* to create a new folder). To delete a folder (and all the images contained within) press ▶ then the ▦ / ✚ button to display the image index screen. Use the ◀ control button to select the folder bar on the left of the image index. Select the folder you want to delete with the ▲ / ▼ control buttons. Press the 🗑 button, then select **Delete** to delete the current folder, or press **AF/Enter** to select a different folder to delete.

Tip
Formatting a memory card will erase all images regardless of whether they have been set to protected or not.

› Protecting images

Marking images for protection will ensure that they are not erased accidentally. In Playback, images can be protected by pressing **MENU** and selecting **Protect**.

To choose specific images to protect, select **Marked images**. Use the ◀ / ▶ buttons to move through the images on your memory card. Press the **AF/Enter** button to mark the displayed image for protection. A green ⊙⊸ Protect symbol will appear in the center of the image. When you have marked the full range of images you wish to protect, press **MENU**. Highlight **OK** and press **AF/Enter** to confirm. Alternatively, highlight **Cancel** and press **AF/Enter** to continue with image marking. Press the ▶ button to exit protect images and return to Playback.

To cancel all the protected images, select **Cancel All** on the Protect screen.

2 » SCENE SELECTION MODES

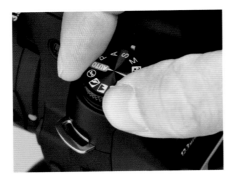

The A500 and A550 have a number of different settings in Scene Selection mode to enable you to shoot effectively in a variety of situations. The camera automatically sets the exposure controls (aperture, shutter speed, ISO, and flash, if activated) as well as drive mode, creative style, and white balance. How these controls are set will depend on the Scene Selection mode chosen. There is little opportunity to override the settings the camera chooses, other than selecting

Note:
Many of the creative controls found in Exposure mode, such as exposure compensation and ISO setting, are unavailable in Scene Selection.

flash on or off. Each Scene Selection mode represents a different photographic style. These styles are predetermined and are as follows:

 Auto

Portrait

 Landscape

 Macro

Sports Action

 Sunset

 Night Portrait/Night View

 Flash Off

When you turn the Mode Dial to your selected setting, the Help Guide screen will display an explanation of the selected mode, along with suggested methods for shooting your chosen subject. Full details for each Scene Selection can be found on the following pages.

BEAMISH BUS »
Using Auto mode meant I could concentrate on watching and capturing events and details on a family day at an outdoor museum, rather than on thinking about camera settings.

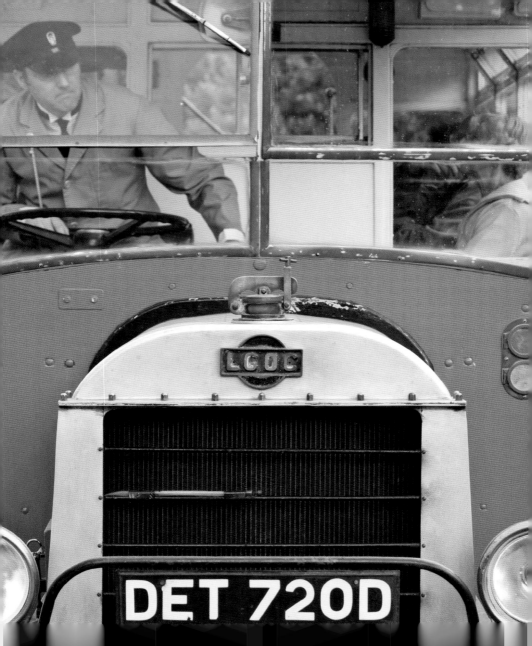

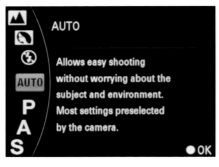

2 › Full Auto mode

OUT FOR A WALK
Auto mode is perfect when taking your camera out for a "walk," when you do not want to worry about setting the various camera controls.

Auto mode allows you to take a photograph of any subject, in a wide variety of situations, since the camera will automatically adjust its settings to suit the prevailing conditions. This is useful if you are in a fast moving situation when there is little time to think about the optimum camera settings.

The camera will select the ISO, aperture, and shutter speed, and will always try to bias those settings so that you can successfully use the camera handheld. If the inbuilt flash is activated, it will automatically pop up if required.

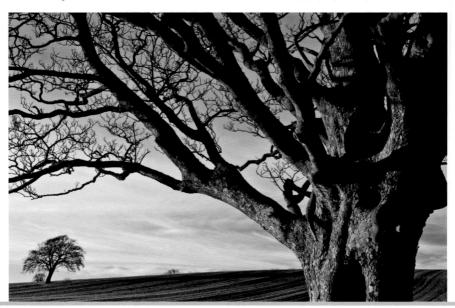

FULL AUTO MODE SETTINGS

Quality Setting

RAW can be selected in both 3:2 and 16:9 aspect ratio; RAW and JPEG combined in both 3:2 and 16:9 aspect ratio; JPEG with all size options (large, medium, or small) and quality (fine or standard) in both 3:2 and 16:9 aspect ratio available.

Exposure settings

Multi-segment metering; shutter speed, aperture, and ISO are chosen automatically depending on subject and lighting conditions; Auto White balance; Long exposure noise reduction; High ISO noise reduction.

Focus settings

Automatic AF point selection in Automatic focus mode; Face Detection; Smile Shutter.

Frame advance

Single frame advance; Continuous High and Low speed advance; 10-second self-timer; 2-second self-timer; Remote Commander.

Flash settings

Auto flash and fill-flash are available and will be selected automatically if first activated via **Fn** menu (no exposure compensation is possible); Flash Off.

Using Full Auto mode

1) Turn the mode dial to AUTO .

2) Lightly press the shutter button to focus. The focus confirmation symbol and active focus points will light in the viewfinder or LCD (if using Live View) when focus is achieved. You may need to use manual focus if the light level is too low for autofocus to work efficiently.

3) Depress the shutter button fully to take the photograph.

4) The captured photograph will be displayed on the LCD screen by default for two seconds unless the review time has been adjusted.

Tips

Set the flash mode to ⚡ Fill-Flash when you wish to use the flash.

Select the ⚡ Flash Off setting on the Mode dial when shooting in conditions where the use of flash is not allowed.

› Portrait mode

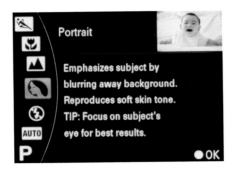

Portrait

Emphasizes subject by blurring away background. Reproduces soft skin tone. TIP: Focus on subject's eye for best results.

AUTO

P

● OK

A quick look on photo sharing web sites such as Flickr will leave you in no doubt that people like to take photos of people. Humans are social creatures, so it should come as no surprise that photos of friends, family, and pets are such popular subjects. These photos of people or animals are most often head-and-shoulders shots, taken in a vertical, or "portrait," format. However, you should not feel confined to shooting in this format, and you may enjoy experimenting with portraits of people in horizontal, or "landscape," format to put them in the context of their environment.

Lens choice is very important in portrait photography, since the wrong choice can distort the subject's features. A wide-angle lens can make the facial features closest to the camera look disproportionately large, whereas a telephoto lens tends to flatten the facial features.

The golden rule with portraiture is to ensure that the eyes of the subject are in focus. However, there's no harm in breaking rules: who says that portraits have to be solely about the face? Concentrate on features such the hands, which can be almost as expressive as the face.

Tips

If the subject is backlit, try using autoflash to help balance the contrast levels.

Use the red-eye reduction function if the eyes of your subject appear red when you are shooting with flash (see page 154).

THE EYES HAVE IT ⌄
The subject's eyes are pin-sharp—it doesn't matter that the ears aren't. Would the portrait have been as successful if it had been the other way around?

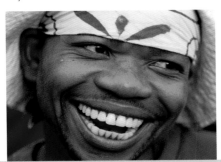

PORTRAIT MODE SETTINGS

Quality Setting
RAW can be selected in both 3:2 and 16:9 aspect ratio; RAW and JPEG combined in both 3:2 and 16:9 aspect ratio; JPEG with all size options (large, medium, or small) and quality (fine or standard) in both 3:2 and 16:9 aspect ratio available.

Exposure settings
Multi-segment metering; shutter speed, aperture, and ISO are chosen automatically depending on subject and lighting conditions; Auto White balance; Long exposure noise reduction; High ISO noise reduction.

Focus settings
Automatic AF point selection in Automatic focus mode; Face Detection; Smile Shutter.

Frame advance
Single frame advance; 10-second self-timer; 2-second self-timer; Remote Commander.

Flash settings
Auto flash and fill-flash are available and will be selected automatically if first activated via **Fn** menu (no exposure compensation is possible); Flash Off.

Using Portrait mode

1) Turn the mode dial to .

2) Point the camera at your subject. Take care in your composition not to let distracting elements detract from your subject. The classic example is a photo where the subject appears to have a tree growing out of their head.

3) Lightly press the shutter button to focus. The focus confirmation symbol and active focus points will light in the viewfinder when focus is achieved. The exposure settings (aperture and shutter speed) will also be displayed in the viewfinder.

4) The flash will pop up automatically if light levels are low and flash has been activated via the **Fn** menu. To reduce the chance of red-eye, **Red eye reduc**. should be switched to **On** *(see page 154)*.

5) Depress the shutter button fully to take the photograph.

6) The captured photograph will be displayed on the LCD screen by default for two seconds unless the review time has been adjusted.

7) Activating Face Detection or Smile Shutter will automate your portrait making further.

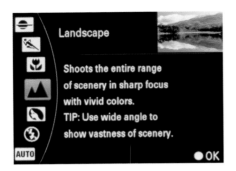

The natural landscape as a subject has fascinated photographers since the invention of photography in the 19th century. There can be few things more satisfying than successfully capturing the essence of a landscape photographically, particularly when the weather and therefore lighting conditions are changeable. Getting a taste for landscape photography can result in a lifetime's obsession. With the changing of the seasons, the time of day, and the weather, there is almost an infinite number of subjects to shoot, even if you restrict yourself to your own backyard.

The most common lenses used in landscape photography are wide-angle lenses, since they allow the greatest depth of field and capture the widest view of a scene. However, it is worth experimenting with different lenses; even telephoto lenses have their place in landscape photography.

Landscape mode on the A500 and A550 is designed to enable you to shoot in a wide variety of landscape situations, with accurate colors and a broad depth of field. To achieve this, the camera attempts to use as small an aperture as possible, without reducing shutter speed to a point where camera shake becomes a problem.

Tips

If you wish to emphasize expansive areas of the landscape, set your zoom lens to its wide-angle setting.

Don't be afraid of getting in close and filling the frame with the subject.

SPACE TO BREATHE
I wanted to convey a sense of the scale of this Northumberland landscape. I achieved this by including more sky than landscape, emphasizing the wonderful clouds that stretched off to the far horizon.

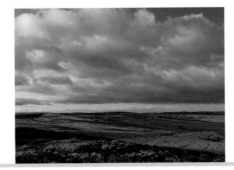

LANDSCAPE MODE SETTINGS

Quality Setting

RAW can be selected in both 3:2 and 16:9 aspect ratio; RAW and JPEG combined in both 3:2 and 16:9 aspect ratio; JPEG with all size options (large, medium, or small) and quality (fine or standard) in both 3:2 and 16:9 aspect ratio available.

Exposure settings

Multi-segment metering; shutter speed, aperture, and ISO are chosen automatically depending on subject and lighting conditions; Auto White balance; Long exposure noise reduction; High ISO noise reduction.

Focus settings

Automatic AF point selection in Automatic focus mode; Face Detection; Smile Shutter.

Frame advance

Single frame advance; 10-second self-timer; 2-second self-timer; Remote Commander.

Flash settings

Fill-flash is available and will be selected automatically if first activated via **Fn** menu (no exposure compensation is possible); Flash Off.

Using Landscape mode

1) Turn the mode dial to .

2) Point the camera at your subject. Take care in your composition not to let distracting elements detract from your subject. Look in all four corners of the frame, not just in the center.

3) Lightly press the shutter button to focus. The focus confirmation symbol and active focus points will light in the viewfinder when focus is achieved. The exposure settings (aperture and shutter speed) will also be displayed in the viewfinder.

4) The flash will automatically pop up if light levels are low and flash has been activated via the **Fn** menu.

5) Depress the shutter button fully to take the photograph.

6) The captured photograph will be displayed on the LCD screen by default for two seconds unless the review time has been adjusted.

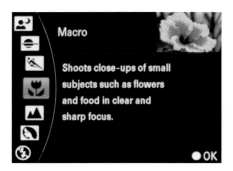

Macro

Shoots close-ups of small subjects such as flowers and food in clear and sharp focus.

● OK

The inclusion of Macro mode on the A500 and A550 can be a source of confusion if you've recently migrated from a compact digital camera. On a compact digital, macro mode will allow you to focus on tiny details, often just a few centimeters from the subject. Macro mode on the A500 and A550 will not allow you do this unless you have attached a macro lens or are using extension tubes *(see page 169).*

A true macro photograph is one where the focused image projected onto the sensor is the same size as the subject (a ratio of 1:1). Although the 18-55mm kit lens commonly sold with the cameras is not a true macro, with a minimum focusing distance of only 25cm (at a magnification of 0.34x), it will allow you capture striking close-ups.

Overall image sharpness can be tricky to achieve in both macro and close-up photography. The closer you focus on a subject, the less depth of field you will be able to achieve. When you are using Macro mode, the SteadyShot function will not be fully effective. Using a tripod in this situation will give you more satisfactory results.

> ### *Tips*
>
> *For really effective close-up and macro photography, get as near to the subject as the minimum focusing distance of the lens will allow.*
>
> *Set the flash mode to* 🚫 *Flash Off when you are shooting a subject less than 3ft (1m) away.*

CLOSE SCRUTINY ⌄
One of the joys of macro photography is making unusual images of ordinary household objects such as these wood screws.

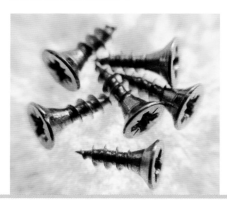

MACRO MODE SETTINGS

Quality Setting
RAW can be selected in both 3:2 and 16:9 aspect ratio; RAW and JPEG combined in both 3:2 and 16:9 aspect ratio; JPEG with all size options (large, medium, or small) and quality (fine or standard) in both 3:2 and 16:9 aspect ratio available.

Exposure settings
Multi-segment metering; shutter speed, aperture, and ISO are chosen automatically depending on subject and lighting conditions; Auto White balance; Long exposure noise reduction; High ISO noise reduction.

Focus settings
Automatic AF point selection in single-shot focus mode; Face Detection; Smile Shutter.

Frame advance
Single frame advance; 10-second self-timer; 2-second self-timer; Remote Commander.

Flash settings
Auto flash and fill-flash are available and will be selected automatically if first activated via **Fn** menu (no exposure compensation is possible); Flash Off.

Using Macro mode

1) Turn the mode dial to 🌷.

2) Point the camera at your subject. If you are employing a tripod, selecting 10-second timer delay or using the optional remote commander will help to cut the risk of camera shake reducing the sharpness of your photo.

3) Lightly press the shutter button to focus. The focus confirmation symbol and active focus points will light in the viewfinder when focus is achieved. If the camera struggles to focus, you may be closer to the subject than the minimum focusing distance of the lens. If this occurs, move the camera back from the subject until focus can be confirmed.

4) The flash will pop up automatically if light levels are low and flash has been activated via the **Fn** menu.

5) Depress the shutter button fully to take the photograph.

6) The captured photograph will be displayed on the LCD screen by default for two seconds unless the review time has been adjusted.

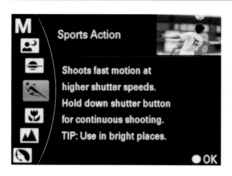

Sports Action

Shoots fast motion at higher shutter speeds. Hold down shutter button for continuous shooting. TIP: Use in bright places.

● OK

Tips

In this mode, the camera will shoot images continuously if the shutter button is kept depressed, enabling you to capture a sequence of shots.

If you hope to capture a crucial, live-action moment, press the shutter button down halfway until you are ready. Then you can act quickly to obtain the perfect photo.

Participants in a sporting event may not appreciate a flash being fired at them when they are concentrating on the event. To shoot without flash, set the flash mode to (🚫) Flash Off.

Because of the name and the symbol of a figure running, you'd be forgiven for thinking that Sports Action mode is only needed at track and field events. In fact, the mode is designed to enable you to capture sharp images of moving subjects, outdoors or in bright conditions indoors. Subjects that can be shot with Sports Action mode are as diverse as children playing in the yard to jets taking off at an airshow. The mode forces the camera to use the fastest shutter speed, depending on the maximum aperture of the lens used and the intensity of the available light.

The skill in capturing fast action is learning to anticipate what is about to happen, where it will happen, and how close you need to be to photograph the event. It's worth learning those skills at smaller venues such as school sports days and local football games before tackling something as big as the Olympics.

FOLLOW THE LEADER ⌄
Sports Action mode is ideal for fast-moving, never-to-be-repeated events such as this Italian shepherd leading his flock down a country lane.

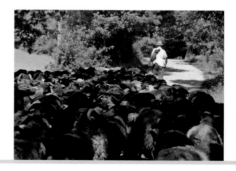

SPORTS ACTION MODE SETTINGS

Quality Setting
RAW can be selected in both 3:2 and 16:9 aspect ratio; RAW and JPEG combined in both 3:2 and 16:9 aspect ratio; JPEG with all size options (large, medium, or small) and quality (fine or standard) in both 3:2 and 16:9 aspect ratio available

Exposure settings
Multi-segment metering; shutter speed, aperture, and ISO are chosen automatically depending on subject and lighting conditions; Auto White balance; Long exposure noise reduction; High ISO noise reduction.

Focus settings
Automatic AF point selection in continuous focus mode; Face Detection; Smile Shutter.

Frame advance
Continuous High and Low speed advance; 10-second self-timer; 2-second self-timer; Remote Commander.

Flash settings
Fill-flash is available and will be selected automatically if first activated via **Fn** menu (no exposure compensation is possible); Flash Off.

Using Sports Action mode

1) Turn the mode dial to .

2) Point the camera at your subject. Be prepared to pan the camera to follow the subject.

3) Lightly press the shutter button to focus. The focus confirmation symbol and active focus points will light in the viewfinder when focus is achieved. The exposure settings will also be displayed in the viewfinder.

4) The flash will pop up automatically if light levels are low and flash has been activated via the flash button. Fill-flash and flash off are the only two selectable flash options.

5) At the desired moment, depress the shutter button fully to take the picture, following the movement of the subject.

6) Keep your finger on the shutter button to take multiple shots of the subject. The camera will stop firing once the frame buffer is full and will not continue until the buffer is sufficiently clear.

7) The captured photograph will be displayed on the LCD screen by default for two seconds unless the review time has been adjusted.

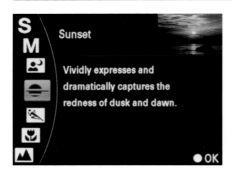

It's almost a photographic cliché, but there are few times when the landscape can look as dramatically colorful than at sunrise or sunset. However, it is often difficult to tell whether a particular sunrise or sunset will develop its true color potential. Complete cloud cover generally will not produce an interesting color unless the sun passes through a break in the cloud below the horizon. Clear conditions are also unlikely to provide drama, although sometimes haze caused by humidity or atmospheric dust can cause an interesting pink or red glow to develop. For this reason, there is often more chance of dramatic color at sunset than at sunrise because of dust buildup during the day.

One positive sign that an interesting sky may occur is when cloud is broken up with sufficient gaps for the setting sun to shine through. Another potential cause of a colorful sunrise or sunset is when there is a layer of thin, high-altitude cloud such as cirrus, which is often the first (at sunrise) or last (at sunset) type of cloud to develop color. Sunset Mode will allow you to capture the vivid colors of a sunset, by automatically setting the white balance to emphasize the reds in the image.

Tip

Before the sun rises or after it has set, the contrast level will be high—the sky will be much brighter than the landscape. A subject in your photo may be recorded as a silhouette. This can be an effective way of producing a striking abstract image.

SANDS AT SUNSET ⌄
Wet sand is a good reflector of light, particularly at sunset when the colors from all around the sky are reflected back at the camera.

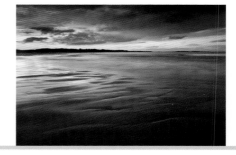

SUNSET MODE SETTINGS

Quality Setting

RAW can be selected in both 3:2 and 16:9 aspect ratio; RAW and JPEG combined in both 3:2 and 16:9 aspect ratio; JPEG with all size options (large, medium, or small) and quality (fine or standard) in both 3:2 and 16:9 aspect ratio available.

Exposure settings

Multi-segment metering; shutter speed, aperture, and ISO are chosen automatically depending on subject and lighting conditions; Auto White balance; Long exposure noise reduction; High ISO noise reduction.

Focus settings

Automatic AF point selection in Automatic focus mode; Face Detection; Smile Shutter.

Frame advance

Single frame advance; 10-second self-timer; 2-second self-timer; Remote Commander.

Flash settings

Fill-flash is available and will be selected automatically if first activated via **Fn** menu (no exposure compensation is possible); Flash Off.

Using Sunset mode

1) Turn the mode dial to .

2) Point the camera at your subject. If you are using a tripod, selecting 10-second timer delay or using the optional remote commander will help to cut the risk of camera shake reducing the sharpness of your photo.

3) Lightly press the shutter button to focus. The focus confirmation symbol and active focus points will light in the viewfinder when focus is achieved.

4) The flash will pop up automatically if light levels are low and flash has been activated via the flash button.

5) Depress the shutter button fully to take the photograph.

6) The captured photograph will be displayed on the LCD screen by default for two seconds unless the review time has been adjusted.

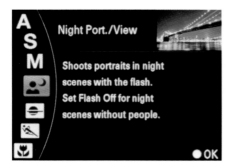

What can seem like a dull town or city by day can be transformed at dusk into a wonderland of light and color. Ironically, night photography is often better if carried out before night falls completely. The shapes of unlit areas of buildings will be lost against the night sky once it is black.

The optimum time to shoot night photographs is at dusk, when there is still color in the sky. Depending on the time of year, this will be approximately half an hour after sunset. In winter, dusk does not last long, so planning your shots when it is still light will help you make the most of this time. If you have a variety of shots planned for one location, start shooting toward the east first as this half of the sky will be darkest first. The western half of the sky will retain color for longer, so it's worth leaving any shots in this direction until last. Reverse this when shooting just before the dawn.

The cold of winter brings another challenge for night photography. Batteries do not work as well in the cold, and you may find that power is lost more quickly than usual. Carry a spare battery inside your jacket to keep it warm to exchange with your main battery if necessary.

TRIUMPHANT ARCH ⌄
Dusk is the optimum time of day for night photography. The braces on the Millennium Bridge, Gateshead, would have been lost against the sky if I'd waited until it was black.

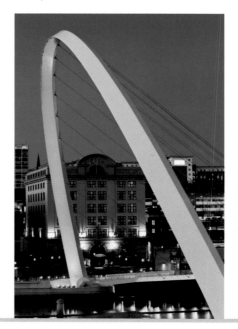

NIGHT PORTRAIT/VIEW MODE SETTINGS

Quality Setting

RAW can be selected in both 3:2 and 16:9 aspect ratio; RAW and JPEG combined in both 3:2 and 16:9 aspect ratio; JPEG with all size options (large, medium, or small) and quality (fine or standard) in both 3:2 and 16:9 aspect ratio available.

Exposure settings

Multi-segment metering; shutter speed, aperture, and ISO are chosen automatically depending on subject and lighting conditions; Auto White balance; Long exposure noise reduction; High ISO noise reduction.

Focus settings

Automatic AF point selection in Automatic focus mode; Face Detection; Smile Shutter.

Frame advance

Single frame advance; 10-second self-timer; 2-second self-timer; Remote Commander.

Flash settings

Auto flash and fill-flash are available and will be selected automatically if first activated via **Fn** menu (no exposure compensation is possible); Flash Off.

Using Night Portrait/View mode

1) Turn the mode dial to 👤🌙 .

2) Point the camera at your subject. Shutter speeds are likely to be low. If you are employing a tripod, selecting 10-second timer delay or using the optional remote commander will help to cut the risk of camera shake reducing the sharpness of your photo.

3) Lightly press the shutter button to focus. The focus confirmation symbol and active focus points will light in the viewfinder when focus is achieved. You may need to use manual focus if the light level is too low for the autofocus function to work efficiently.

4) The flash will pop up automatically if light levels are low and flash has been activated via the flash button. Switch flash to off if your main subject is beyond the flash range.

5) Depress the shutter button fully to take the photograph.

6) The captured photograph will be displayed on the LCD screen by default for two seconds unless the review time has been adjusted.

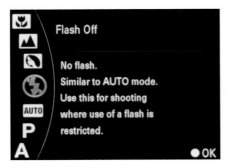

Flash Off

No flash.
Similar to AUTO mode.
Use this for shooting where use of a flash is restricted.

●OK

Essentially the same as Automatic mode, Flash Off would be selected in a situation where the use of flash would not be appreciated—or creatively desired.

Candid street photography at night or in a low-light situation would not work with flash. Not only would the atmosphere of the scene be diminished, but also the use of flash would draw attention to the fact that you were taking a photo. Your photography would cease to be candid very quickly!

A tripod, although generally a useful tool in low-light situations, can be a hindrance when speed of mobility is important. Fortunately the SteadyShot facility of the A500 and A550 reduces the risk of camera shake, making handheld, low-light photography more practicable. Another way to reduce the risk of camera shake is to use a lens with as large a maximum aperture as possible. Sony produces an f/1.4 50mm lens that would be a useful option for handheld, low-light photography, since faster shutter speeds would be achievable.

Tips

In this mode, the shutter speed may be slower than usual, enabling sufficient light to be captured by the sensor for the creation of a satisfactory image. This means that subjects will be blurred if there is any motion.

Switch on SteadyShot to reduce the risk of camera shake with slower shutter speeds.

CHURCH INTERIOR ⌄
The light level was low in this church. However, the use of flash would not have been sympathetic to the subject. The camera was mounted on a tripod and available light used.

FLASH OFF MODE SETTINGS

Quality Setting
RAW can be selected in both 3:2 and 16:9 aspect ratio; RAW and JPEG combined in both 3:2 and 16:9 aspect ratio; JPEG with all size options (large, medium, or small) and quality (fine or standard) in both 3:2 and 16:9 aspect ratio available.

Exposure settings
Multi-segment metering; shutter speed, aperture, and ISO are chosen automatically depending on subject and lighting conditions; Auto White balance; Long exposure noise reduction; High ISO noise reduction.

Focus settings
Automatic AF point selection in Automatic focus mode; Face Detection; Smile Shutter.

Frame advance
Single frame advance; Continuous High and Low speed advance; 10-second self-timer; 2-second self-timer; Remote Commander.

Flash settings
Flash is disabled.

Using Flash Off mode

1) Turn the mode dial to .

2) Point the camera at your subject. Shutter speeds are likely to be low if you are indoors or in an unlit area. If you are using a tripod, selecting 10-second timer delay or using the optional remote commander will help to cut the risk of camera shake reducing the sharpness of your photo.

3) Lightly press the shutter button to focus. The focus confirmation symbol and active focus points will light in the viewfinder when focus is achieved. You may need to use manual focus if the light levels are too low for autofocus to work efficiently.

4) Depress the shutter button fully to take the photograph.

5) The captured photograph will be displayed on the LCD screen by default for two seconds unless the review time has been adjusted.

Exposure in photography refers to the amount of light allowed to fall on the film or, in the case of digital cameras, the image sensor. This is determined by controlling, in combination, the camera shutter speed and the size of the lens aperture. A slow shutter speed allows more time for light to hit the sensor than a fast one, while a wide aperture will let in more light than a narrow one.

Shutter speed is measured in fractions of a second: 1/125, 1/250, 1/500, 1/1000, etc. The difference between each consecutive shutter speed is known as a stop. So, for example, there is a one-stop difference between a shutter speed of 1/125 and 1/250. A speed of 1/250 lets twice as much light into the camera as 1/500, and half as much as 1/125.

The size of the aperture is measured in f-stops. The higher the number of the f-stop, the smaller the aperture opening. The most commonly used f-stops, in sequence, are f/2.8, f/4, f/5.6, f/8, f/11, f/16, and f22. As with shutter speeds, each

stop represents either a doubling or halving of the amount of light let through. So, f/5.6 will allow in half as much light as f/4, but twice that of f/8.

The photograph below was taken with a shutter speed of 1/125 sec. and an aperture of f/11, using ISO 200. From the table, you can see that I could have chosen several other shutter speed/aperture combinations to achieve the same exposure.

SHUTTER SPEED/APERTURE

Shutter speed:

1/30	1/60	1/125	1/250	1/500

Aperture (f-stops):

f/22	f/16	f/11	f/8	f/5.6

EXPOSED TO THE ELEMENTS ⌄

A third way of controlling exposure is to use the ISO setting. The ISO value is measured in stops. ISO 400 is half as sensitive to light as ISO 800, but twice as sensitive as ISO 200. If I'd used ISO 400 for this image of the lighthouse on Berwick pier, United Kingdom, I could have chosen a shutter speed of 1/250 sec. instead of 1/125.

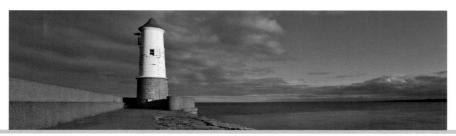

› Shutter speed/aperture relationship

There is a reciprocal relationship between shutter speed and aperture. If one is changed, the other must also be altered to maintain the same amount of exposure. A shot that is exposed correctly at a shutter speed of 1/125 sec. and an aperture size of f/11 will expose equally well at 1/250 sec. and f/8. This is because both have been altered by one stop, so that the faster shutter speed of the latter combination is balanced by using a wider aperture.

As we shall see in other sections of this book, choosing different shutter speeds and aperture size combinations will result in different effects. By selecting a fast shutter speed, it is possible to freeze action, and by setting a wide aperture, a shallow depth of field is achieved. But in either case, the shutter speed and aperture size must be balanced if the exposure is to be satisfactory.

When too little light has been allowed to hit the sensor, making the image darker than required, this is known as underexposure. Conversely, when there is too much light, and the brighter areas of the image are burnt out and show as pure white, this is referred to as overexposure. Underexposed and overexposed areas of an image will register on the camera's LCD display.

But underexposure and overexposure can be subjective concepts, and you should not feel bound to keep within the conventional boundaries. Creative use of overexposure can result in beautiful "high-key" images, where bright highlights are deliberately blown out; in the same way, dramatic, brooding images can be created by underexposing. You may find that experimenting with different manual settings will open up a whole new realm of photographic self-expression.

SNOW ≫
I wanted a bright, crisp image to convey the freshness of this snow scene. This meant carefully considering the correct exposure. Underexposure would not have suited the subject at all.

There are two ways to meter a scene to determine the shutter and aperture value for a correct exposure. The first method is to use a handheld meter to measure the amount of light falling onto the scene. This is referred to as making an incident reading. The second method is to use your camera's metering system to measure the amount of light being reflected from the scene, referred to as making a reflective reading. Of the two, incident readings tend to be more accurate, since they are not fooled by elements in a scene that are dark and light absorbing, or bright and highly light reflective.

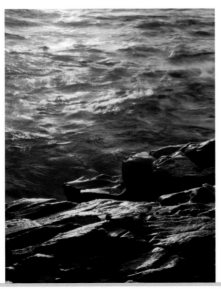

› Using the camera meter

When your A500 or A550 meters a scene, it attempts to average out all the tones presented to it to suggest a shutter and aperture combination that would give a correct exposure for an 18% mid-gray card. This is generally fine for an average scene where the amount of light tones neatly matches the amount of dark.

Problems arise, however, when there is a preponderance of one set of tones over the other. Snow and sand scenes are often underexposed by camera meters because the camera tries to average out the scene to a mid-gray. In this instance, you would need to override the suggested camera exposure, increasing it to make the snow or sand lighter. The reverse applies to scenes with a large number of dark tones. By attempting to average out the scene to mid-gray, the camera will lighten the dark tones by overexposing the image.

« **HIGHLIGHTS**
The contrast level jumped when the rising sun lit the wet rocks on this stretch of Northumberland coast. I used exposure compensation to ensure that detail was retained in the highlights when I felt that the camera's metering was too biased to the shadow areas.

› Exposure compensation

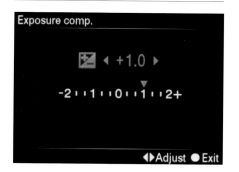

Exposure comp.

🔲 ◄ +1.0 ►

-2 ı ı 1 ı ı 0 ı ı 1 ı ı 2+

◄►Adjust ● Exit

Using exposure compensation will allow you to override the camera's suggested exposure and choose your own interpretation of the scene. You can make the tones in the scene lighter or darker, depending on which option you choose.

Using the Exposure modes, exposure compensation of up to +/- 2 stops in ⅓-stop increments is possible with each camera, regardless of which metering mode has been selected. However, exposure compensation is not available in the Scene Selection modes.

› Using exposure compensation

1) Turn the mode dial to any Exposure mode with the exception of **M** (Manual).

2) Compose your shot and partially depress the shutter button to obtain an exposure reading.

3) Check the exposure level indicator in the viewfinder or on the LCD screen to ensure that it is at the center of the exposure scale.

4) To set the level of compensation, press the 🔲 exposure compensation button. Turn the ⬤ control dial to the left to decrease the exposure, or to the right to increase the exposure. The exposure will decrease or increase in ⅓-stop increments.

5) Take the photograph and use the histogram *(see pages 70–1)* to assess the quality of the exposure.

6) Apply further levels of compensation if required and reshoot the photograph.

7) Reset the exposure compensation value to the center point.

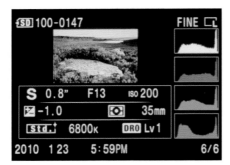

A histogram is essentially a graph showing the range of tones that have been captured in an image, from black on the left edge to white on the right. If a histogram is skewed to the left, this indicates that the image may be underexposed; if skewed to the right, it is possible that the image may be overexposed and too bright. However, it might be that you are aiming for a bright, "high key" image, or a more "heavy," underexposed effect. The histogram is a general guide to the exposure of the image, but you should not allow it to stifle your creativity.

A histogram is a graphic means of representing the distribution of dark and light tones in an image. It is a very useful way of assessing whether or not an image is correctly exposed, as well as judging the richness of the overall tonal range of the image.

The histogram allows a much more precise assessment than simply looking at the image on the LCD monitor, especially on a bright day when it can be hard to see the screen image clearly. With practice, you will find that you are able to interpret the information on the histogram quite easily, and this will be key to fine-tuning the exposure of your images.

The vertical axis shows how many pixels there are for each level of tone. There is no ideal shape for a histogram, and a peak or spike anywhere along it is merely an indication that you have a lot of similar tones in the image.

> **Note:**
> The histogram displayed in **Live View** mode does not necessarily indicate the histogram of your final image. It is only a representation of the tones of the image on the LCD. The histogram will differ depending on how you set such options as exposure compensation or flash.

› How to check the histogram

1) In Playback, press **DISP** on the control button until the detailed image review screen is displayed.

2) When the image includes an area that is pure black or pure white, that area of the image flashes on the histogram display. This is referred to as clipping, and there will be no detail in those areas. It is impossible to improve these clipped tones in a computer once the image has been made.

3) If necessary, reshoot the image, adjusting the exposure compensation (not available in Scene Selection mode). For instance, increasing the exposure will brighten the whole image, shifting the entire histogram to the right. If the exposure is darkened, the histogram will shift to the left.

PEAKS AND TROUGHS »
The first image *(top)* is badly underexposed and the histogram is clipped on the left; there will be no detail in the darkest shadow areas.

The second image (*center*) is perfectly exposed and no detail has been lost.

Finally, the third image (*bottom*) is overexposed and the histogram is clipped on the right; there will be no detail in the brightest highlight areas.

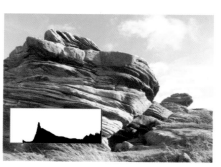

2 » EXPOSURE MODES

Exposure modes give you complete control over how you create your image. By choosing to control the shutter speed or aperture size, you will be able to achieve an almost unlimited range of creative effects with your camera. The following section will show you how you can achieve the best results from your camera using the various exposure and metering modes, as well as the image options on the shooting function menu.

› The Shooting Function menu

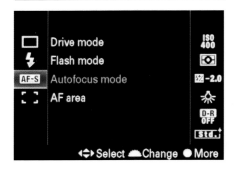

Using the various Exposure modes opens up a range of creative options not available when using Scene Selection. Pressing the **Fn** button when in shooting mode will allow you to set eight different parameters that are not accessible in Scene Selection, and have greater control over two others.

› Accessing the Shooting Function menu options

1) In shooting mode, press the **Fn** button.

2) Use the ◀ / ▲ / ▶ / ▼ control buttons to navigate around the Shooting Function screen.

3) Press **AF/Enter** when the desired Shooting Function option is highlighted.

4) Use the ▲ / ▼ control buttons to jump through the sub-options of the desired Shooting Function option. Press **AF/Enter** to set your choice.

5) The camera will then return to shooting mode.

Warning!

It is easy to forget that you've changed the shooting function settings and for the camera to be in an inappropriate mode the next time you come to use it. Make it a habit to reset your camera to a familiar "baseline" at the end of each photography session.

› Drive mode

Drive mode
Single-shot adv.

◄◆► Select ● Exit

On the Shooting Function menu, you can choose between six different methods of frame advance.

Single-shot advance

Only one photograph will be taken when the shutter button is fully depressed. The shutter button must be released before the camera can be used to take another photograph.

Continuous advance

When you press the shutter button, the camera will continue to shoot at a maximum of five frames per second until either the memory card or the image buffer is full, or you stop pressing down on the shutter button. There are two standard continuous advance modes, Hi and Lo. See the table, below, for the maximum number of frames per second (fps) achievable in Live View and OVF modes.

Self timer ⏱

Selectable between 2 and 10 seconds. When the shutter button is pressed the self timer lamp will flash and an audio signal will count down the time until the shot is taken.

Bracket continuous BRK C

Bracketing allows you to shoot three different shots at different exposure levels: a base exposure, one shot over, and one shot under, with either a ⅓- or ⅔-stop difference. Hold down the shutter button to take the three shots in rapid succession.

Bracket white balance BRK WB

A similar idea to exposure bracketing, but with the white balance altered between three shots instead. When Lo is selected, white balance is shifted 10 mired (a unit indicating the color conversion quality in color temperature filters) between each shot, and when Hi is selected, it is shifted by 20 mired. Bracket white balance is not a continuous frame advance, and the shutter button must be pressed three times.

Remote commander

Select this option if you wish to use the RMT-DSLR1 Remote Commander (sold separately) with your camera.

	Hi	Lo
Live View mode	Max. 4 fps	Max. 3 fps
OVF mode	Max. 5 fps	Max. 3 fps

2

› Autofocus mode

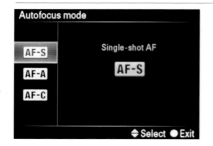

On the Shooting Function menu, you can choose between three different methods of autofocus: Single-shot (**AF-S**), Automatic (**AF-A**), and Continuous (**AF-C**) (*see pages 36-7* for a full description of each method).

› Autofocus area

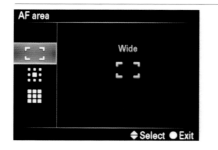

Automatic AF point selection will be selected in Scene Selection mode. In exposure mode, you are able to choose where your A500 or A550 will autofocus within the scene. This will be most useful when you want to precisely focus on a

particular place in the scene without relying on the camera automatically choosing an arbitrary point.

Wide

The camera will determine automatically which of the nine AF areas is used in focusing within the AF area.

Spot

The A500 and A550 use the AF point located in the center of the viewfinder for autofocus only.

Local

You determine which of the AF points is used to autofocus. In shooting mode, with Local AF area activated, use the ◄ / ▲ / ► / ▼ control buttons to move the AF point around the focus areas in the viewfinder (**OVF**) or on the LCD screen (**Live View**). Press **AF/Enter** to select the center focus area only.

> *Notes:*
> The maximum frame rate of Continuous advance will depend on the image quality selected and speed of your memory card.
>
> The A550 can achieve 7 fps using Speed Priority Continuous Advance, though both exposure and focus are set when the first shot is taken.

› Metering mode

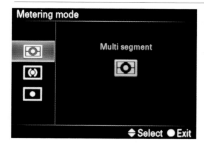

Metering mode

Multi segment

◆Select ●Exit

The A500 and A550 have three different metering modes, each of which is useful in specific situations.

Multi-segment metering

This metering system divides the scene into separate zones and measures the light in each of these zones independently. The camera then calculates the exposure by comparing the information from each of these zones. This system is generally very accurate and can cope with a wide range of different lighting conditions.

Center-weighted metering

This metering system measures the light level for the entire scene, but biases the exposure to the center. This way of determining exposure requires more care than multi-segment metering particularly if the area you wish to expose correctly is not on the middle of the image.

Spot metering

This mode takes a reading from a small area around the center focus point. Using spot metering is an accurate way to determine the correct exposure from a small area of the scene. This is useful when there is a large area of dark or light tone that you wish to ignore to correctly expose an object that is a mid-tone.

BEACH POOL

I could have set the camera to Scene Selection to capture this image of a cloud reflected in a beach pool, but decided to use the creative options of the Exposure modes. I knew the light sand would fool the multi-segment meter, so I used the spot meter to base the exposure on the areas of blue sky. The camera was on a tripod, so shutter speed was irrelevant. I used aperture priority to ensure that the reflection was sharp, and a small aperture to increase depth of field.

› White balance

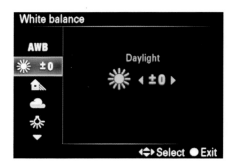

What we perceive to be a white light source, either natural or artificial, can vary enormously in color, and this will have a dramatic effect on the color cast of a photographic image. This variation is known as differences in color temperature, and it is measured in degrees Kelvin.

To produce an image that represents colors accurately, it is necessary that white be represented correctly. This process is known as white balance. In Exposure mode, the A500 and A550 allow you to adjust the white balance of an image.

Use the white balance facility when the color tone of your image is not as you expected. It can also be used if you wish to change the color tone of the image for

creative purposes. Both cameras have a range of preset white balance shortcuts (*see table*) that can be quickly set using the white balance menu, or you can create a custom white balance to achieve more accurate colors.

WHITE BALANCE SHORTCUTS

Auto white balance	**AWB**
Daylight 5200°K	☀
Shade 7000°K	🏠
Cloudy 6000°K	☁
Tungsten lighting 3200°K	💡
Fluorescent lighting 4000°K	💡
Flash 6000°K	**WB** ⚡
Custom white balance	◿▣

Setting White Balance presets

1) Press the **Fn** button and select **White balance**.

2) Select either Auto white balance (AWB), which instructs the camera to adjust automatically to the lighting conditions, or choose an option for a specific light source, in which case the color tones will be adjusted for that light source.

3) To fine-tune the white balance of the presets, use the ◀ / ▶ control buttons. Adjusting towards the + will add a red tone to the image, adjusting toward – will add a blue tone.

> ### Note:
> When creating a custom white balance, the message "Custom WB error" indicates that the value is beyond the expected range. If this value is used as your custom white balance setting, the ◣●◢ indicator turns yellow on the recording information display on the LCD monitor. It is recommended that you set the white balance again for a more accurate value.

Setting color temperature and color filter

The A500 and A550 allow you to specify a Kelvin value between 2500°K and 9900°K in increments of 1000°K, starting at the default of 5500°K. There is also the option to fine tune the white balance further by adding green (G) or magenta (M), based on the CC (color compensation) filter standard, starting at the default of 0.

1) Press the **Fn** button and select **White balance**.

2) Highlight the Kelvin color temperature value and use the ◀ / ▶ control buttons to increase or decrease the temperature. Increasing the Kelvin value will make the image more red, decreasing the value will make the image more blue.

3) Highlight the color filter value, then use the ◀ control button to add green to a maximum value of 9 or use ▶ to add magenta to a maximum value of 9 (0 is neutral and has neither green nor magenta added).

› Custom white balance

When you wish to shoot a scene that is lit by a number of different types of light source, setting a custom white balance is recommended to represent the scene as accurately as possible.

1) Press the **Fn** button and select **White balance**.

2) Highlight ◣●◿ and then press ▶ to highlight ◣●◿ **SET**. Press **AF/Enter**,

3) Point your camera at a pure white object (such as a piece of paper) so that the focus area in the center of the viewfinder is fully covered by the object. Press the shutter button.

4) The camera now calculates and displays the white balance, and sets that value as the custom white balance. Press the **AF/Enter** button to continue.

5) The monitor returns to the recording information display, with the memorized custom white balance setting retained.

> *Note:*
> When the camera is set to Scene Selection, white balance is fixed at Auto white balance **AWB**. It is not possible to select a different white balance setting.

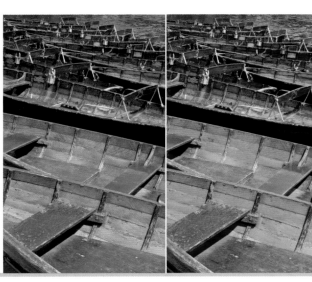

« ROWBOATS
The image on the left was produced by the white balance tungsten preset, rendering it too blue. The image on the right was made with the daylight setting, a more appropriate choice for this scene.

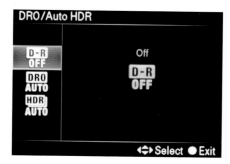

The A500 and A550 can apply contrast control in high-contrast situations, referred to as the D-RangeOptimizer, the D standing for dynamic, as in dynamic range. Although the camera cannot cope with extremely high contrast, the D-RangeOptimizer function will help to balance the contrast in your images. D-RangeOptimizer attempts to do this by modifying the shadows and highlights of your image to improve the details in those areas.

A new feature included on the A500 and A550 is the ability to shoot High-Dynamic Range (HDR) images in-camera. When shooting HDR, two images with different exposures can be shot, then merged to create a final image that offers improved contrast control. The one disadvantage of this method is that the camera must be kept still while shooting the two exposures and any movement in the image kept to the minimum.

D-RANGE OPTIMIZER OPTIONS

D-R OFF Off No optimization is performed on the image.

DRO AUTO Auto Divides the image into small areas and automatically applies contrast control where it is needed. This process will take time to complete and may reduce the number of images you can shoot consecutively in continuous frame advance.

DRO Level Applies contrast control either weakly (Lv 1) or with gradual strength up to maximum contrast control (Lv 5).

HDR OPTIONS

HDR AUTO The exposure difference is calculated and applied automatically.

HDR EV You set the exposure difference between 1 EV and 3 EV in ½-stop increments.

Note:
Auto **DRO AUTO** D-RangeOptimizer is applied when shooting in the following Scene Selection modes: Auto, Portrait, Landscape, Macro, Sports Action, and **D-R OFF** Off is selected when shooting in Sunset or Night Port./View.

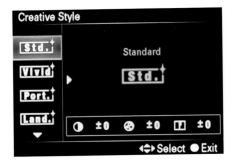

The A500 and A550 can apply various effects to your images, such as increasing contrast or boosting the saturation. Six preset styles are available from the Creative Style menu. When shooting RAW files, these effects are applied in-camera, but can be canceled when the RAW files are converted on your PC or Mac, using the Image Date Converter software supplied with your camera. It is also possible to apply these effects retrospectively using the Image Data Converter. If you are shooting JPEGs, the Creative Styles will be "baked" into the image and it will be harder to change the effect at a later date without losing image quality.

Note:
When the camera is set to Scene Selection mode, it uses the Standard Std. Creative Style.

CREATIVE STYLES

Standard Std.
Renders colors as accurately as possible with a boost in the contrast.

Vivid Vivid
Overall saturation and contrast are boosted. This would give the effect of a high-contrast transparency film.

Portrait Port.
Designed to render skin tone faithfully. Reds will not be as saturated, and sharpness will be reduced.

Landscape Land.
Saturation, contrast, and sharpness are all boosted in the image to increase its vividness.

Sunset Sunset
Emphasis is placed on reds, oranges, and yellows in a scene, and overall saturation and contrast are increased.

Black and white B/W
Color will be removed and the image rendered purely in shades of gray.

The preset Creative Styles can be further refined by altering the ◑ contrast, ◉ saturation, or ▯ sharpness.

RIVER REFLECTIONS »
Good photos aren't just found at eye-level. Be sure to look up and down to assess the full potential of the scene in front of you.

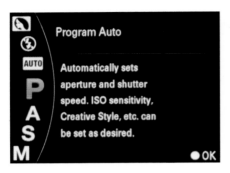

Program Auto

Automatically sets
aperture and shutter
speed. ISO sensitivity,
Creative Style, etc. can
be set as desired.

● OK

Program Auto mode is similar to full Auto in Scene Selection mode. However with Program Auto, the camera sets the exposure automatically, while still allowing you to create your own custom settings, such as D-Range optimization and the ISO settings.

This is the mode you would use if you just want to "point and shoot" without worrying too much about aperture or shutter speed, but still have a level of creative control.

SERVING DONUTS »
Visiting a food fair, held under canvas at night, meant dealing with a variety of different light levels and sources. Using Program Auto allowed me to move around the various booths at the fair without needing to worry about the shutter speed or aperture. This meant I could work quickly and make the most of the photo opportunities that arose.

PROGRAM AUTO MODE SETTINGS

Quality setting

RAW can be selected in 3:2 and 16:9 aspect ratio; RAW and JPEG combined in both 3:2 and 16:9 aspect ratio; JPEG with all size options (large, medium, or small) and quality (fine or standard) in both 3:2 and 16:9 aspect ratio available.

Exposure settings

Multi-segment, Center-weighted, and Spot metering; Exposure compensation; auto-exposure bracketing; D-RangeOptimizer (JPEG only); HDR (JPEG only); Long exposure noise reduction; High ISO noise reduction.

Focus settings

Single-shot, Continuous, and Automatic AF point selection; Wide, Local, and Spot AF point selection; Face Detection; Smile Shutter.

Frame advance

Single frame advance; Continuous High and Low speed advance; 10-second self-timer; 2-second self-timer; Remote Commander; 3-shot exposure bracketing; 3-shot white balance bracketing.

Flash settings

Fill flash; Slow synchronization; Rear curtain synchronization; Flash compensation; Red-eye reduction; Wireless flash with compatible external flash units; External flash.

Using Program Auto mode

1) Turn the mode dial to **P**.

2) Point the camera at your subject.

3) Lightly press the shutter button to focus. The focus confirmation symbol and active focus points will light in the viewfinder when focus is achieved. The exposure settings will also be displayed in the viewfinder.

4) Depress the shutter button fully to take the photograph.

5) The captured photograph will be displayed on the LCD screen by default for two seconds unless the review time has been adjusted.

> **Note:**
> The camera sets both the shutter speed and the appropriate aperture value. Unlike full Auto mode, all other creative controls (such as AF settings) are still user selectable.

› (A) Aperture Priority mode

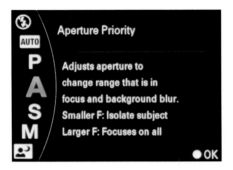

	Aperture Priority
⊗	
AUTO	
P	Adjusts aperture to
A	change range that is in
S	focus and background blur.
M	Smaller F: Isolate subject
⊡	Larger F: Focuses on all
	● OK

Aperture Priority is used when control of the amount of sharpness, or depth of field, of your image is more important than the shutter speed. Landscape photographers find this control particularly important, especially when they want to record the scene with sharpness extending from the front of the image to the far horizon (or within the limits of the lens used). This has the effect of making an image look as though it could be "stepped into." To achieve this appearance, the photographer would select the smallest aperture that was available.

However, you may wish to isolate and emphasize one particular element in the image, such as a flower in a flowerbed. Using a large aperture will give you less depth of field, making the area behind and in front of the flower less sharp. This will have the effect of making the flower stand out more from its surroundings in your photo. This technique works particularly well with longer lenses such as the Sony 70-200mm G lens.

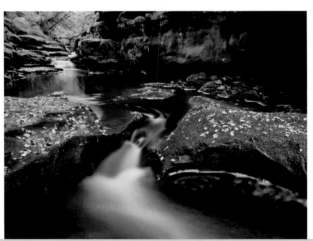

« TUMBLING WATERS
In this photograph of a Northumbrian waterfall, United Kingdom, aperture priority was chosen so that I could select a small aperture to increase the depth of field in the image to ensure front-to-back sharpness.

APERTURE PRIORITY SETTINGS

Quality setting

RAW can be selected in 3:2 and 16:9 aspect ratio; RAW and JPEG combined in both 3:2 and 16:9 aspect ratio; JPEG with all size options (large, medium, or small) and quality (fine or standard) in both 3:2 and 16:9 aspect ratio available.

Exposure settings

Multi-segment, Center-weighted, and Spot metering; Exposure compensation; auto-exposure bracketing; D-RangeOptimizer (JPEG only); HDR (JPEG only); Long exposure noise reduction; High ISO noise reduction.

Focus settings

Single-shot, Continuous, and Automatic AF point selection; Wide, Local, and Spot AF point selection; Face Detection; Smile Shutter.

Frame advance

Single frame advance; Continuous High and Low speed advance; 10-second self-timer; 2-second self-timer; 3-shot exposure bracketing; 3-shot white balance bracketing; Remote Commander.

Flash settings

Fill flash; Slow synchronization; Rear curtain synchronization; Flash compensation; Red-eye reduction; Wireless flash with compatible external flash units; External flash.

Using Aperture Priority mode

1) Turn the mode dial to **A**.

2) Point the camera at your subject. Turn the ▓▓▓ control dial to select the appropriate aperture value.

3) Lightly press the shutter button to focus. The focus confirmation symbol and active focus points will light in the viewfinder when focus is achieved. The exposure settings will also be displayed in the viewfinder.

4) Depress the shutter button fully to take the photograph.

5) The captured photograph will be displayed on the LCD screen by default for two seconds unless the review time has been adjusted.

Tips

When aperture width is reduced, shutter speed is slower. A tripod ensures a sharp image.

In Aperture Priority mode, shutter speed is automatically adjusted to obtain the correct exposure. If this cannot be obtained with the selected aperture value, the shutter speed light flashes. Adjust the aperture setting.

Shutter Priority

Adjusts shutter speed to
change the expression
of a moving subject.
Faster SS: Stop action
Slower SS: Blur motion

● OK

Shutter Priority mode is used when the
shutter speed is more important than the
depth of field in creating the image you
have visualized. If there is movement in the
scene, you will need to determine the
appropriate shutter speed that will capture
that movement in a satisfying way.

For example, selecting a fast shutter
speed will enable you to create a crisp,
sharp image of a moving subject, while
slowing the shutter speed down allows you
to capture a sense of movement, such as in
water or windblown trees. Remember,
even when SteadyShot is switched on,
there will be a limit to how slow the shutter
speed can be before you risk causing
camera shake in your image. The slower
the shutter speed, the more necessary a
tripod or other support will become.

Tips

*If you are shooting an image of a
moving subject indoors, or in other
low-light situations, you may need to
select a higher ISO setting to achieve
a sufficiently fast shutter speed.*

*When the shutter speed is one second
or more, noise reduction will take
place after the image has been shot.
During this time, you will not be able
to shoot another image.*

《 SPRING LAMBS
Young animals can be skittish. To create this
portrait of two English lambs, I moved slowly into
position to avoid frightening them. The camera
was set to shutter priority, with a fast shutter
speed (1/320 sec.) to avoid unsharpness caused
by the lambs moving during the exposure.

SHUTTER PRIORITY SETTINGS

Quality setting
RAW can be selected in 3:2 and 16:9 aspect ratio; RAW and JPEG combined in both 3:2 and 16:9 aspect ratio; JPEG with all size options (large, medium, or small) and quality (fine or standard) in both 3:2 and 16:9 aspect ratio available.

Exposure settings
Multi-segment, Center-weighted, and Spot metering; Exposure compensation; auto-exposure bracketing; D-RangeOptimizer (JPEG only); HDR (JPEG only); Long exposure noise reduction; High ISO noise reduction.

Focus settings
Single-shot, Continuous, and Automatic AF point selection; Wide, Local, and Spot AF point selection; Face Detection; Smile Shutter.

Frame advance
Single frame advance; Continuous High and Low speed advance; 10-second self-timer; 2-second self-timer; 3-shot exposure bracketing; 3-shot white balance bracketing; Remote Commander.

Flash settings
Fill flash; Slow synchronization; Rear curtain synchronization; Flash compensation; Red-eye reduction; Wireless flash with compatible external flash units; External flash.

Using Shutter Priority mode

1) Turn the mode dial to **S**.

2) Point the camera at your subject. Turn the ⚙ control dial to select the appropriate shutter value.

3) Lightly press the shutter button to focus. The focus confirmation symbol and active focus points will light in the viewfinder when focus is achieved. The exposure settings will also be displayed in the viewfinder.

4) Depress the shutter button fully to take the photograph.

5) The captured photograph will be displayed on the LCD screen by default for two seconds unless the review time has been adjusted.

> ### Note:
> The photographer sets the shutter speed, and the camera chooses the appropriate aperture value. Use when choosing the correct shutter speed (i.e., to "freeze" motion) is more important than depth of field to the success of the image.

Manual Exposure

Adjusts aperture and shutter speed manually.
TIP: Use BULB to show trailing motion by using a long exposure.

● OK

Manual Exposure mode allows you to control the exposure by adjusting both the shutter speed and the aperture setting yourself; the camera does not adjust one setting based on your control over the other. This is particularly useful in challenging lighting conditions, when the camera may be fooled by the luminosity or reflectivity of a scene into making an exposure that is unsatisfactory.

There are also occasions when you may require something other than a scene that is "perfectly exposed," for example a bright, high-key image or a darker, dramatic one, which the camera may have judged to be underexposed and tried to adjust for. Manual exposure offers you full control of how light or dark the final image will be.

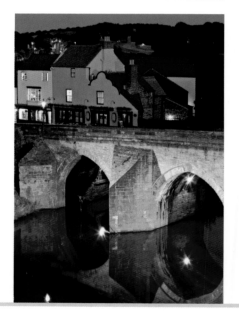

FLOODLIT BRIDGE »
I knew the meter would be fooled by the contrast in this scene, so I switched to manual exposure mode and set my own exposure.

MANUAL EXPOSURE MODE

Quality setting

RAW can be selected in 3:2 and 16:9 aspect ratio; RAW and JPEG combined in both 3:2 and 16:9 aspect ratio; JPEG with all size options (large, medium, or small) and quality (fine or standard) in both 3:2 and 16:9 aspect ratio available.

Exposure settings

Multi-segment, Center-weighted, and Spot metering; Exposure compensation; auto-exposure bracketing; D-RangeOptimizer (JPEG only); HDR (JPEG only); Long exposure noise reduction; High ISO noise reduction.

Focus settings

Single-shot, Continuous, and Automatic AF point selection; Wide, Local, and Spot AF point selection; Face Detection; Smile Shutter.

Frame advance

Single frame advance; Continuous High and Low speed advance; 10-second self-timer; 2-second self-timer; Remote Commander; 3-shot exposure bracketing; 3-shot white balance bracketing.

Flash settings

Fill flash; Slow synchronization; Rear curtain synchronization; Flash compensation; Red-eye reduction; Wireless flash with compatible external flash units; External flash.

Using Manual Exposure mode

1) Turn the mode dial to **M**.

2) Point the camera at your subject. Turn the ⚙ control dial to select the appropriate shutter value. Turn the ⚙ control dial while holding down ±⧉ to change the aperture value.

3) To change the shutter speed and aperture value combination without changing the exposure you've set, hold down the **AEL** button and rotate the ⚙ control dial at the same time. Rotating the dial to the left increases the length of the shutter speed and reduces the aperture size; rotating to the right decreases the length of the shutter speed and increases the aperture size.

4) Lightly press the shutter button to focus. The focus confirmation symbol and active focus points will light in the viewfinder when focus is achieved. The exposure settings will also be displayed in the viewfinder.

5) Depress the shutter button fully to take the photograph.

6) The captured photograph will be displayed on the LCD screen by default for two seconds unless the review time has been adjusted.

Photography is all about recording a moment in time. That moment could be as short as 1/4000 of a second, barely time to blink. At the other extreme, that moment could be extended to a minute, an hour, or even several hours if the light levels are sufficiently low to avoid overexposure.

With the camera set to Bulb, the shutter will stay open for as long as you have your finger on the shutter button, or if locked open with a remote commander.

This flexibility can be used to create weird and wonderful effects. Any bright light source that moves during the exposure will be recorded as a trail. This can include fireworks and car headlamps, as well as stars as they move across the night sky.

Another use for Bulb mode is recording the movement of water, whether that movement is rain running down a window or waves breaking on a beach. The longer the shutter is held down using bulb, the more ethereal the effect of the water's movement will become.

> ### Tips
>
> *Use a tripod and turn off the SteadyShot function while using the Bulb setting.*
>
> *Set the focus to infinity in manual focus mode when shooting fireworks and star trails.*
>
> *For best results, use the wireless remote commander, available separately. Pressing the shutter button on the remote commander triggers Bulb shooting, and pressing it a second time stops Bulb shooting. This removes the need to press and hold down the shutter button on the camera.*

« TIDAL WATER
Holding the shutter open with Bulb for two minutes has recorded the water washing around these old wooden jetty posts as a misty blur.

BULB MODE SETTINGS

Quality setting

RAW can be selected in 3:2 and 16:9 aspect ratio; RAW and JPEG combined in both 3:2 and 16:9 aspect ratio; JPEG with all size options (large, medium, or small) and quality (fine or standard) in both 3:2 and 16:9 aspect ratio available.

Exposure settings

Multi-segment, Center-weighted, and Spot metering; Exposure compensation; auto-exposure bracketing; D-RangeOptimizer (JPEG only); HDR (JPEG only); Long exposure noise reduction; High ISO noise reduction.

Focus settings

Single-shot, Continuous, and Automatic AF point selection; Wide, Local, and Spot AF point selection; Face Detection; Smile Shutter.

Frame advance

Single frame advance; Continuous High and Low speed advance; 10-second self-timer; 2-second self-timer; Remote Commander; 3-shot exposure bracketing; 3-shot white balance bracketing.

Flash settings

Fill flash; Slow synchronization; Rear curtain synchronization; Flash compensation; Red-eye reduction; Wireless flash with compatible external flash units; External flash.

Using Bulb mode

1) Turn the mode dial to **M**. Turn the ⚙ control dial to the left past 30" to select **Bulb.**

2) Point the camera at your subject.

3) Lightly press the shutter button to focus. The focus confirmation symbol and active focus points will light in the viewfinder when focus is achieved. The exposure settings will also be displayed in the viewfinder.

4) Depress the shutter button fully to take the photograph. Keep your finger on the shutter button until you judge the appropriate amount of time has elapsed.

5) If the exposure was longer than one second and Long Exposure NR is switched on, camera noise reduction is activated and will take the same amount of time that the shutter was open. You cannot take any more shots during this period.

6) Once noise reduction is complete, the captured photograph will be displayed on the LCD screen by default for two seconds unless the review time has been adjusted.

2 » MENU SUMMARY

Menus or selected functions in italic are not available in Scene Selection modes.

📷 Recording 1	Options
Image size	Large; Medium; Small
Aspect ratio	3:2; 16:9
Quality	RAW; RAW+JPEG; JPEG: Fine; Standard
Flash compensation	ADI flash; Pre-flash TTL
AF Illuminator	Auto; Off
SteadyShot	On; Off
Color Space	AdobeRGB; sRGB

📷 Recording 2	Options
Long Exposure Noise Reduction	On; Off
High ISO Noise Reduction	On; Off

⚙ Custom	Options
Eye-start AF	On; Off
AEL button	AEL hold; AEL toggle
Red-eye reduction	On; Off
Auto review	2 sec. / 5 sec. / 10 sec. / Off
Auto off w/VF	On; Off
Grid Line	On; Off

▶ Playback	Options
Delete	Deletes all or only marked images
Format	Formats currently selected memory card
Slide show	Auto playback of images at intervals of 1 sec. / 3 sec. / 5 sec. / 10 sec. / 30 sec. Repeat On; Off
Protect	Marked images; Cancel all
Specify Printing	DPOF setup: Marked images; Cancel all; Date Imprint: On; Off
Playback Display	Auto rotate; Manual rotate

🔧 Setup 1	Options
LCD Brightness	Automatic Manual; Five levels of brightness
Date/Time setup	Set year/month/day; time yyyy/mm/dd; dd/mm/yyyy; mm/dd/yyyy
Power Save (LV)	10 sec. / 20 sec. / 1 min. / 5 min. / 30 min.
Power Save (OVF)	10 sec. / 20 sec. / 1 min. / 5 min. / 30 min.
Control for HDMI	On; Off
Language	English, French, German, Spanish, Italian, Portuguese, Dutch, Russian, Swedish, Danish, Norwegian, Finnish, Polish, Czech, Hungarian
Help Guide display	On; Off

🔧 Setup 2	Options
File number	Series; Reset
Folder name	Standard form; Date form
Select folder	Choose folder on currently selected memory card
New folder	Creates new folder on the currently selected memory card
USB connection	Mass Storage; PTP
Audio signals	On; Off

🔧 Setup 3	Options
Cleaning mode	Okay; Cancel
Pixel mapping	Okay; Cancel
Version	Okay
Reset default	Okay; Cancel

2 » SHOOTING FUNCTION MENU

Some options on the Shooting Function (Fn) menu are not available in Scene Selection.

Shooting Function Menu	Options
Autofocus mode	Single-shot AF; Automatic AF; Continuous AF
Autofocus area	Wide; Spot; Local
ISO sensitivity	Auto; 200; 400; 800; 1600; 3200; 6400; 12800
Metering mode	Multi-segment; Center-weighted; Spot
Flash compensation	± 2 stops
D-RangeOptimizer	Off; Automatic; Custom; HDR
White balance	Auto; Daylight; Shade; Cloudy; Incandescent; Fluorescent; Flash; Temperature & color filter; Custom
Creative Style	Standard; Vivid; Portrait; Landscape; Sunset; Black and White; Contrast; Saturation; Sharpness

» DEFAULT SETTINGS

Select Reset default on 🔧 Setup 3 to restore the A500 and A550 to the factory settings:

Exposure compensation	±0.0
Recording information display	Graphic display
Playback display	Single-image screen (with recording info)
Drive mode	Single-shot advance
ISO	AUTO
Flash mode	Fill-flash (only if built-in flash is open)
Autofocus mode	AF-A
AF area	Wide
Face Detection	On
Smile Shutter	Off
ISO	AUTO
Metering mode	Multi-segment
Flash compensation	±0.0
White balance	AWB (Auto white balance)
Color Temperature / Color filter	5500K, Color filter 0
Custom white balance	5500K
DRO / Auto / HDR	DRO Auto
Creative Style	Standard

📷 Recording Menu

Image size	L:14M (DSLR–A550); L:12M (DSLR–A500)
Aspect ratio	3:2
Quality	Fine
Flash control	ADI flash
AF illuminator	Auto
SteadyShot	On
Color Space	sRGB
Long exposure noise reduction	On
High ISO noise reduction	Normal

⚙ Custom Menu

Eye-Start AF	On
AEL button	AEL hold
Red-eye reduction	Off
Auto review	2 sec.
Auto off w/ VF	On
Grid Line	On

▶ Playback Menu

Specify Printing—Date imprint	Off
Slide show—Interval	3 sec.
Slide show—Repeat	Off
Playback display	Auto rotate

🔧 Setup Menu

LCD brightness	Auto
Power save (LV)	20 sec.
Power save (OVF)	10 sec.
CTRL for HDMI	On
Help Guide display	On
File number	Series
Folder name	Standard form
USB connection	Mass storage
Audio signals	On

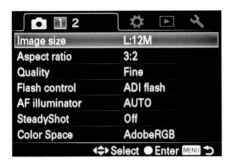

5) The option sub-menu is displayed. Use the ▲ / ▼ control buttons to move the highlight bar up and down the sub-menu options on the LCD.

6) Press **AF/Enter** to choose the desired sub-menu option.

7) Press **MENU** to exit the Recording Menu and return to shooting mode.

There are two recording menus that between them control nine aspects of how your images are captured. The first recording menu includes options that will affect the quality of the files recorded, the color space used, and whether SteadyShot image stabilization is active. The procedure for accessing each of the options on Recording menu 1 is the same and is given below.

1) Press **MENU**.

2) 📷 1 is automatically highlighted.

3) Use the ▲ / ▼ control buttons to move the highlight bar up and down the options on the LCD.

4) With the desired option highlighted, press **AF/Enter**.

› **Image size**

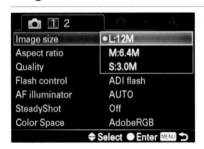

When shooting RAW files at an aspect ratio of 3:2 (see following entry), the image is captured at the full resolution of the A500 and A550's sensor. If you are shooting JPEGs, you have the option of creating lower-resolution files, which will take up less space on your memory card, but will mean that there will be a lower limit for acceptable print sizes with those images.

IMAGE SIZE CHART

Camera & aspect ratio	Large	Medium	Small
A500 3.2	12mp (4272 x 2848px)	6.4mp (3104 x 2070px)	3.0mp (2128 x 1416px)
A500 16.9	10mp (4272 x 2400px)	5.4mp (3104 x 1744px)	2.5mp (2128 x 1192px)
A550 3.2	14mp (4592 x 3056px)	7.4mp (3344 x 2224px)	3.5mp (2288 x 1520px)
A550 16.9	12mp (4592 x 2576px)	6.3mp (3344 x 1872px)	2.9mp (2288 x 1280px)

› Aspect ratio

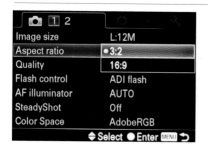

The aspect ratio of an image is the ratio of the width to the height. The A500 and A550 allow you to choose between creating images with an aspect ratio of 3:2 or 16:9. The default setting is 3:2 and matches the aspect ratio of 35mm film. The aspect ratio of 16:9 matches the standard for HDTV. If you intend to view your photos primarily on an HDTV, it would be worth considering using 16:9.

› Quality

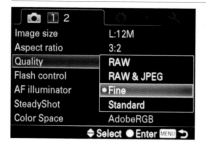

There are four quality settings on the A500 and A550: RAW; RAW+JPEG; Fine; and Standard. JPEG files will take up far less space on your memory card than RAW files, but do not offer the same level of potential image quality *(see page 216)*. There are two levels of JPEG compression: Fine and Standard. Standard has a higher level of compression than Fine and will result in images with a higher amount of JPEG artifacts and

therefore lower image quality. However, you will be able to save more JPEGS at Standard quality onto a memory card than JPEGs saved at Fine quality.

> **Note:**
> The full resolution of the sensor is not used in 16:9 mode, and the same effect could be achieved by cropping an image shot in 3:2 to 16:9 in photo editing software.

› Flash control

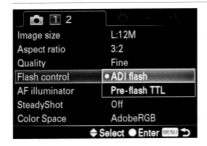

The A500 and A550 have two ways to determine the correct exposure for external flash units. Advanced Distance Integration (ADI) or Pre-flash through the lens (TTL). ADI is potentially the more accurate of the two methods, but will only work with ADI compatible lenses and is not accurate if the flash-to-subject distance cannot be determined. Use Pre-flash TTL if your lenses are not ADI compatible *(see page 155 for further details).*

› AF illuminator

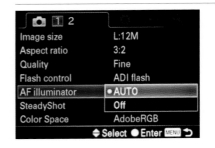

When light levels are low and flash is activated, the flash will pulse short bursts of light to assist the AF system by illuminating your subject. If you are using an external flash, the AF illuminator of the external flash is used instead. The AF illuminator will not operate when the autofocus mode is set to continuous or when the subject is moving and AF is set to automatic.

› SteadyShot function

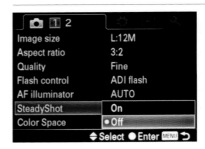

The SteadyShot function can reduce the effect of camera shake by the equivalent of between 2.5 and 4 stops of shutter

speed. SteadyShot is a sensor based stabilization method in which movement is detected by the camera and compensated for by rapidly shifting the sensor in the opposite direction.

In the viewfinder, the █.ııll SteadyShot scale indicator shows the camera shake status. To cut camera shake to a minimum, wait until the scale falls as far as possible before you start to shoot.

> **Note:**
> SteadyShot may not be fully effective immediately after the camera has been switched on, or if you press the shutter button too quickly. Wait for the █.ııll scale indicator to fall, then press the shutter button slowly.
>
> Turn off the SteadyShot function when using a tripod.

» AVOIDING CAMERA SHAKE

Camera shake refers to any unwanted movement of the camera after the shutter button has been pressed, which results in blurred images. In avoiding camera shake, the correct posture is essential. Stand as steadily as possible, with your feet shoulder-width apart. If you wish to shoot from a kneeling position, steady your upper body by resting your elbow on one knee. With either stance, tuck your elbows lightly against your body.

With one hand, grip the camera firmly. Use the other hand to support the lens. The «((ᵂ))» camera shake warning light will flash in the viewfinder if there is camera shake. In this case, employ a tripod to support the camera, or use the flash so that you can increase the shutter speed.

> **Note:**
> The «((ᵂ))» Camera shake warning indicator is displayed only in shooting modes that automatically set the shutter speed. The indicator is not displayed in either shutter priority or manual, though SteadyShot will still be available.

« CAMERA SHAKE
This image suffers from camera shake. The shutter speed was too long to successfully hold the camera by hand.

2

› Color Space

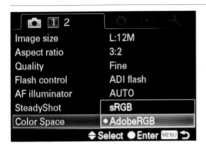

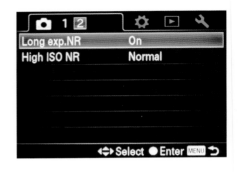

The term "color space" typically refers to the range of colors a digital device can either record or display. This is also known as the color gamut. The A500 and A550 can record images using either of two color spaces, sRGB and AdobeRGB.

The sRGB color space has a smaller gamut than AdobeRGB, and is typically used for photography on the internet and instore photo printers. This is the best choice for images that are to be used or printed without much post-processing.

AdobeRGB has a much wider gamut than sRGB and is more often used for professional printing and reproduction applications, or where there will be a significant amount of post-processing.

The second of the two Recording menus shows options to specify whether noise reduction is applied during long and high ISO exposures. The procedure for accessing each option is the same and is shown below.

1) Press **MENU**.

2) ⬛ 1 will automatically be highlighted. Press ▶ to select ⬛ 2.

3) Use the ▲ / ▼ control buttons to move the highlight bar up and down the options on the LCD.

4) With the desired option highlighted, press **AF/Enter**.

5) The option sub-menu is displayed. Use the ▲ / ▼ control buttons to

move the highlight bar up and down the sub-menu options.

6) Press **AF/Enter** to choose the desired sub-menu option.

7) Press **MENU** to exit the Recording menu and return to shooting mode.

› Long exposure noise reduction

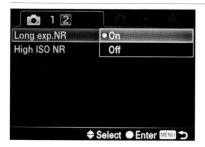

When an exposure is made of one second or longer, noise reduction is activated. This will take the same length of time as the original shutter speed. During this time you will not be able to shoot any more images. When the exposure mode is set to **AUTO** or Scene Selection, noise reduction is applied automatically and cannot be turned off. Noise reduction is not applied to images shot using continuous advance or continuous bracketing.

› High ISO noise reduction

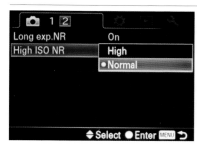

When ISO is set to 1600 or higher, noise reduction is activated. Set to normal, noise reduction is lightly applied to your image. Set to high, noise in the image is reduced more thoroughly, although the time taken to process the image is increased. During the noise reduction process you will not be able to shoot any more images. When the exposure mode is set to **AUTO** or Scene Selection, noise reduction is applied automatically and cannot be turned off. Noise reduction is set to normal with images shot using continuous advance or continuous bracketing.

Warning!

Using extremely long shutter speeds with long exposure noise reduction activated will drain your camera's battery. Use a fully charged battery and carry a charged spare battery.

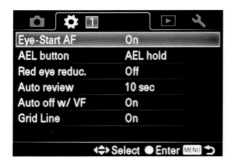

The Custom function menu has six options that allow you to fine-tune how the camera handles in various shooting situations. Two enable you to conserve battery power. The other four are subjective choices; how you set them depends on your shooting style. The procedure for accessing each option is the same and is given here.

1) Press **MENU**.

2) Press ▶ and highlight ✿ 1.

3) Use the ▲ / ▼ control buttons to move the highlight bar up and down the list of options.

4) With the desired option highlighted, press **AF/Enter**.

5) The option′s sub-menu is displayed. Use the ▲ / ▼ control buttons to move the highlight bar up and down the sub-menu options on the LCD.

6) Press **AF/Enter** to choose the desired sub-menu option.

7) Press **MENU** to exit the Custom menu and return to shooting mode.

› Eye-Start AF

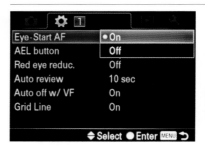

Autofocus is automatically activated by sensors below the viewfinder when you bring the camera to your face. It is recommended that Eye-Start is switched off when the optional FDA-M1AM Magnifier or the FDA-A1AM Angle Finder is fitted to the viewfinder.

> ### Tip
>
> *Moving your finger in front of the Eye-Start sensors below the viewfinder is a quick way to turn off the LCD screen when it is in shooting mode.*

› AEL button setup

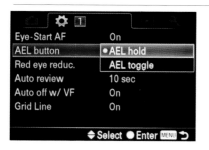

Pressing the **AEL** (or AutoExposure Lock) button temporarily locks the current exposure values. This allows you to recompose your image without changing the locked exposure values (autofocus will still be available and focus is not locked until the shutter button is pressed or the shot is taken).

Notes:
When exposure is locked, ✱ appears in the viewfinder and on the LCD screen.

In manual exposure, the **AEL** button is used to simultaneously alter the shutter speed and aperture value combination without changing the overall exposure. When **AEL toggle** is selected, pressing the **AEL** button locks this facility until pressed again.

When **AEL hold** is selected from the sub-menu, the exposure is locked until you release the AEL button. When **AEL toggle** is selected from the sub-menu, the exposure is locked by one press of the **AEL** button and not unlocked until either the **AEL** button is pressed again, the shooting mode is changed, or the camera is switched off.

› Red-eye reduction

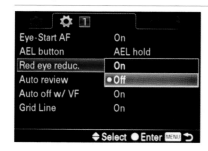

Red-eye is caused by flash light bouncing off the blood vessels at the back of your subject's eye. This can be reduced by the camera firing pre-flashes before the photograph is taken, causing the pupils in your subject's eye to contract. Red-eye reduction is not needed for flash photography that does not involve people and can be switched off using this Custom menu option.

› Auto review

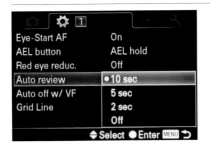

After you have created a photo, the A500 and A550 will display the image on the LCD for a set period of time. The default is 2 sec., but this can be changed to Off, 5 sec., or 10 sec. The longer the LCD is active, the more quickly the battery will be exhausted, so use a setting that is as energy efficient as possible, but that is still useful.

› Auto off w/VF

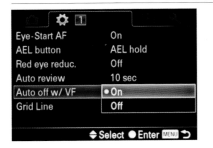

The sensors below the eyepiece activate autofocus and turn off the LCD screen. If you want the LCD to remain on when you

look through the viewfinder, set this option to **Off**. However, as noted previously, the longer the LCD is active, the more quickly the battery will be exhausted.

› Grid Line

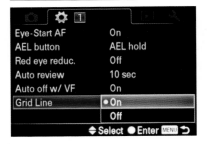

When using **MF CHECK LV**, a set of grid lines can be overlaid on the LCD screen. This grid can be used as a compositional tool and is particularly useful when shooting architectural subjects. By using the grid lines, it is far easier to ensure that vertical or horizontal lines (such as the sides of buildings) are perfectly straight than when using your own judgment alone. The grid can be switched on or off using this function.

» PLAYBACK MENU 1

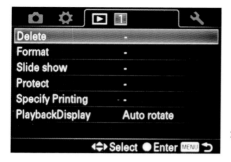

Playback allows you to delete or protect images on a memory card, format the card, and specify how images are displayed or printed. The procedure for accessing each menu option is the same and is shown below.

1) Press **MENU**.

2) Press ▶ and highlight [▶] **1**.

3) Use the ▲ / ▼ control buttons to move the highlight bar up and down the list of options.

4) With the desired option highlighted, press **AF/Enter**.

5) The option sub-menu is displayed. Use the ▲ / ▼ control buttons to move the highlight bar up and down the sub-menu list of options.

6) Press **AF/Enter** to choose the desired sub-menu option.

7) Press **MENU** to exit the Playback menu and return to shooting mode.

› Delete

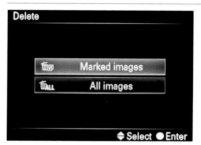

The image files in the current folder can be deleted using this option. You can specify all the files to be deleted or mark a range of files that subsequently will be deleted.

› Format

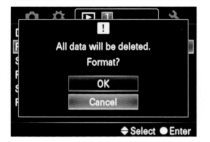

Formatting a memory card will initialize it ready for use. Most memory cards are pre-formatted, but it is still advisable to format it before first using it to store images. Any files that are on the memory card before it is formatted will be erased.

› Slide show

The various display options for image slide shows are set on this screen. During a slide show, images can be displayed onscreen for a period of 1 sec., 3 sec., 5 sec., 10 sec.,

or 30 sec. You are also able to specify whether the Repeat facility is switched On or Off.

› Protect

Files can be protected from accidental deletion by using this options screen. You can specify one file, mark a range of files, or protect all the files. However, note that protected images will still be erased if the card is formatted.

› Specify Printing

Using this option, images can be marked for printing using the DPOF standard.

The number of prints to be made from each image can also be specified, with the option of overlaying the date and time the image was shot on the final print(s) *(see pages 220–22)*.

› PlaybackDisplay

When an image is created, the camera notes the orientation of the image. By default, an image shot vertically will be automatically rotated when displayed on the LCD in Playback. By selecting **Manual rotate**, images will not be rotated unless you physically specify their rotation by pressing **Fn** during image playback.

BEACON ON THE PIER »

The curves of this seafront barrier made a perfect frame for the lighthouse on the pier beyond.

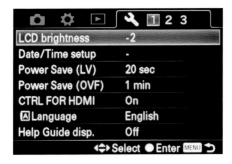

move the highlight bar up and down the sub-menu options.

6) Press **AF/Enter** to choose the desired sub-menu option.

7) Press **MENU** to exit the Setup menu and return to shooting mode.

The various options in Setup 1 will allow you to customize how the LCD operates, the date and time, control for HDMI, the language used by the camera, and whether the help guides are displayed. The procedure for accessing each option is the same and is given here.

1) Press **MENU**.

2) Press ▶ and highlight 🔧 1.

3) Use the ▲ / ▼ control buttons to move the highlight bar up and down the list of options.

4) With the desired option highlighted, press **AF/Enter**.

5) The option sub-menu is displayed. Use the ▲ / ▼ control buttons to

› LCD brightness

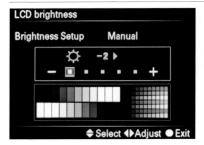

The A500 and A550 have a sensor to the right of the LCD screen that can adjust the brightness of the display automatically depending on ambient lighting condition.

To manually set the brightness of the LCD display, select **Brightness Setup Manual** and use the ◀ / ▶ buttons to move the slider to the left to darken the display, or right to lighten it. Ideally, the brightness level should be set to a point where every tone in the color charts can be distinguished individually.

› Date /Time setup

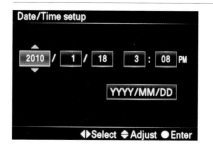

The date and time can be altered, and the date order method changed using this option. The date order choices are YYYY/MM/DD, MM/DD/YYYY, or DD/MM/YYYY. The date and time an image is created is written to the image metadata, and can be used by computer operating systems and some image database packages to sort files in chronological order.

› Power Save (LV)

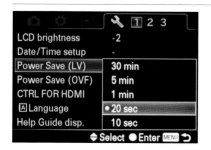

The A500 and A550 have two different settings for Power Save depending on whether Live View **LV** or the optical

viewfinder **OVF** is selected. There are five options for the length of time before Power Save is activated and the camera is shut down: 10 sec., 20 sec., 1 min., 5 min., 30 min. It is recommended that as short a length of time that will be least frustrating to you is specified before Power Save is activated by the camera. Using Live View is very demanding on power, and constant use will quickly exhaust the batteries.

› Power Save (OVF)

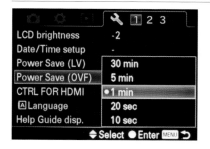

With OVF selected, there are five options for the length of time before Power Save is activated: 10 sec., 20 sec., 1 min., 5 min., 30 min. Although using the optical viewfinder is less dependent on batteries than Live View, it is recommended that you specify the least frustrating amount of time before Power Save is activated.

› CTRL for HDMI

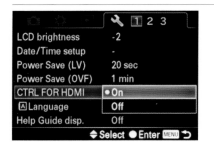

When the camera is connected to a Bravia compatible television, the television remote can be used to control certain of the camera's playback functions. If the camera starts to perform erratically when connected to a non-Bravia television, set CTRL FOR HMDI to Off.

› Language

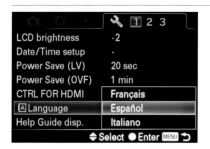

The A500 and A550 can display menu and shooting options in the following languages: English, French, Spanish, Italian,

German, Portuguese, Dutch, Russian, Swedish, Danish, Norwegian, Finnish, Polish, Czech, or Hungarian.

› Help Guide display

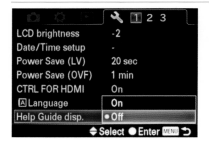

As you use your A500 or A550, help guides are displayed that explain how the various functions of the camera work. Once you feel you know your way around the camera, you can select **Off** to make the operation of your camera slightly faster.

» SETUP 2

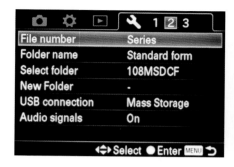

Setup 2 allows further customization. The procedure for accessing each option is the same and is shown below.

1) Press **MENU**.

2) Press ▶ and highlight ✎ **2**.

3) Use the ▲ / ▼ control buttons to move the highlight bar up and down the list of options.

4) With the desired option highlighted, press **AF/Enter**.

5) The option sub-menu is displayed. Use the ▲ / ▼ control buttons to move the highlight bar up and down the sub-menu list of options.

6) Press **AF/Enter** to choose the desired sub-menu option.

7) Press **MENU** to exit the Setup menu and return to shooting mode.

› File number

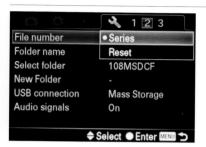

Whenever you create an image with your camera, the image is assigned a file name and is placed in the current selected folder. The file name is composed of the prefix _DSC and a four-digit number followed by a suffix denoting the file type (either JPEG or RAW). The four-digit number is a count of the number of images you've shot with the camera, starting from 0001.

By selecting **Series**, when the file number reaches 9999, the counter will be reset and will start from 0001 again. By selecting **Reset**, the camera will reset the number to 0001 before the counter reaches 9999 whenever the folder format is changed; when all the images in the folder are deleted; when the memory card is replaced; or whenever the memory card is formatted.

› Folder name

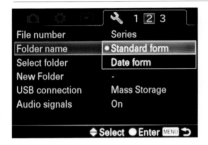

Images are stored in folders on the memory card within the main DCIM folder. You can create new folders on the memory card using New Folder farther down Setup 2. Folder name allows you to choose between two naming conventions whenever a new folder is created.

By selecting **Standard form**, whenever a new folder is created it is named with a three-digit number followed by MSDCF. The three-digit number is the unique folder name number.

By selecting **Date form**, whenever a new folder is created, it is named with a three-digit number followed by five numbers. The first three numbers are the unique folder name number. The fourth is the last digit of the year, the next two numbers indicate the month, and the final two the day. So, 10000215 would be folder 100 created on February 15th, 2010.

› Select folder

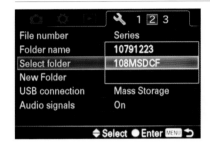

Select this option to choose the image folder you wish to use. That folder will then be employed by the camera to store images in as they are created.

› New folder

This option creates a new folder on the memory card, which will be used by the camera to store images in as they are produced. The folder will be created using the naming convention chosen in **Folder name** (*left*).

› USB connection

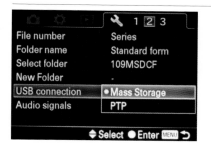

Connecting your camera to various other devices requires you to specify the type of USB required. When connecting the camera to a PC or Macintosh to copy images, set the USB connection to **Mass Storage**; when connecting to a printer, set the USB connection to **PTP** (Picture Transfer Protocol).

> **Note:**
> Using an application or printer that does not support AdobeRGB may result in images with inaccurate colors. If in doubt, convert your files to sRGB before use. Using AdobeRGB is not recommended if you intend to upload images to a web site or file sharing service.

› Audio signals

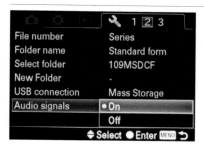

The A500 or A550 will make various sounds to confirm when certain functions have been activated (e.g., when autofocus is locked). These audio signals can be turned On or Off with this option.

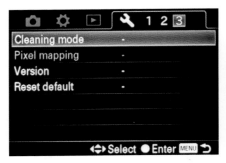

As with Setup 1 and Setup 2, you will be able to customize aspects of how the camera operates with Setup 3.

1) Press **MENU**.

2) Press ▶ and highlight 🔧 3.

3) Use the ▲ / ▼ control buttons to move the highlight bar up and down the list of options.

4) With the desired option highlighted, press **AF/Enter**.

5) The option sub-menu is displayed. Use the ▲ / ▼ control buttons to move the highlight bar up and down the sub-menu list of options.

6) Press **AF/Enter** to choose the desired sub-menu option.

7) Press **MENU** to exit the Setup menu and return to shooting mode.

› **Cleaning mode**

Cleaning mode will only work when the battery icon on the LCD is showing three bars or more, otherwise a power insufficient warning message will be displayed. *(See page 230–1 for more information about cleaning the sensor on your A500 or A550.)*

› **Pixel mapping**

The LCD screen on the back of the camera is a high-precision device. However, errors in the display may become apparent, in the

form of erroneous colored dots or pixels. If this happens, you can apply pixel mapping, which will attempt to reduce the problem. To use the pixel mapping facility, follow this procedure:

1) Switch the camera to **Live View**.

2) Attach the lens cap to the lens.

3) Press **MENU**, navigate to 🔧 **3** and select **Pixel mapping**.

4) Press **AF/Enter** when prompted.

› Version

Sony issues updates to the firmware of the A500 and A550 periodically. The version number is the number of the firmware update installed in the camera. Sony will announce when an update is available on its web site, and via news forums, or by email if you registered your camera online. Full instructions on how to update your camera will be included with the update.

› Reset default

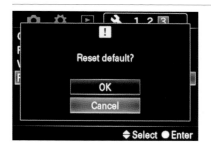

The A500 and A550 can be reset to the original factory settings. This includes the settings for the shooting modes, as well as those set using the custom menu screens. Note that once you have reset the camera, you will lose all the changes to any settings made previously.

> **Note:**
> Firmware is essentially another name for the software than runs inside the A500 and A550 to keep them functioning correctly.

α500

SONY

Chapter 3
IN THE FIELD

3 IN THE FIELD

What makes a good photograph? It's a simple question, yet it has many answers. You could argue that a good photograph is one that is correctly exposed. There is merit to that answer, but there is more to photography than good technique. A photo may be pin-sharp, but uninspiring.

As a photographer, you are trying to convey a sense of being in a particular place at a specific moment in time. You do need technical skills to achieve this, but you also need to add something else to the photo. This "something else" is the element that engages the attention of the person who will see your finished image.

Sometimes this is easy. A picture of members of your immediate family will always be interesting to other relations—often regardless of the technical merits or otherwise of the photo. It becomes more difficult to engage a person's attention when the subject is not connected to them in any way. Then the success of the image will be entirely dependent on the creative decisions you made at the moment you took the photograph. This chapter will explore those decisions.

TRAINED EYE ⌄

It was the atmospheric lighting that caught my eye in this busy locomotive repair shed. The contrast level was high and I had to use HDR *(see page 79)* to capture the scene photographically how I perceived it visually.

» DEPTH OF FIELD

A camera will never be able to represent exactly what the human eye sees. Generally, we see the world as being in focus, regardless of whether objects are nearby or in the distance. There are limitations to the way in which the camera can duplicate this effect. What the camera does offer, though, is the opportunity to make creative decisions about how much of the image will be in focus.

In its simplest meaning, depth of field refers to what is in focus in an image and what is not. A photograph's depth of field is a zone that extends both forward of, and behind, the main point of focus, which appears sharp in the finished image.

Determining the depth of field

Three main factors determine the depth of field of an image: the focal length of the lens, the aperture, and the distance from the camera to the subject. Choice of aperture is generally the key to using depth of field creatively, since choice of focal length of lens may be limited, and the distance to the subject may be predetermined.

A small aperture will give a broad depth of field, whereas a big aperture will give a shallow depth of field. (Aperture numbers are expressed in fractions: f/8 is a smaller aperture, and will give a broader depth of field, than f/2.8, which is a larger aperture and will produce a shallower depth of field.)

KITCHENWARE »
Shot at f/5.0, the image on the left has virtually no depth of field and only the spice jars (the objects that I focused on) are sharp. It was only by stopping down to f/2.5 that I was able to extend the zone of sharpness to include the bottles at the back.

» CAPTURING MOTION

Capturing movement effectively with the camera can be one of the biggest photographic challenges, but also one of the most satisfying. As with depth of field, it is impossible for the camera to record movement in the same way that we perceive it: the camera produces a shot of a single moment in time, whereas we see continuous movement.

There are several techniques to allow you to convey movement in an image, depending on the effect you wish to achieve.

Freezing action

You may not wish to achieve a pin-sharp image of your moving subject, since including a little blur will help to emphasize the feeling of motion, especially in a subject that is traveling at great speed. However, "freezing" a fast moving subject will have a drama of its own.

To achieve a very sharp image, you will need to use as fast a shutter speed as possible, and have a reliable means of supporting the camera firmly. The A500 and A550 have a maximum shutter speed of 1/4000 sec., which is more than enough for freezing action. Remember, though, that such a high shutter speed will allow only a limited amount of light onto the sensor, especially in low light conditions, so you will need to use a large aperture and may also need to increase the ISO setting accordingly.

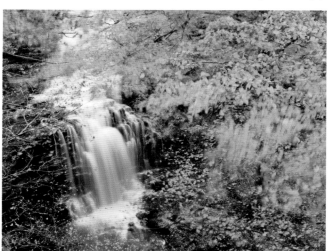

« YORKSHIRE WATER
Dull, overcast days are perfect for woodland scenes. However, the light level is generally very low, and without increasing the ISO it is difficult to use a small aperture for depth of field without the shutter speed being correspondingly long.

Camera support

The form of camera support you choose will depend on your subject matter, and on the conditions in which you are shooting. For instance, in situations where you need to move rapidly from one place to another, a monopod will give you the stable support you need without slowing you down.

Consider the subject's speed

Another thing to consider is that the speed at which your subject appears to be moving will depend not just on its actual speed, but on the angle from which it approaches the frame. If the subject is approaching head-on, it will appear to be moving more slowly than if it passes the camera at a right angle.

The best results are likely to be achieved by positioning yourself at an angle of around 45 degrees to the subject. This will give the final image a feeling of speed, but also give you more control over the exposure. You may find that a slightly slower shutter speed works perfectly well from this angle, which could result in a more satisfactory exposure.

Panning

An interesting effect can be achieved by panning with the camera, that is, following the moving subject with the shutter open. This technique works best when the subject is moving past the camera at a right angle.

When you keep the camera still and shoot an image of a moving subject, the subject will be blurred and the stationary elements of the image will be sharp. Panning with the camera gives the opposite result: the moving subject will be sharp, but the motionless surroundings will be blurred.

SPEED BIRD ⌄

For several minutes I watched this blue tit zip in and out of its nest in a brick wall. Before flying into the nest, it would always pause very briefly as though posing. I knew I'd need to use a fast shutter speed and time the moment right if I wanted to freeze it. Even at 1/400 sec. There is still a slight amount of movement, but I captured the shot.

This is a very effective way to communicate speed and motion.

For this technique to work effectively, it is necessary to move the camera smoothly through a single plane (i.e., horizontally if the image is moving across the frame). To achieve this, make sure you have a stable footing, and keep your elbows tucked in, to give the camera stability. When the subject moves past you, press the shutter button and follow the subject by moving from your waist.

As with other methods of shooting moving subjects, the correct shutter speed is crucial to success. Different speeds will result in slightly different effects, but a range of between 1/8 sec. and 1/125 sec. should work well.

« SAN FRANCISCO TRAM
This tram trundles along at a respectable speed for a vehicle dating from 1928. Because the tram was heading toward me, I needed to use the Continuous autofocus function to keep the front in focus and a shutter speed of 1/500 sec. to "freeze" the movement.

Blurring

Another way of expressing motion in an image is to aim deliberately for the subject to be blurred. This technique is seen most often in images of fast-flowing rivers and waterfalls. Here, it has a softening effect on the water, rather than giving crisp definition to it splashing. For the best effect, the subject should be moving across the frame, rather than approaching you.

To achieve blurring of subjects in motion, you will need a lower shutter speed. On a bright day, you may need to lower the ISO setting to avoid overexposure, and a small aperture will be required.

If you wish to blur only the moving elements in the image, you will need to mount the camera on a tripod to avoid camera shake. You may wish to aim for a more impressionistic effect, however, in which case try experimenting with handholding the camera instead.

SENSE OF DANGER ⌄
This sign caught my imagination when driving around the island of Benbecula in the Outer Hebrides. I wanted to convey the speed of the cars that threatened the otters that crossed at this point. After a bit of experimentation, I found that 1/50 sec. gave me the right amount of blur on the cars to achieve this.

Perspective is the term used to describe the perceived spatial relationships between the different elements in an image, and the apparent changes in size of objects at varying distances from each other.

It is often thought that different lenses actually create different perspectives, but this is not true, since perspective is simply a function of distance. However, different types of lens do lend themselves to the creative exploration of perspective.

If you wish to place an emphasis on the subject matter in the foreground of your image, a wide-angle lens will do this effectively, since it allows you to get closer to the foreground object and places it within the wider context of its surroundings. It is useful if we refer to this as a "wide-angle perspective."

Alternatively, using a telephoto lens will tend to give the impression that the elements in the image have been compressed, from the foreground into the distance. This is not because the lens has altered the perspective, but simply because the telephoto lens has a greater working distance than the wide-angle and will bring more elements, from greater distances apart, into the shot. If you're close to your subject (with a wide-angle lens), it will appear more remote from other elements of the image.

With a telephoto, the perceived compression of the elements is due to the subject appearing much closer to elements in front of and behind it.

« VISUAL COMPRESSION
The use of a telephoto lens has caused the houses that surround Hexham Abbey, United Kingdom, to look more "stacked" together than they are in reality.

» COMPOSITION

Some photographers claim that there are definite rules that must be obeyed to produce pleasing photographic compositions. Following are descriptions of some of those rules. However, rules in photography can and should be broken if you want to be truly creative.

Rule of Thirds

The Rule of Thirds is a useful basic compositional device, which can be a valuable aid in placing the elements of an image pleasingly within the frame. It states that an image should be imagined as being divided by two sets of parallel lines, one set dividing the horizontal axis into three equal spaces, the other doing the same along the vertical axis, resulting in nine equal segments.

The elements of the image are arranged so that they sit on or near these lines, or at the

intersection of two of the lines. One simple example is a seascape, where the horizon is placed near the upper or the lower of the two horizontal lines, depending on whether the sky or the sea is to be the dominant element in the image.

It is argued that placing the elements at these points in the frame creates more balance and interest in the composition than would be the case if the subject was placed in the center of the frame.

FLOTATION RING »
I placed the center of the flotation ring support in the bottom "third" to create a sense of space around the structure. The orange of the flotation ring is also a striking color combination with the blue sky.

3

The Golden Section

Also known as the Golden Ratio or the
Golden Rectangle, this ancient concept is
a rather more complex variation of the
Rule of Thirds. It involves dividing the
frame into rectangles with proportions of
1:1.618 (width:length). By removing a
square from a rectangle of these
proportions, another rectangle with the
same proportions is formed.

As with the Rule of Thirds, placing
important elements in the image along
the lines and intersections formed in this
manner creates a pleasing composition. If
the rectangles continue to be segmented,
creating smaller and smaller rectangles,
and the different-sized elements of the
image are arranged accordingly, a pleasing
"golden spiral" can be created.

The Golden Triangle

The Golden Triangle is a variation of the
Golden Section, which is especially useful
in composing images where the elements
are dominated by diagonal lines. It is
created by bisecting one of the two
identical angles of an isosceles triangle in
such a way as to create a smaller triangle
of the same proportions. Again, placing
elements on the lines or intersections that
are created will result in a pleasing,
dynamic composition.

THE GOLDEN TRIANGLE ⌄
The placement of the rocks in the foreground
and the radio tower on the headland forms the
shape of the Golden Triangle.

The Rule of Odds

The theory behind the Rule of Odds is that an odd number of elements in a scene is visually preferable to an even number, because the central element is automatically framed by those elements that surround it.

Symmetry

Although symmetry is a powerful compositional tool, it should be used sparingly, since overuse can make your photographs look contrived. Symmetry is the direct opposite of the Rule of Odds, in that symmetries require an even number of elements. A tree and its reflection in a pond is an obvious example of symmetry. However, symmetries can also involve non-related objects that merely resemble each other in shape, color, or texture.

Color

Color can also be used as a compositional device. When viewed together, different colors can be harmonious (e.g., reds and yellows, or yellows and greens) or complementary (e.g., orange and blue, or magenta and green). A harmonious color scheme is restful, passive, and natural; an image in which two complementary colors appear will be more dynamic, vibrant, and less natural.

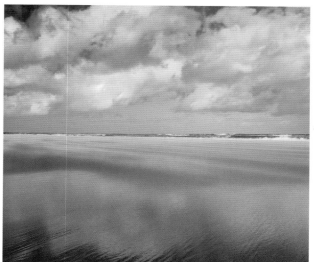

« REFLECTIONS
There was just enough wet sand on this beach in Northumberland, United Kingdom, to reflect the cloud-covered sky above. I composed the shot with the horizon in the middle of the frame to make the composition more symmetrical.

Photography is all about light. In fact, the word "photography" is derived from the Greek words *photos* (light) and *graphos* (writing). You are "writing with light" when you press the shutter button on your camera. The quality of light you use when creating an image will determine the success or otherwise of your image. Some subjects suit a certain type of light more than another, and there is some skill to judging which is right for your image. But that is part of the joy of photography, and it is something that will become increasingly apparent with practice.

Color temperature

What you believe to be white light may be anything but. The human brain is remarkably adept at adjusting to a small bias in the color of light. A good example is the color of light emitted by an ordinary domestic light bulb, which is rich in red and yellow wavelengths, but comparatively weak in blue, yet it is still perceived by the brain to be a "white" light source.

This bias of colors in light is known as color temperature. You would use the white balance settings on your camera to compensate for the changes in color temperature found between different sources of light.

NIGHT GLOW ⌄
I set the white balance to daylight for this dusk shot. This meant that the light flooding out of the inn was recorded more "warmly" than I perceived it. But, I felt that this made the place look more welcoming, particularly in contrast to the cold blue of the darkening sky.

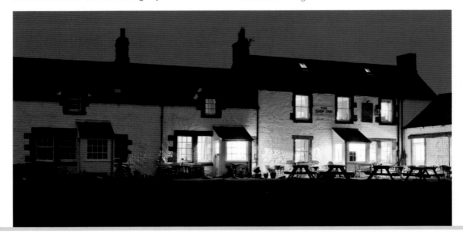

» LIGHT SOURCES

By far the most common source of natural light, no matter how indirect, is the sun. Even if we photograph an image lit by moonlight, that light is still sunlight, but reflected from the surface of the moon.

All sunlight is scattered and absorbed to some degree by the earth's atmosphere. Different wavelengths of sunlight are affected in different ways; the shorter the wavelength of light (and therefore the more blue the perceived color), the greater the scattering and absorption. Different atmospheric conditions have different effects. At high altitudes, where there is little atmosphere, light is scattered less, making it appear more intensely blue.

However, it is not necessary to travel far to see how light is affected by the atmosphere. Both the color and intensity of sunlight can be seen to change throughout the day. At sunrise and sunset, sunlight passes more obliquely through the atmosphere. The result is decreased contrast, a reduction in the intensity of light, a greater scattering of blue light, and a

color shift to red/orange. This is the reason why sunrise and sunset have their characteristic warm, red glow. As the sun rises, the light passes through a gradually reducing band of atmosphere, both the contrast and intensity of the light quickly increase, and the color temperature "cools" to the whiter light of midday as less blue light is scattered.

DAWN AND DUSK　　　　　　　　　　**»**
The first and last light of day are when sunlight is at its "warmest," as shown in this photograph of evening light on All Saints Church in Newcastle, United Kingdom.

3 » CONTRAST

The contrast in a scene is the range of tones from the darkest point to the brightest highlight. We are able to adapt to scenes of high contrast and see detail both in the shadows and in the bright areas. A camera typically can't record detail in both, so a choice must be made between recording detail in the shadows and losing it in the highlights, or vice versa. Contrast is highest in the natural world on a cloudless day, when the sun is at its highest at local noon. Cloud will help to reduce the contrast in a scene: the more cloud there is, the "softer" the sunlight will become. Complete cloud cover or mist will give the softest natural light of all. This soft light may not be flattering to wide-open landscapes, but is excellent for woodland scenes, close-up photography, and portraiture.

« SUBTLE CONTRAST
The soft light of an overcast fall day was perfect for this image of the River Allen in an English woodland. If the light had been "harder," the contrast would have been greater and I would have struggled to retain detail in the highlights on the water and the shadows on the far bank.

» LIGHTING DIRECTION

The direction of your light source, whether it is natural or artificial, will have a crucial effect on the subject you are shooting. Understanding how the direction of light affects the image will enable you to decide on the effect you want and how to achieve it. In addition, it may even have a bearing on the time of day you choose to create a particular image.

Frontal lighting

If you take an image with bright sunlight behind you, or with the flash, your image will have frontal lighting. This will mean that the whole of the image will be evenly lit. And while it is easy to assume that the best photographs are produced on the sunniest days, in the most direct light, this is not necessarily the case.

Bright frontal lighting does have its disadvantages. It has a tendency to "flatten" images, the absence of shadows removing areas of contrast and interest. However, this lack of contrast does mean that getting the right exposure should be simple.

Oblique lighting

Sunset and sunrise are favorite times of the day for landscape photographers, and not just because they offer the richest and most varied natural colors. These are the times when the sun is lowest in the sky, and the natural light is at its most oblique.

Unlike frontal lighting, oblique lighting offers a wide range of effects that have the potential to give an image more life and atmosphere. It is this kind of light that casts the most interesting shadows, defining the shape of the landscape and picking out details in a way that the midday sun simply does not.

However, oblique lighting can create problems for photographers. The fact that it casts shadows can lead to high contrast, which can make it difficult when choosing an exposure. Bracketing your images, and using HDR (high dynamic range imaging) techniques in post-processing, can enable you to create an image that will show detail in shadowed areas, without the brighter parts being burnt out.

Backlighting

As the word suggests, a backlit subject is one that is illuminated from behind. This can result in hauntingly beautiful images, but it must be handled skilfully if it is to be pleasingly effective.

By its very nature, a backlit subject is likely to be in shadow and, therefore, is in danger of appearing as nothing more than a silhouette in your finished image. This can often be very effective in itself, especially when the subject has a strong and interesting shape, such as a leafless tree in winter or a striking piece of

3

sculpture. If this is the effect that you are looking for, you need to meter for the brighter areas of the image, to bring out the colors to best effect.

If a silhouette is not what you are looking for, and you require the subject to be well defined, you will need to throw some light into the shadows to achieve a balanced exposure. This can be done with fill-flash or by using a reflector, which bounces light back onto the subject and can be purchased quite cheaply. If you choose to use flash, take care that you do not overdo it, or you will risk losing the

pleasing effect of the backlighting.

This technique is only suitable for close-range work on small, more intimate subjects, rather than on huge architectural features or vast landscapes. The distance at which it will be most effective will depend on the size of the reflector or the power of the flash.

BACKLIGHTING ⌄
If a subject is translucent, such as this strand of kelp, backlighting helps to bring out the shape and form of the subject.

» IMAGE PROPERTIES, OPTICAL

Flare

Lens flare occurs when non-image forming light enters the lens, bounces around the various elements inside the lens, and then hits the camera sensor. It frequently occurs when shooting toward a strong light source, such as the sun, resulting in strange streaks and colored blobs in the final image. Lens flare can also cause a reduction in either part or all of the image.

Because we don't experience lens flare with our eyes, it could be argued that it should be avoided if we are aiming to capture reality exactly as we perceive it. However, this is an entirely subjective issue, and allowing lens flare to creep into an image can be used to creative effect.

If you wish to avoid lens flare, there are several techniques that can be employed. Most important is to keep the front element of the lens (and any filters used) as clean as possible. Fingerprints on lens glass won't help the issue at all! Using a lens hood will stop direct light from entering obliquely from the side of the lens—although lens hoods aren't

convenient if you regularly use a clip-on filter system. Mounting the camera on a tripod and casting a shadow with your hand or body over the front of the lens is an extremely effective way of cutting out lens flare. The trick is not to end up in the final photo! Digital photography has made this technique easier, since it is simple to check whether this has happened and to reshoot if necessary.

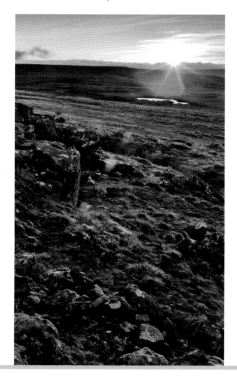

MOORLAND SUNSET »
Shooting directly into the sun has caused pronounced lens flare to run diagonally down the photo. If I'd waited a few minutes for the sun to set further, the problem would have lessened, though the photo would not have been as dramatic.

Pincushion and barrel may seem strange words to associate with a camera lens, but both are accurate descriptions of the types of distortion sometimes seen in images. They describe how a perfectly straight line—such as the horizon when looking out to sea—is curved by the optical properties of a lens. This is particularly apparent when using older zoom lenses, or cheaper lenses where performance is sacrificed to reduce their cost.

Pincushion distortion results in straight lines appearing to bow in toward the center of the image; barrel distortion causes straight lines to bow outward. Fortunately, most good imaging software programs have facilities for correcting such distortion, although some image quality may need to be sacrificed to achieve this. Generally, however, distortion is not noticeable on most photographs, so you may not need to correct for it very often.

Chromatic aberration

Chromatic aberration (or achromatism) is caused by the inability of a lens to focus the various wavelengths of colored light at the same point. This results in fringing along the boundaries of light and dark areas of an image. The effect can be reduced—usually more successfully in RAW files than JPEGs—using software such as Adobe Lightroom or Capture One. You may find older lenses more prone to chromatic aberration, since newer lenses will have been designed to reduce this effect with digital cameras.

Vignetting

When the corners of the image appear darker than the center, the effect is known as vignetting. Most lenses will display a certain amount of vignetting at maximum aperture, but the problem usually disappears once the lens has been stopped down. Vignetting can often be corrected in post-production, using software such as Adobe Photoshop, but this correction can cause further problems, such as the possibility of increased noise in the adjusted areas.

Using wide-angle lenses with multiple filters, or fitting a large filter holder, can also cause the corners of an image to darken. To prevent this, some filter holder manufacturers make special wide-angle lens adapters for their systems that position the filter holder closer to the front of the lens.

DISTORTION ≫

The wide-angle lens I used for this shot suffers from barrel distortion. Fortunately, the effect is rectifiable in image software. The white line in the photo shows where the horizon should be if there was no distortion.

CHROMATIC ABERRATION ≫

The telltale red and green fringing caused by chromatic aberration.

Dynamic range and clipping

Compared to the human eye, the sensor in a digital camera can only record a relatively narrow range of levels of tone. The dynamic range of a camera is the spread of tones from the darkest to the lightest that can be captured successfully. To some extent, therefore, achieving the correct exposure requires a compromise: you must make a creative judgment about the part of the tonal range you want to record. In a high-contrast scene, for instance, it may be impossible to record the highlights successfully without loss of detail in the shadow areas.

Where tonal information is lost, it is said to have been clipped. Clipping is displayed on the histogram of the Sony A500 and A550, and can be seen as a spike at either end of the histogram *(see page 70-1)*. A clipped highlight would record as pure white, a clipped shadow as a detail-free black. ARW (RAW) files offer some scope to recover lost detail, as does shooting in JPEG using D-RangeOptimizer *(see page 79)*.

Noise

All images captured by digital devices display noise to some degree or other. This is manifested by random variations in the brightness levels of the pixels that make up the digital image. Noise is particularly apparent in large areas of even tone, such as blue sky or dark shadows. It can make areas of even tone look "gritty" or grainy.

Noise in digital images captured with a camera increases as the ISO value rises

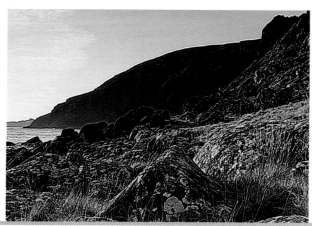

« TOO SHARP
This photo has been oversharpened, and the tell-tale "halo" would be visible even in a small print.

(see page 42–3). For maximum quality, use the lowest ISO value possible and avoid underexposing the image, since this increases the chance of noise occurring if later you try to correct this mistake.

The Sony A500 and A550 do have a noise reduction function, which can be turned on or off, although it is disabled in continuous shooting mode.

Aliasing

A digital image is composed of individual pixels (or picture elements) that become more apparent the closer you zoom into the image. At a magnification greater than 500%, you begin to lose the sense that you're looking at a photograph. Instead, it begins to resemble an abstract mosaic of colored tiles. Because a digital image is made up of these discrete squares of color, a problem known as aliasing can occur. Aliasing is commonly used to describe the jagged stepped effect that sometimes is seen on sharp diagonal lines or curves. To reduce this effect, digital cameras have a low-pass filter in front of the sensor. This gently softens the image to smooth out the "jaggies," as they are sometimes called.

Sharpening images

Images that come from a digital camera with a low-pass filter in front of the sensor inevitably look "unsharp." This is not generally noticeable when shooting JPEG because the camera will apply a certain amount of sharpening to the image at the point of capture. If you use RAW files, however, you will need to sharpen your images in post-production before printing them or using them on a web site. Most good photo editing software will allow you to sharpen the image by varying degrees, but note that an over-sharpened image will appear to have a halo at the boundary between areas of light and dark tones. How much sharpening an image needs will depend on how it is to be used. An image that is to be printed may require more sharpening than one that is to be used onscreen.

JPEG compression

The image data in a JPEG is compressed to make the file size smaller. This compression works by reducing the amount of detail in the image, degrading it to a greater or lesser degree. This is referred to as "lossy" compression, and is seen as fine detail becoming mushy and coarse.

There are certain color combinations that work well together, and one of these is orange and blue. Orange is a very warm, vibrant color that appears to "leap" forward in a photograph. Blue is the opposite; it's cool and perceived to recede in an image. The combination isn't restful in the way that a combination of green and yellow would be. Blue and orange are on opposite sides of the color wheel and are described as complementary colors. When they are put together, an effect known as simultaneous contrast occurs, where one color makes the other appear to be more vibrant.

LAST LIGHT OF DAY ⊗

The town of Hexham in Northumberland, United Kingdom, is in a river valley. When the sun sets, the abbey—the highest point in the town—is the last building to lose the sun, when the rest of the town is lit purely by ambient light from the sky. When I shot this image, there were no clouds: the ambient illumination came purely from a cool blue sky; the perfect complement to the warmth of the light on the abbey.

» LOW-LEVEL FRAMING

The default position when taking a photograph is to shoot from eye-level. While this may be fine for most situations, some subjects benefit from a change of perspective. Subjects that are naturally closer to the ground than you may look odd when shot from above.

Getting down low to the level of the subject makes for a more pleasing and intimate photograph—despite the odd looks that people passing by will sometimes give you! This applies to photographing children, animals, and even elements in the landscape.

Live View on the A500 and A550 is particularly useful for very low-level photography. Angling the LCD screen up will allow you to see your composition without the strain of having to bend right down to look through the viewfinder.

« DOWN IN THE BUTTERCUPS
The main problem I had in capturing this image, was the breeze blowing the buttercups to and fro. I didn't want to use too high an ISO value to avoid excessive noise, so resorted to a wide aperture instead. At ISO 200, an aperture of f/5.6 gave me a shutter speed of 1/100 sec. This was just fast enough to "freeze" the flowers successfully.

Travel photography often requires fast reactions. Events and situations are fleeting, and a decisive moment can be so easily missed. The key is to be vigilant and aware of what is happening around you. Set the camera to the fastest shutter speed possible and use continuous frame advance. Creating a rapid sequence of images of an event will quickly use up space on a memory card, but it will help you capture that one perfect, never to be repeated, moment.

Do not be tempted to edit in-camera though, and start deleting images straight away. What may seem to be a worthless snap initially may turn out to be the most pleasing image after you have given it careful consideration later.

« HIDE-AND-SEEK
There was a definite ambiguity about whether this girl in Stone Town, Zanzibar, wanted to have her photograph taken. With much giggling (not from me), she hid behind her school satchel, peeking out every so often to see what was happening and how the game was progressing. A shutter speed of 1/200 sec. and continuous focus activated allowed me to capture the decisive moment when she stared into the camera lens, daring me to take her photo.

» NIGHT PHOTOGRAPHY

Urban night photography is most effective before night has truly fallen. The optimum time to shoot is roughly half an hour after dusk, when there is still light and color in the sky. It is possible to achieve the same effect at an equivalent time before dawn. However, not every building is floodlit throughout the night, so some research will be necessary to avoid a wasted trip. Because the light level is generally low at this time of night, a long shutter speed will be needed. Setting the camera on a tripod will be the only way to avoid camera shake. Any movement during the exposure will be recorded as a blur, the degree of which is determined by the shutter speed.

VILLAGE LIGHT ⌄

It's not just cities that make rewarding nighttime subjects. Alnmouth is a small village on the Northumberland coast, United Kingdom. When the streetlights are lit at dusk, they sparkle on the water of the Aln river. The camera was set to BULB for this photo and the shutter locked open for two minutes. Any movement on the water has smoothed out so that it looks calm, but the long shutter speed is apparent in the way the clouds have drifted across the sky.

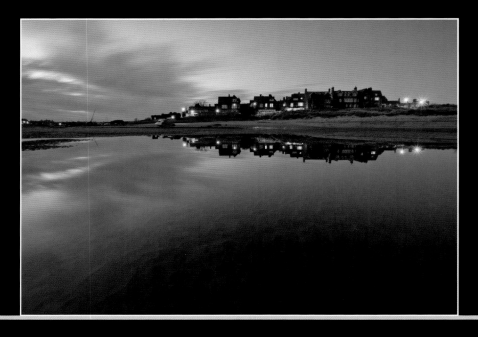

By creating a photograph, you are telling a story. Every element in the photograph has to support the story you want to tell. Anything that is unnecessary or out of place in the photograph will detract from that story. It is all about finding the right viewpoint to cut out the distractions and make the most of the subject of the photo. Sometimes the ideal viewpoint is immediately obvious, while on other occasions it can take time and patience. Often the simplest solution is the most striking.

« FISHING BOAT
This boat had been pulled up onto the harbor at Seahouses, Northumberland, United Kingdom, for repair. Around the boat was the usual clutter of a busy port, and I felt that this clutter was too distracting. Getting down low, below the boat, and selecting a "standard" lens allowed me to find a simple composition that was purely about the boat and the wispy clouds that seemed to curl around its radio mast.

» CREATING A SILHOUETTE

Camera sensors cannot record the range of brightness levels that the human eye can distinguish. Because of this there is always going to be a level of compromise between what you can see and what the camera can capture successfully, without it losing detail in either the highlights or the shadows. It is almost impossible to record the fine detail of any subject that is in front of a bright pre-sunrise or post-sunset sky without using fill-in flash or some other form of artificial illumination. In the case of something as large as a tree, this will be an impractical proposition. The compromise we are forced to reach is to

let our subject be recorded as a silhouette. With the right subject, this can make for an effective image. The key to a successful image is to keep the composition simple and not to allow a number of diverse subjects merge into one unrecognizable, puzzling shape.

TREE AGAINST A MULTICOLORED SKY ⌄

The contrast range in this wintry English scene was far too great for the camera to handle. If I'd exposed to record detail in the tree, the sky would have been hopelessly washed out. To me, the most important element of this scene was the range of colors in the sky. I was quite happy to let the tree be recorded as a silhouette and to correctly expose for the sky.

Chapter 4
FLASH

4 FLASH

When light levels are low and extra illumination is needed, a flash unit—whether built into the camera or added as an accessory—is a useful photographic tool. When using flash, however, many people are disappointed by the results. Often the subject is overexposed or is not lit at all. The occasions when flash works seem more like happy accidents than consciously planned occurrences.

The main problem with flash is that it is a relatively weak light with a limited range. The popping of flash units in a crowd at a concert is a familiar sight, but it is unlikely that any of those flashes will be effective unless the photographer is directly in front of the stage. Another problem with flash is that it is a hard, directional, and unflattering light. Fortunately, flash light can be modified, either by using a diffusion screen or by bouncing it off a handy wall. These techniques, which will be covered later in this chapter, help to soften the light and make it more natural.

GUIDE NUMBERS

Every flash unit has a set power output, known as a guide number or GN. This number will determine the effective range of the flash in either meters or feet (or often both), and will vary with the ISO rating. The built-in flash unit on the Sony A500 and A550 has a GN of 12 (meters) at ISO 100.

The GN can be used to calculate the f-stop (aperture value) that should be used for a subject at a given distance, or the effective flash distance at a specified f-stop. The respective formulas for both situations are:

f-stop = GN / distance
distance = GN / f-stop

Using the A500 and A550 flash GN as an example, a subject 3 meters away would require a camera aperture setting of f/4 to be exposed correctly (12 / 3 = 4).

Doubling the ISO doubles the GN too. Therefore, to expose the same subject correctly, the camera would need setting to f/8 (24 / 3 = 8). *(See the table on page 151 for further examples of flash settings at different ISOs.)*

BROCOLITIA, NORTHUMBERLAND »
Flash doesn't need to be fixed to the camera. For this photo of a Roman temple, the shutter speed was 8 seconds, and during the exposure I fired the flash-gun at 90° to the camera, directly toward the temple altar.

4 » THE BUILT-IN FLASH

The flash unit installed in the body of the Sony A500 and A550 is small and is fixed in position directly above the lens axis. It is only effective with lenses that are longer than 18mm. In common with external flash units, the built-in flash is a very directional light that can be harsh and unflattering. Having the option of flash is better than not having it, however, and the built-in flash is useful for creating fill-in light.

In Scene Selection mode, when light levels are low or if your subject is backlit, the flash will pop up automatically when the shutter button is lightly pressed down halfway. The flash can be deactivated via the **Fn** menu screen (with the exception of Flash Off in which flash is disabled). In Exposure mode the flash button needs to pressed to raise the flash even if flash is activated via the **Fn** menu screen.

AVOIDING A SILHOUETTE ⊻
Without flash my exposure options would have been limited when trying to photograph this ornate cycle way sign in County Antrim, Ireland. Exposing for the pre-dawn sky would have meant recording the sign as a silhouette. Exposing for the sign would have meant losing virtually all the detail in the sky. Using flash allowed me to balance the exposure of the two subjects and record color and detail in both.

› Activating the built-in flash

1) Press the **Fn** button.

2) Highlight **Flash mode** and press **AF/Enter**.

3) Select the desired flash mode using ▲ / ▼ and **AF/Enter** to confirm.

4) Press the ⚡ flash button if shooting in Exposure mode.

5) If the ⚡ flash indicator is blinking in the viewfinder (or on the LCD in Live View), the flash is charging and the shutter button will not be operable.

6) When the ⚡ flash button is lit, the flash is charged and the photograph can be taken.

7) If the built-in flash is no longer required, push the flash lightly but firmly back down into the camera body until it clicks into place.

Note:
When the exposure mode is set to AUTO or Scene Selection, the ⚡ SLOW Slow sync., ⚡ REAR Rear sync., and ⚡ WL Wireless flash options cannot be selected.

BUILT-IN FLASH SETTINGS

Flash Off
Flash is completely disabled.

Autoflash
AUTO The flash will fire automatically when lighting conditions require it, either when light levels are low or as fill-in flash.

Fill-flash
The flash is fired every time you take a photograph, regardless of the ambient light levels.

Slow sync.
SLOW The flash is fired every time you take a photograph. The shutter speed can be set slower than the maximum sync. speed to expose the background correctly, as well as the flash-lit subject *(see page 152)*.

Rear sync.
REAR The flash is fired just before the exposure is completed every time a photo is taken *(see page 152)*.

Wireless
WL Fires an external off-camera flash remotely *(see page 157)*.

One of the most valuable uses of flash is as fill-flash, or fill-in flash. In this situation, flash is used to fill in areas of deep shadow in an image, such as those found on a subject that is backlit by bright sunlight. Aesthetically, this is a good way to create portraits. The subject's hair will be backlit by the sun (an effect known as "rim lighting") and the subject won't be squinting, which would be more likely if they were facing the sun. The shadows do not need to be eliminated entirely, but the use of flash can help you achieve a more even exposure.

Using flash in this way can also help to prevent camera shake, as the camera will probably be using the flash-sync. speed of 1/160 sec.—with a standard lens and SteadyShot activated, this speed is more than sufficient to avoid camera.

To adjust the ratio of the flash light to the ambient light in Exposure mode use the flash exposure compensation setting *(see page 153)*.

> ### Notes:
> In low-light conditions, if AF illuminator is set to Auto on 📷 1, the flash may automatically pop up to briefly light the scene to assist the AF system to focus correctly (not in Continuous AF or if Smile Shutter is activated).
>
> Using a large lens hood may prevent the flash from fully lighting your subject. Remove the lens hood when you use the flash.

FOCUSING **»**

Without the AF Illuminator, I would have struggled to find the correct focus distance from the camera to these lobster pots as the ambient light-level was extremely low.

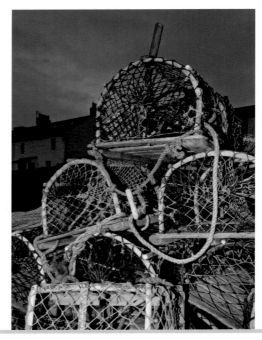

› Flash and Live View

Using Live View *(see page 39–41)* and the histogram display is generally a useful way to assess the exposure of a scene before the shutter button is pressed and the image made. However, Live View is not accurate with flash since the final exposure is determined by the flash firing when the shutter button is pressed. You will find when using flash that the histogram in Live View is often very different to the histogram of your final flash-lit image.

› Flash AF illuminator

Flash is not only useful for illuminating your subject. When light levels are low, flash can be used to assist autofocus, making focusing more accurate than if you relied on manually focusing the lens. The flash AF illuminator works by pulsing

flashlight at your subject until the focus distance is determined.

> **Notes:**
> AF illuminator does not function when Continuous AF is selected or if your subject is moving when Automatic AF is selected.
>
> The AF illuminator is only effective with lenses with a focal length of 300mm or less.
>
> When an external flash unit is attached to your camera, the AF illuminator of the flash unit is used.

› Built-in flash exposure

The range of the built-in flash will depend on the ISO sensitivity and aperture value. Use the chart below to gauge the appropriate settings in different situations.

	Aperture	f/2.8	f/4.0	f/5.6
ISO setting	200	3.3–20ft (1–6m)	3.3–14ft (1–4.3m)	3.3–9.8ft (1–3m)
	400	4.6–28ft (1.4–8.6m)	3.3–20ft (1–6m)	3.3–14.0ft (1–4.3m)
	800	6.6–39ft (2–12m)	4.6–28ft (1.4–8.6m)	3.3–20ft (1–6m)

» FLASH SYNCHRONIZATION

› Front- and rear-curtain synchronization

The shutter in your A500 or A550 comprises two light metal curtains, one in front of the other. The two curtains are designed to travel upward at the same speed. When you press the shutter button, the front curtain begins to rise, exposing the sensor to light. After an appropriate delay, the rear curtain also begins to rise, stopping light from hitting the sensor once more. The delay is the shutter speed you or the camera has chosen.

When using flash with front-curtain synchronization, the flash is fired the moment the first (or front) curtain begins to rise. With the flash set to rear-curtain synchronization, the flash is not fired until the end of the exposure, when the second (rear) curtain has begun to travel upward.

The practical difference is apparent when you use slow synchronization and have a subject that is moving from one side of the image frame to the other during the exposure. With front-curtain synchronization, the subject's initial movement will be frozen by the flash at the start of the exposure. With the shutter still open, any movement subsequent to the firing of the flash will be recorded as a blur in front of the subject as it continues moving across the frame.

With rear-curtain synchronization, the subject will move across the frame and not be lit by flash light until it has reached the far side. Since the shutter has been open and recording this movement, there will be a blurred trail behind the subject.

› Slow synchronization

One of the problems with using flash is that the camera will tend to default to a fast shutter speed. This often results in your subject being correctly exposed, but anything in the scene beyond the range of your flash unit will be underexposed. Slow synchronization forces the camera to use a shutter speed that is slow enough to correctly expose the background. In low-light conditions, this may mean the shutter speed will be too slow to successfully handhold the camera. In this instance, you will need to set the camera on a tripod. Although this may seem to defeat the purpose of using flash, with a little practice, the technique will enable you create strikingly effective images.

A FINE BALANCE »
Without using slow sync. flash, the sky and the building in the background, would have been hopelessly underexposed. As a bonus the snow falling as I took this shot has been lit by the flash, adding to the atmosphere of the photo.

› Flash compensation

The built-in flash should correctly expose your subject within the limits of the exposure chart on page 151. But it is not infallible and there may be times when you will need to override the flash exposure.

1) In shooting mode, press **Fn** and select **Flash compens**.

2) If the flash overexposed your subject, use ◄ to reduce the power of the flash by up to two stops in increments of a third of a stop.

3) If the flash underexposed your subject, use ► to increase the power of the flash by up to two stops in increments of a third of a stop.

4) Press **AF/Enter** to confirm the new setting. The camera will return to shooting mode.

5) After creating the photograph, reset flash compensation back to 0.

> **Notes:**
> Flash compensation is not available in the Scene Selection modes.
>
> When flash compensation is set, 🔣 will be displayed in the viewfinder and on the LCD in Live View.

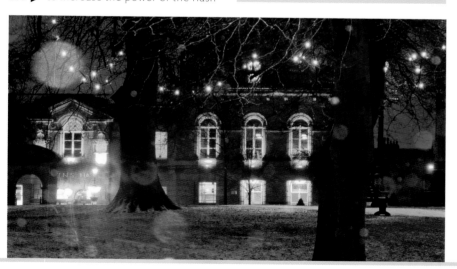

› High-speed flash synchronization

The flash sync. speed is the fastest shutter speed you can use with a flash unit. This is to ensure that the shutter of the camera opens in conjunction with the flash firing. On the A500 and A550, the built-in flash has a sync. speed of 1/160. You can use a longer shutter speed than that *(see Slow synchronization, page 152)*, but not faster.

This limitation will become apparent when you want to use flash as fill-in light on a sunny day. The shutter speed will be capped at the flash sync. speed, which may cause your image to be overexposed if a higher shutter speed was necessary for the correct exposure.

Sony produces two flash units that are capable of shooting with a higher-speed flash synchronization, the HVL-F58AM and HVL-F42AM. With these flash units attached to your camera (either physically or via a wireless connection), you can use flash at any speed up to the maximum of 1/4000 sec.

When either the HVL-F58AM or HVL-F42AM flash units are attached to the camera, the viewfinder will show ⚡WL/H .

› Red-eye reduction

The phenomenon of red-eye is one of the most common problems experienced when shooting portraits with flash. It occurs when light from the flash is picked up by the blood vessels in the subject's retina and directed straight back at the lens. It is a particular problem when the flash is mounted on top of the camera.

Red-eye reduction sets the flash to fire a series of short pulses before the shutter is opened. This causes the pupils of the subject's eyes to contract. When the flash is fired again to create the photo, the smaller pupils let in less light, thereby reducing the amount of light reflected from the retina back to the camera's lens.

To enable red-eye reduction:

1) Press **MENU** and select ⚙ Custom **1**.

2) Set **Red-eye reduc.** to **On**.

3) The Red-eye reduction symbol ⚡👁 will be displayed on the LCD screen when the flash is raised.

» EXTERNAL FLASH UNITS

An external, detachable flash unit is invaluable in extending the flexibility of your image making, since it offers much greater lighting power than the camera's own integrated flash.

Sony offers a range of external flash units, with many attributes that are optimized for use with the new **α** range. Units that are compatible with the A500 and A550 are HVL-F20AM, HVL-F42AM, HVL-F58AM, and the ring light HVL-RLAM. Details of each of these appear in the following pages.

These flash units include both ADI and TTL exposure facility *(see right)*. These settings instruct the flash to take its exposure information from the camera. The flash then adapts its own settings accordingly, to give you the optimum flash level for your shot.

› Flash exposure

The cameras have two ways to determine the correct exposure for external flash units.

ADI (Advanced Distance Integration) flash
This method uses the focus distance information from the lens and pre-flash light metering information.

Pre-flash TTL (Through the Lens)
This method uses the pre-flash metering information only.

ADI is potentially the most accurate method but will only work with ADI compatible lenses. It is not accurate if the flash-to-subject distance can't be determined—such as when wireless flash is used or when the flash light is bounced using a reflector.

1) Press **MENU** and select 📷 Recording **1**.

2) Set Flash control to **ADI flash** or **Pre-flash TTL** as desired.

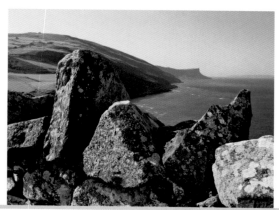

« **RECLAIMING SHADOW DETAIL**
Flash isn't just useful when the light level is low. For this photo, I used off-camera flash on an extension cable *(see page 162),* held to the right of the camera to help fill in the heavy shadows that were cast by the harsh summer sunlight.

› Mounting an external flash

When Sony took over the assets of Konica Minolta, it inherited a flash mounting system unique to that company. Most camera manufacturers use a variation of the ISO 518 hot-shoe standard. The Sony range of cameras employs a different shaped flash mount or hot shoe entirely. This means that a flash has to be designed specifically for the Sony system, or an adapter must be fitted if you wish to connect a standard flash.

1) Ensure that both the camera and the flash unit are switched off.

2) Push the mounting foot of the flash firmly onto the camera hot shoe. The flash will lock into place automatically.

3) Switch on the camera and flash unit.

4) On the camera, adjust the white balance settings if not on automatic or already set to flash.

Sony's proprietary hot shoe design

5) To remove the flash unit, press the mounting foot release button on the flash unit and pull it off the camera.

› Bounce flash

One way to reduce the hardness of flash light is to reflect or "bounce" the light from another surface before it lights the subject of your photo. Reflecting the light in this way makes it a larger and therefore softer light source. For this technique to work, you will need a flash with a head that can be angled upward or sideways. The most common surface to bounce flash light from is a ceiling, though a wall could also be used.

Another item to note is that the flash light will take on some of the color of the surface from which you bounce it. To avoid unwelcome color casts, try to use as neutral a colored surface as possible.

The HVL-F20AM, HVL-F42AM, and HVL-F58AM all have varying levels of bounce flash capability. The HVL-F20AM tilts

> **Note:**
> When using the bounce flash technique, the higher the ceiling, the greater the flash-to-subject distance. The higher the ceiling, the more you will need to use either a higher ISO or a larger aperture to compensate.

vertically, enabling light to be bounced off the ceiling or a reflector. The other models have heads that also swivel on the horizontal axis, enabling light to be bounced off walls and other surfaces for a greater range of effects.

> ## Wireless flash

With a wireless enabled flash, you can set the flash unit to fire remotely without it needing to be attached to the camera. This will give you more flexibility in how you use the flash to light your subject, and allow you more control of the shadow and highlights in the image.

1) Ensure that both the camera and the flash unit are switched off.

2) Attach the wireless flash to the camera hot shoe.

3) Switch on the camera and flash unit.

4) Press **Fn** and select **Flash mode** and

then ⚡WL. Remove the flash unit from the hot shoe and press the ⚡ flash button to activate the built-in flash.

5) If you test fire the flash, use the **AEL** button to lock the exposure.

6) Turn off the wireless flash via the **Fn** menu once wireless flash shooting has finished.

> ### Notes:
> If the built-in flash is used when the camera is set to wireless mode, you will get inaccurate flash exposures.
>
> The AEL button should be set to **AEL Hold** if wireless flash is used.

BOUNCING FLASH LIGHT ≫
The photo on the left was shot at ¼ power with direct flash, while the image on the right was shot at full power but with the flash unit pointing up to a reflector panel that was angled toward the elephant. Using the reflector panel has softened the light making the shadows less harsh and more pleasing.

› EXTERNAL FLASH UNITS: HVL-F20AM

The HVL-F20AM is an inexpensive, compact flash unit, which offers a maximum range of nearly twice that of the built-in flash units on the A500 and A550. The compact and lightweight design of the flash allows it to be folded down neatly and left mounted on the camera when it is not in use. As with the other Sony flash units (*see following pages*), the HVL-F20AM offers intelligent white balance adjustment, based on the camera's own color temperature information and settings.

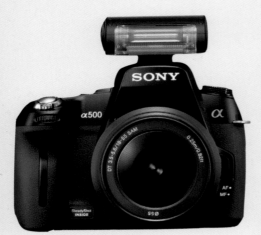

HVL-F20AM flash unit, left, and mounted on the A500, above

Guide number (GN)
20 (meters)—ISO 100, at 50mm focal distance

Flash coverage (lens focal length; range)
27mm (indoor mode); 50mm ("Tele" mode)

Wireless TTL Mode
No

Tilt/swivel
75° vertical

Recycling time
5 sec.

Approximate number of flashes per set of batteries
150 with Ni-MH batteries

Dimensions (w x h x d)
2½ x 3¾ x 1in (62 x 94 x 24mm)

Weight
3.2oz (90g)—without batteries

Included accessories
Soft carry case, user manual

› EXTERNAL FLASH UNITS: HVL-F42AM

In common with the HVL-F58AM (*see page 160*), this flash unit includes a High-Speed Synchronization (HSS) mode. This enables you to use flash with very high shutter speeds (from 1/500 to 1/4000 sec.) and is especially useful for capturing fast-moving subjects. This model, and the HVL-F58AM, also offers full manual control over the flash, and the facility to adjust the flash coverage to the size of the camera's image sensor, reducing light falloff at the periphery of images.

Guide number (GN)
42 (meters)—ISO 100, at 105mm focal distance

Flash coverage (lens focal length; range)
24–105mm; 16mm with built-in wide panel

Wireless TTL Mode
Yes

Tilt/swivel
90° vertical; 90° left; 180° right

Recycling time
0.1–3.7 sec. (flash at full power when fitted with fresh alkaline batteries)

Approximate number of flashes per set of batteries
180 with alkaline batteries; 260 with Ni-MH batteries

Dimensions (w x h x d)
3 x 4⅞ x 4in (75 x 123 x 100mm)

Weight
12oz (340g)—without batteries

Included accessories
Mini stand for wireless shooting, soft carry case, user manual

› EXTERNAL FLASH UNITS: HVL-F58AM

The HVL-F58AM external flash unit is regarded by Sony as its flagship flash for the **α** DSLR range, and it offers exceptional versatility. The ability of the flash head to pivot on the horizontal axis, in addition to the usual vertical axis, allows an impressive degree of control over the direction of the flash. The recharge time is fast, and the unit has a large, easy-to-read LCD screen.

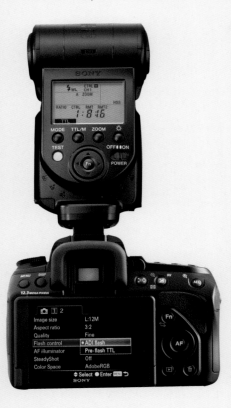

Guide number (GN)
58 (meters)—ISO 100, at 105mm focal distance

Flash coverage (lens focal length; range)
24–105mm (16mm with built-in wide panel)

Wireless TTL Mode
Yes

Tilt/swivel
150° up; 10° down; 90° left and right.

Recycling time
0.1–5 sec. (flash at full power when fitted with fresh alkaline batteries)

Approximate number of flashes per set of batteries
100 with alkaline batteries; 200 with Ni-MH batteries

Dimensions (w x h x d)
3⅛ x 5⅞ x 4¼in (77 x 147 x 106mm)

Weight
15.6oz (440g)—without batteries

Included accessories
Mini stand for wireless shooting, soft carry case, user manual

› EXTERNAL FLASH UNITS: HVL–RLAM

This ring light is designed for lighting close-up macro subjects. It provides constant illumination, rather than flash, enabling you to check the effect of your lighting as you go. There is a choice of two power levels, one offering softer light and the other a brighter level of illumination.

In addition, it is possible to illuminate either the entire ring, or just the left or right half. Using the entire ring results in a shadow-free image, whereas illuminating just half of the ring will create shadow and contrast, accentuating detail and texture in the photograph.

Illumination intensity
150 lux

Shooting distance
0.1–0.5 meters recommended

Wireless TTL Mode
No

Full emission
Full; right half only; left half only

Recycling time
N/A

Approximate battery life
40 min. with alkaline batteries; 110 min. with Ni-MH batteries.

Dimensions (w x h x d)
Control unit: 2⅝ x 3⅛ x 3⅛in (64 x 78 x 79mm)
Ring light: 5 x 5⅝ x 1in (124 x 141 x 24mm)

Weight
6.4oz (180g)—complete, without batteries

Included accessories
Ring light, 49/55mm adapter ring, soft carry case, shoe adapter, user manual

› FLASH ACCESSORIES

**FA-CC1AM
Off-camera
flash cable**

**FA-HS1AM Hot shoe
adapter**

**FA-MA1AM Macro light
adapter**

Sony produces a number of accessories for your external flash that will help you make the most of its potential.

Off-camera flash cable FA-CC1AM

This 59⅛in (1.5m) extension cable allows you to take your flash off-camera for less direct lighting.

Extension cable for flash FA-EC1AM

Extends the length of the off-camera flash cable FA-CC1AM by a further 59⅛in (1.5m).

Off-camera shoe (for HVL-F36AM flash) FA-CS1AM

This adapter allows you to use the off-camera flash cable FA-CC1AM with the HVL-F36AM flash.

Hot shoe adapter FA-HS1AM

Converts the proprietary Sony hot shoe for compatibility with third-party flashes using the ISO 518 hot shoe standard.

External battery adapter for flash FA-EB1AM

An additional power supply for the HVL-F56AM flash, which helps to reduce the flash recycling times.

Triple connector for flash FA-TC1AM

Allows the connection of up to three additional flash units to the A500 and A550, using additional FA-EC1AM extension cables.

Macro light adapter FA-MA1AM

This accessory allows the connection of the ring light HVL-RLAM to a compatible macro lens (SAL-30M28 and SAL-50F18).

› Flash diffusers

A flash diffuser is a very economical way of spreading the light from a flash, preventing it from being concentrated in one place, and causing harsh light and unattractive strong shadows. The diffuser works by softening the light and bouncing it from different surfaces around the subject, creating lighter shadows, for a much more sympathetic effect.

Different types of flash diffuser are available. Some fit over the flash head, while others are attached around it. Jessops produces a very economical flash diffuser, which fits all flash units, and Lumiquest has a huge range of custom-made diffusers, including some to fit most of the flashes available for the A500 and A550 models..

Tips

Make your own flash diffuser easily and cheaply, using a piece of white card, secured to the flash with Velcro.

Combined with the flash unit's adjustable bounce angle capability, a diffuser allows you to throw softer light at a chosen angle, for optimum light of your subject.

› Flash brackets

Both the Sony HVL-42AM and HVL-58AM external flash units have wireless capability, meaning that they can be detached from the camera during use. This enables you to position the flash where you think it will work best, rather than having it mounted on the camera and being limited by its bounce angle capability.

For stability in such situations, it is usually possible to mount a flash unit on a tripod, or even just to lay it on a flat surface. Another possibility is a proprietary flash bracket, which is secured to the camera and supports the flash on a flexible arm or bracket, so that it can be positioned as you wish.

A flash bracket will also allow you to attach a "flash brolly," another useful way of diffusing and spreading light over a broader area. Such equipment is light and portable, and need not necessarily be restricted to use indoors or in the studio.

Lumiquest "Big Bounce" flash diffuser

Chapter 5
CLOSE-UP

5 CLOSE-UP

An exploration of the potential of close-up photography offers exciting new possibilities for the photographer who is used to making images of landscapes, sporting events, or people. Whereas these subjects tend to be represented in the image much as we perceive them with the naked eye, close-up photography offers a fresh way of looking at the things around us, and opens up new worlds of creativity.

SLR cameras offer huge benefits over other types of camera when it comes to close-up photography. The viewfinder will display accurately what will be captured in the frame, which is vitally important when the subject is so close to the camera. And the lenses available offer manual focus and complete control over depth of field, also vital for effective close-up photography.

Tip

The "working distance" is the distance the camera needs to be from the subject to obtain the reproduction ratio you are aiming for. Your choice of lens will affect this working distance. For example, with a 200mm macro lens, the working distance for 1:1 reproduction will be double that of a 100mm lens. This extra working distance can offer valuable extra flexibility, especially with a subject that might move slightly as you try to set up your shot.

AMMONITE

Natural patterns, such as the spiral of this fossilized ammonite, make excellent macro subjects. By getting in close and excluding any extraneous detail, the photo is purely about shape and texture.

» DEPTH OF FIELD

Accurate control over depth of field is the key to success with close-up photography. At very close working distances, depth of field becomes increasingly shallow. This often makes smaller apertures necessary, which in turn makes longer exposures inevitable. For this reason, a tripod or other sturdy camera support is essential if images are to be sharp.

Working with such a shallow depth of field makes accurate focusing critical if you want to create truly satisfying images. In addition to deciding on the subject, you may need to decide on which small detail of your subject you wish to be in focus. Again, a tripod is essential if such delicate work is to be fully rewarded.

Note:
Close-up photography is often referred to as "macro" photography, but macro has a specific meaning. It refers to the photography of objects at life-size or larger. A true macro lens allows a reproduction ratio of at least 1:1. Some zoom lenses are advertised as having macro potential, when their reproduction ratio is only 1:2 or 1:4. Whereas such lenses offer potential for exciting close-up photography, this is not macro photography in the true sense.

CREATIVE BLURRING
Shallow depth of field always limits macro photography, but can be used creatively to make the sharp part of the image stand out from out-of-focus areas.

Owning a macro lens is not a requirement for taking macro images, since there are several small pieces of equipment that can be added to your existing kit to enable reasonable macro capabilities. They are unlikely to give such good results as true macro lenses, but they can be a very satisfying entry into a whole new area of photography.

One of the most economical of these is a close-up attachment lens. These are single magnifying lenses that simply screw onto the front of the camera lens, in the same way as a filter. A close-up attachment lens works by reducing the minimum focusing distance of the lens to which it is attached. They do not interfere with the camera's exposure or focusing systems, and have the additional advantage of being light and easy to carry, as well as relatively inexpensive to purchase.

Close-up attachment lenses produce the best results when used in conjunction with prime (fixed focal length) lenses, rather than zoom lenses. Although Sony does not produce these lenses, other manufacturers, such as Nikon and Canon, offer good ranges suitable for a variety of lenses.

The strength of close-up attachment lenses is measured in diopters, usually +1, +2, +3, or +4. The smaller the number, the less the magnification. It is possible to stack close-up attachment lenses together to increase the magnification, but image quality will be seriously compromised.

« GARDEN MACRO
Flowers are particularly tricky to shoot as macro subjects, since the slightest breeze will cause the flower to start moving, leading to unsharp images. Try to shield flowers and similar subjects from the wind with your body, and wait for the them to be perfectly still before creating your photo.

› Extension tubes

Kenko Extension Tube Set

Extension tubes (or extension rings) are simple, lightweight tubes that are designed to be attached between the camera and the lens. This decreases the minimum focusing distance, thereby increasing the magnification factor.

Extension tubes offer perhaps the best way of entering the world of macro photography without going to the expense of purchasing a macro lens. They have one great advantage over close-up attachment lenses, in that they contain no glass elements. This means that they have very little, if any, detrimental effect on the optical quality of the lens or the final image. They can also be used in conjunction with most lenses. Again, Sony does not make extension tubes itself, but manufacturers such as Kenko produce a comprehensive range.

Extension tubes typically come in sets of three tubes of different lengths, which can be used individually or in any combination to obtain the desired magnification.

Note:
Not all extension tubes allow the use of autofocus, and even on those that do, capability may be compromised. Up to three stops of light can be lost by adding extension tubes between the camera and the lens. You may find that the AF starts to "hunt" due to this lack of light. If this happens, you will need to switch the camera to manual focus. Exposure will also need to be set using manual exposure mode.

LIGHTING FOR CLOSE-UP ≥
The problem of how to light a subject is solved when the subject is light, like the flame from a candle shown here.

Bellows work in much the same way as extension tubes, by increasing the distance between the camera and the lens. They are also free of glass, so do not impair the optical quality of the lens you are using.

Unlike extension tubes, bellows do not come in set lengths, but instead extend along a track system and are then locked in place at the required length. Since they are heavy and rather cumbersome, their use is usually confined to the studio, rather than being used outdoors.

They can also give rewarding results, with the right combination of lens and bellows offering magnification of the subject to many times life-size. As already mentioned, depth of field will be shallow when working with these methods, so ensuring that the subject can be kept motionless, and using a tripod, are crucial. There are no bellows made specifically for the A500 and A550 lens mount, but fitting an M42 adapter will allow bellows designed for that lens mount to be used.

› Reversing rings

A reversing ring allows the lens to be mounted in reverse on the camera, so that the front element of the lens is closest to the camera. This allows you to focus much more closely on the subject than normal, and can be especially useful if you are using a standard, rather than a macro, lens. Reversing rings are lightweight and inexpensive, and allow the use of lenses from systems that would not otherwise be compatible.

> ### Tip
>
> *The M42 lens mount dates from 1949 and uses a simple, screw thread fitting. It is a manual focus system and no electronic information is transmitted between the lens and the camera. You will need to shoot in manual and set both the aperture (on the lens) and shutter speed yourself. However M42 lenses are worth persevering with as they are in plentiful supply second-hand and are generally a fraction of the price of a modern AF lens.*

HOME-MADE REFLECTOR ⌄
To light this fossilized trilobite evenly, I placed it on a lightbox and used sheets of paper to "bounce" the light back onto the body of the fossil.

» USING FLASH IN CLOSE-UP

Flash will often be necessary in macro work. As we have already seen, depth of field is often reduced to a minimum, invariably making small apertures necessary. This in turn means that a slow shutter speed will usually be needed, in order for sufficient light to reach the sensor. Using flash will mean that a faster shutter speed can be used, which is especially useful if your subject could be prone to slight movement.

> ### Tip
>
> *If you wish to undertake close-up or macro photography outdoors, you may wish to purchase a "light tent." This can be a cost-effective way of shielding your subject from the breeze, reducing movement that could ruin a shot. It also gives a diffused light, minimizing shadows. If you construct your own light tent, use neutral-tone fabric that will not reflect its color onto the subject.*

BEACH CURVES »
This photo of fronds of seaweed clinging to a rock was shot at the minimum focusing distance of my standard lens. Using an aperture of f/16 to ensure maximum depth of field, meant a shutter speed of ½ second, so I had no choice but to mount the camera on a tripod.

The Sony HVL-RLAM is a ring flash that has been designed specifically with Sony DSLRs in mind. It uses LED technology rather than the conventional flash tube. This produces a clear white light that provides accurate color reproduction. It has an effective working distance of between 4in and 20in (0.1 and 0.5m), making it perfect for macro work. The flash offers the option of lighting the whole unit, or just the right or left side, giving a high degree of creative control over shadow effects.

» MACRO LENSES

Using a dedicated macro lens will enable you to use both auto-exposure and auto-focus. Sony currently produces three macro lenses for the **α** system. All three are fixed focal-length lenses offering 1:1 magnification and yet they can also be used as conventional primes.

The least expensive of the trio is the f/2.8 30mm DT lens (SAL-30M28). This is a recent addition to the Sony lineup and was designed for use with APS-C sensor cameras. It utilizes the faster and quieter SAM AF system and is capable of focusing down to 0.7in (2cm).

30mm DT f/2.8 lens

50mm f/2.8 lens

100mm f/2.8 lens

Next in the Sony range of macro lenses is the f/2.8 50mm (SAL-50M28). It's a far more expensive and weighty proposition than the 30mm macro lens. It has more refinements that the 30mm, such as focus hold and the option of a focus limiter (to prevent the lens from traveling the full distance of its focus range when used as a conventional prime). The minimum focusing distance of 7.8in (20cm) is considerably farther than the 30mm lens, but this is not a drawback because the working distance is greater.

The last lens in the Sony range is the f/2.8 100m lens (SAL-100M28). Like its 50mm sibling, it is more expensive than the 30mm lens and is heavier than both combined. It also has focus hold and the option of a focus limiter. A feature shared with the 50mm lens is a non-rotating manual-focus ring during autofocus. This will be of benefit to filter users who do not want filters such as polarizers to rotate once they've been aligned correctly. The minimum focusing distance of the 100mm lens is 13.7in (35cm), but once again the working distance is greater than either the 30mm or 50mm lens.

FUEL GAUGE
Interesting details are to be found everywhere, even in something as commonplace as a car dashboard. Even though this is a very simple subject, there is still a story to be told in the picture. The fuel gauge is close to empty. This could imply any number of things and it is up to the viewer of the photograph to "write" the story for himself.

Chapter 6
LENSES

6 LENSES

Sony's lineup of lenses has a heritage dating back to before the development of DSLRs. Many of the lenses that Sony produces for its ranges of cameras were originally designed by Konica Minolta. This means that there is a large number of lenses available secondhand that should be compatible with the Sony A500 and A550.

» LENS RANGES

Sony's range of lenses currently numbers 28 and includes some types unique to the company, such as the auto-focusing 500mm mirror lens, and encompasses lenses designed specifically for the APS-C cameras as well as rugged, professional quality lenses built for day-in, day-out use.

› DT lenses

The DT (or Digital Technology) range of lenses is designed specifically for APS-C sensor cameras such as the A500 and A550. Up until 2008 every DSLR camera in the Sony lineup used an APS-C sensor. This changed with the introduction of the full-frame 24.6mp A900 camera in September 2008. Should you ever contemplate upgrading to the A900 (or the newer A850), it is worth noting that only a cropped 11mp image will be produced by mating a DT lens with this camera. The DT lenses are typically the least expensive in the Sony range and are zooms that are light in weight with relatively small maximum apertures. The exceptions to this general rule are the high-quality (and therefore more expensive) Carl Zeiss 16–80mm lens and the 30mm macro and 50mm f/1.8 prime lenses.

› SAM & SSM lenses

SAM is short for Smooth Autofocus Motor, SSM for Supersonic-Wave Motor. A SAM or SSM designated lens has an inbuilt auto focus (AF) drive. Prior to the introduction of SAM and SSM lenses, the motor to drive the autofocus was housed in the camera body. Although all current Sony cameras have an autofocus motor inside the body, this is now mainly for backward-compatibility with non-SAM and SSM lenses. The advantages claimed for the two systems are a faster, smoother, and quieter autofocus.

50mm DT f/1.8 lens

› G lenses

Each camera manufacturer produces a range of lenses aimed at well-heeled amateurs and professional photographers. These lenses are typically more expensive than the manufacturer's "consumer" lenses and are built to a higher standard with better quality materials. These lenses also tend to have larger maximum apertures and are therefore heavier and larger than an equivalent consumer lens. The G-series is Sony's range of professional lenses, the G standing for Gold. Konica Minolta originally introduced the G designation and lenses from this stable are equally as well regarded.

G lens 70–400mm f/4–5.6 G SSM

› Carl Zeiss lenses

Although the number of Carl Zeiss lenses for the Sony α lens mount is still relatively small, the range has quickly gained a reputation for outstanding quality of construction and image quality. Once again, this quality comes at a price and

Carl Zeiss lenses are among the most expensive of the Sony range. Unique to the Carl Zeiss lens range is the T* coating on the optical surfaces that allows higher light transmission with minimal flare and ghosting.

16–35mm f/2.8 ZA SSM Vario-Sonnar T* lens

› Konica Minolta lenses

It is possible to use older Konica Minolta lenses on the A500 and A550. However, there are some lens designations no longer used by Sony. The HS, or High Speed series introduced by Konica Minolta in 1998, used a (then) new motor system to drive the lens autofocus. Though not as quiet as the later SAM/SSM system, it is regarded as being almost as fast and precise. Another range no longer made by Sony is Konica Minolta's xi series. These lenses used a motor for zooming and focusing—both functions controlled in-camera. Although the camera cannot use the motor-zoom function, the xi series was highly regarded optically and is worth considering as a secondhand purchase.

» FOCAL LENGTH

The focal length of a lens is the distance in millimeters from the optical center of the lens to the focal plane when a subject at infinity is in focus. The focal plane is where the sensor in the A500 and A550 lies. This is shown on the outside of the camera by the ⊖ mark next to the mode dial. The focal length of a lens never changes regardless of the camera it is mounted to. A lens with a focal length of 50mm is always a 50mm lens. Lenses are either of a fixed focal length, commonly referred to as a "prime" lens, or have a variable focal length, or zoom lens.

SNOWY NORTHUMBERLAND ⥯
These images show what a difference using two lenses of different focal lengths makes to a composition. Without moving the camera, the photo on the left was shot with my standard zoom set to 26mm. The photo on the right was shot with my telephoto zoom set to 80mm.

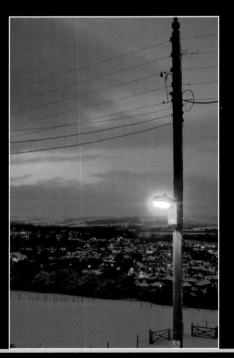
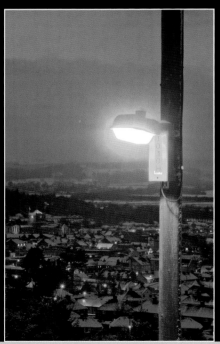

» LENS PROPERTIES

› Angle of view

The angle (or field) of view of a lens is the angular extent of the image projected by the lens and recorded by the film or sensor in the camera. The angle of view is expressed in degrees (°) and can refer to either the horizontal, vertical, or diagonal coverage of the lens. Typically, if you see one angle of view figure it will refer to the diagonal angle of view. The angle of view figure is dependent on the focal length of a lens and the size of the sensor or film that records the image that is projected by that lens.

A lens with a short focal length reduces the size of the image projected onto the sensor. This results in more of the scene being captured by the sensor. Or, to put it another way, the angle of view captured is greater. This is why short focal length lenses are referred to as wide-angle lenses. The longer the focal length of a lens, the smaller the angle of view, but the greater the size of the image projected onto the sensor. This is why a telephoto lens appears to bring distant objects closer to you.

› Crop factor

Until the advent of the DSLR, the standard size of a negative or transparency familiar to most people was 35mm. The economics of making a digital sensor the size of a 35mm frame were prohibitive when DSLRs were first produced. Initially most sensors were made the size of another film format called APS-C.

This format is smaller than 35mm, which causes the angle of view of a lens to be reduced. The crop factor is a figure that tells us how much the angle of view is reduced between the two formats. The Sony A500 and A550 has a crop factor of 1.5x. A lens that has an angle of view of 48° on a 35mm or full-frame camera will have an angle of view of 32° on an APS-C camera. In essence what this means is that a lens will appear to have a longer focal length on an APS-C camera than if used on a 35mm or full-frame camera. Note, however, that the focal length of the lens does not change only the angle of view.

RELATIVE VIEWPOINTS ⌄
Shot on a full-frame camera with a 20mm lens, the inner rectangle shows the angle of view with the same lens on an APS-C DSLR.

» STANDARD LENSES

In "full-frame" terms, a 50mm lens is considered to be a "standard" lens, because it is the one whose angle of view most closely approximates that of the human eye. In the days before zoom lenses, the standard lens would typically have been complemented in a photographer's kit by a wide-angle lens of 28mm or 35mm, and a telephoto lens of perhaps 135mm.

The A500 and A550 use an APS-C size sensor so the focal length that most closely approximates the angle of view of the 50mm standard lens is 33mm.

The 18–55mm kit lens that is commonly sold with the cameras straddles the traditional standard focal length. Sony also produces a 35mm prime lens that could be considered the equivalent to the traditional 50mm standard lens.

Sony f/1.4 35mm lens

《 FISHERMAN, ZANZIBAR
This portrait of a fisherman's catch was shot with a standard prime lens. The perspective of this lens closely matches that of the human eye and so makes the image look more "natural" than it would with a wide-angle lens.

A wide-angle lens is a lens with a wider angle of view than a standard lens. On a "full-frame" camera, this would be a lens that has a focal length of 28mm.

Because of the crop factor, the 18–55mm kit lens that is commonly bundled with the two cameras has an equivalent angle-of-view range to a 27–82.5mm lens on a full-frame camera. This is close to the 28mm wide-angle definition of a wide-angle lens. For those who want a lens with a greater angle of view, Sony has recently introduced an 11–18mm super wide-angle lens for the A500 and A550 that is close to matching the extreme angle of view of a fisheye lens.

The wider the lens, the more unnatural the perspective of an image can look, particularly with images of people. Landscape photographers commonly use wide-angle lenses to create a sense of space or when working close to a subject to emphasize the subject in relation to its surroundings. Another use for a wide-angle lens is the situation where there may be little space to work, such as an interior.

A MATTER OF PERSPECTIVE
Setting my camera inches from the rocks on this beach in Northumberland has allowed me to make the most of the dramatic perspective properties of the wide-angle lens.

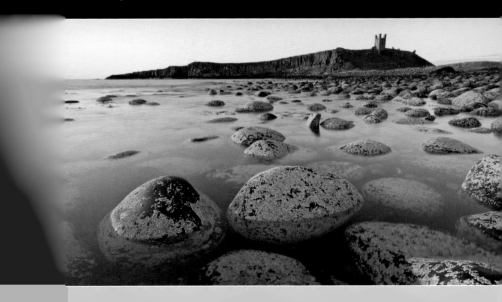

» TELEPHOTO LENSES

Telephoto lenses are popularly known for magnifying distant objects, thereby reducing the need for you to get close to the scene you are trying to shoot. This makes them particularly useful if you are wildlife photographer, and need to be able to keep at a discreet distance to avoid disturbing your subject, or if you wish to undertake candid people shots.

Telephotos are also commonly used in portrait photography, since the subject may feel more comfortable with the camera at a greater distance, and they tend to give a more natural-looking result than wider-angle lenses.

In the landscape, telephoto lenses tend to be less useful, because of their limited depth of field. However, their relatively shallow depth of field can create some very attractive effects in other situations.

The out-of-focus background that is created, known as "bokeh" (from the Japanese word for "blur" or "haze"), can be an attractive foil to the subject of the image. How smooth this background is will be related to the number of blades in the diaphragm of the lens, and how closely they come to creating a circle. Sony prides itself on creating telephoto lenses with circular diaphragms, giving background image highlights smooth, rounded edges.

Because of their size and added weight, telephoto lenses of longer focal lengths are very difficult to handhold. In addition, because of their narrow angle of view, any movement will be exaggerated in the shot. While high shutter speeds and the SteadyShot function will help, ultimately the only way of guaranteeing sharp images is to use a tripod. Some of Sony's longer telephoto lenses have their own mount-collars for added stability when attached to a tripod.

Sony 300mm f/2.8 G lens with a tripod mount-collar

6 » PRIME LENSES

A prime lens is one that has a single, fixed focal length, such as 28mm, 50mm, or 200mm. They contrast with zoom lenses, which offer a range of focal lengths, such as 24–70mm or 70–200mm.

Traditionally, photographers have favored prime lenses over zooms for their optical quality and simplicity. Although the modern zoom lens is capable of outstanding optical quality, prime lenses still have their place in the kit bag.

Some people find that prime lenses help to improve them as photographers: more thought and creativity must be given to the composition and setting up of each shot, in the absence of the possibility of simply adjusting the focal length with a zoom lens.

Sony produces a number of primes in a variety of focal lengths for the α lens mount. From a 16mm wide-angle (which will be super-wide on a full-frame camera) to the specialist 500mm reflex *(see page 188)* there is a prime lens to suit every style of photography.

Sony f/2.8 135mm prime lens

Sony f/2.8 20mm prime lens

A "zoom" is a lens with a variable focal length, such as the Sony 55–200mm f/4–5.6 lens. With just one or two zoom lenses, you can often cover the entire focal length range you'll ever usefully need. This can make a camera bag considerably lighter than if that focal length range were covered by prime lenses only.

Zooms were once disparaged as not matching the optical quality of a good prime lens. However, modern zooms are now generally so good that it is often difficult to tell if an image has been shot with a zoom or a prime lens.

The one advantage a prime lens still has over a zoom is the size of the maximum aperture. A prime lens with a maximum aperture of f/1.4 or f/2.8 is not uncommon. However, a zoom lens with a similar maximum aperture would be very expensive and extremely unwieldy.

« DOOR DETAIL
Using a zoom lens with a useful range means changing the lens less often, allowing you to concentrate on the creative side of your photography.

The 18–55mm kit lens that is available with the A500 and A550 focuses down to 0.25m with a magnification of 0.34. However, it is not a true macro lens, which is generally defined as a lens that offers a magnification of 1. Sony does make a number of lenses (all primes) that offer true macro capability. *(See pages 172–3 for further information about Sony's lineup of macro lenses.)*

Sony 100mm f/2.8 Macro Lens

« DANISH PASTRY
Interesting macro shots can be found anywhere, even when taking a break in a coffee shop!

» TELECONVERTERS

A teleconverter fits between a camera body and a lens, and extends the focal length of the lens by a given factor. Sony makes two teleconverters for the α lens mount. The first is a 1.4x teleconverter that will increase the lens focal length by a factor of 1.4. The second is a 2x teleconverter that will increase the lens focal length by a factor of 2.

Teleconverters are a useful way to make your lens collection more versatile at a relatively low cost. However, teleconverters have two drawbacks. By adding more complexity to the lens system, image quality is inevitably degraded. Adding a teleconverter also causes light to be lost. The 1.4x teleconverter loses one stop of light, the 2x loses two stops.

SAL-14TC

SAL-20TC

Tips

The smaller the maximum aperture of a lens, the less likely that autofocus will work effectively. A lens with an aperture of f/5.6 becomes an f/11 lens with a 2x teleconverter added.

Only selected Sony lenses work with the teleconverters, specifically; 70-200mm f2.8G, 300mm f2.8, and the 135mm f2.8 (T4.5) STF (using manual focus only) lenses.

Teleconverter	Sony Product Code	Specifications	Dimensions: (diameter x length)	Weight
1.4x	SAL-14TC	Lens group elements: 4-5	64 x 20mm	5.9oz (170g)
2x	SAL-20TC	Lens group elements: 5-6	64 x 43.5mm	7.05oz (200g)

» REFLEX LENSES

The longer the focal length of a lens, the longer, heavier, and more expensive the lens becomes. A reflex lens (also known as a mirror or catadioptric lens) is far smaller, lighter, and cheaper than an equivalent conventional lens. It achieves this by using a series of mirrors to focus light instead of a glass lens. Sony produces a 500mm reflex lens (product code SAL-500F80) that is unique in comparison with other reflex lenses in that is it the only lens of this type to autofocus.

Unlike a standard lens, a reflex lens has a fixed aperture. The Sony reflex lens has an aperture of f/8, which will result in a dim image when looking through the viewfinder. The other distinctive feature of the reflex lens is the donut shape of out-of-focus highlights. Whether this is an acceptable compromise for a lightweight alternative to an equivalent conventional lens is a matter of taste and finance.

Sony 500mm Reflex Lens

» MODERN LENS TECHNOLOGY

Sony and Carl Zeiss employ a number of technologies to improve the optical quality, handling, and focusing capabilities of their lens ranges. The following describes these features.

› T* coating

Lens coatings help to minimize reflections on the lens glass and ensure a greater light transmission with a reduction in flare and image ghosting. T* coating is the Carl Zeiss name for their coating system and is only used on their lenses.

Main benefit Less chance of lens flare.

› CA—Circular aperture

A lens aperture iris is made up of a number of blades that form a polygonal shape. Out-of-focus areas in an image take on this shape. The greater the number of blades, the more circular the aperture and the less noticeable the individual shapes.

Main benefit More natural looking out-of-focus areas.

› G-Series

Sony's top-of-the-range lenses with superb
build quality and high-performance class
optics. They are designed for professional
use and as such are generally more costly
than equivalent consumer lenses in the
Sony lineup.
Main benefit Superb optical quality.

› Direct manual focus

Autofocus can sometimes struggle to lock
onto fast moving subjects. DMF is a quick
way to override the autofocus to allow
manual fine adjustment of focusing.
Main benefit Allows you to take control
of focusing even when the camera set to AF.

› Focus hold

The focus hold button can be used to
temporarily disable autofocus without the
need to switch it off using the main switch
on the camera or lens.
Main benefit AF is not permanently
switched off, so you don't need to
remember to switch it back on later.

› SSM and SAM

SSM (Supersonic-Wave Motor) and SAM
(Smooth Autofocus Motor) lenses have
the motor to drive the autofocus built into
the lens rather than relying on a motor
built into the camera. The motor is a
piezo-electric type characterized by quick
start and stop responses. This enables the
lens AF system to be faster, more accurate,
and quieter than the previous camera-
based system.
Main benefit Improved autofocus.

› Anomalous Dispersion (AD) glass

All lenses suffer to certain extent from
chromatic aberration *(see page 134)*.
AD glass has a low refractive index and is
designed to reduce chromatic aberration
to a minimum.
Main benefit Improved image quality
over conventional glass elements.

› Floating-focusing

The extension of the focusing element of
a conventional lens degrades the image
quality at close focusing distances by
causing astigmatic aberration and

curvature. This particularly affects wide-angle lenses. In a lens with floating-focusing a separate glass element is used to correct for this aberration.

Main benefit Improved image quality at close focusing distances.

› Aspheric elements

Light passing through the central area of a lens cannot always be focused at precisely the same distance as light passing through the edge. This will cause uneven image sharpness and color fringing across the image. Aspherical lens elements help to optimize the focus of light evenly across the lens.

Main benefit Clarity and sharpness of the image are improved and aberrations are reduced.

› IF—internal focus

An internal focus lens achieves focus without rotating or moving the front lens element. It manages this by moving an internal lens element group or groups only. This is useful when using filters on the front of the lens, as the alignment of the filters will not be altered during focusing. Another area in which IF is of benefit is when shooting macro subjects. With an IF lens you know that the front lens element

will not extend during focusing and disturb the subject.

Main benefit Filter alignment not altered.

› Focus range limiter

Mainly found on macro lenses, the focus range limiter is a switch that forces the lens to only try to autofocus between a selected range of the possible focusing distances of the lens.

Main benefit Is designed to speed up autofocus operations.

› Tripod collar

When a camera is attached to a long, heavy lens, the center of gravity is shifted away from the camera to somewhere close to the far end of the lens. When the camera and lens are mounted on a tripod, this can make the combination unstable and place a strain on the camera lens mount. A lens with a tripod collar allows you mount the tripod to the lens not the camera. This helps to lessen the strain on the camera lens mount and makes the setup more stable.

Main benefit Reduces the chance of unsharp images and potential damage to the camera.

Settings

> › Aperture Priority
> › ISO 200
> › 1/4 sec. at f/16
> › White balance: 5500°K
> › 18mm lens

SERENDIPITY »

I actually had another shot visualized when I began setting up my camera on this summer morning on an English beach. Unfortunately, another photographer walked straight across my shot and ruined it! However, with his line of footprints making an interesting curve across the sand, I realized I now had a better image than before. Quickly recomposing, and using a wide-angle lens, I shot this photo before the figure vanished out of the shot.

6 » LENS COMPATIBILITY CHART

Lens Name	Sony Product Code	35mm equivalent focal length
11–18mm f/4.5–5.6 DT	SAL-1118	16.5–27
16–105mm f/3.5–5.6 DT	SAL-16105	24–157.5
16–35mm f/2.8 Carl Zeiss Vario-Sonnar T*	SAL-1635Z	24–53
16–80mm f/3.5–4.5 DT Carl Zeiss Vario-Sonnar T*	SAL-1680Z	24–120
18–200mm f/3.5–6.3 DT	SAL-18200	27–300
18–250mm f/3.5–6.3 DT	SAL-18250	27–375
18–55mm f/3.5–5.6 DT SAM	SAL-1855	27–82.5
24–70mm f/2.8 ZA Carl Zeiss Vario Sonnar T*	SAL-2470Z	36–105
28–75mm f/2.8 SAM	SAL-2875	42–112.5
55–200mm f/4–5.6 DT SAM	SAL-55200-2	82.5–300
70–200mm f/2.8 G	SAL-70200G	105–300
70–300mm f/4.5–5.6 G	SAL-70300G	105–450
70–400mm f/4–5.6 G	SAL-70400G	105–600
75–300mm f/4.5 5.6	SAL-75300	112.5–450
30mm f/2.8 Macro DT	SAL-30M28	45
50mm f/2.8 Macro	SAL-50M28	75
100mm f/2.8 Macro	SAL-100M28	150
16mm f/2.8 Fisheye	SAL-16F28	24
20mm f/2.8	SAL-20F28	30
28mm f/2.8	SAL-28F28	42
35mm f/1.4 G	SAL-35F14G	52.5
50mm f/1.4	SAL-50F14	75
50mm f/1.8 SAM	SAL-50F18	75
85mm f/1.4 Carl Zeiss Planar T*	SAL-85F14Z	127.5
135mm f/1.8 Carl Zeiss Sonnar T*	SAL-135F18Z	202.5
135mm f/2.8 (T4.5) STF	SAL-135F28	202.5
300mm f/2.8 G	SAL-300F28G	450
500mm f/8 Reflex	SAL-500F80	750

Angle of view	Minimum focus distance (meters)	Minimum aperture	Maximum magnification	Filter thread size	Dimensions (max. diam. x length; mm)	Weight (g)
104–76	0.25	22–29	0.125	77	83 x 80.5	360
83–15	0.4	22–36	0.23	62	72 x 83	470
83–44	0.28	22	0.24	77	83 x 114	900
83–20	0.35	22–29	0.24	62	72 x 83	445
76–8	0.45	22–40	0.27	62	73 x 85.5	405
76–6.3	0.45	22–40	0.29	62	75 x 86	440
76–29	0.25	22–36	0.34	55	69.5 x 69	210
61–23	0.34	22	0.25	77	83 x 111	955
54–21	0.38	32	0.22	67	77 x 94	565
29–8	0.95	32–45	0.29	55	71.5 x 85	305
34–12.3	1.2	32	0.21	77	87 x 196.5	1340
34–8.1	1.2	22–29	0.25	62	82.5 x 135.5	760
34–6.1	1.5	22–32	0.27	77	94.5 x 196	1490
21–5.2	1.5	32–38	0.25	55	71 x 122	460
50	0.129	22	1	49	70 x 45	150
32	0.2	32	1	55	71.5 x 60	295
16	0.35	32	1	55	75 x 98.5	505
110	0.2	22	0.15	integrated	75 x 66.5	400
70	0.25	22	0.13	72	78 x 53.5	285
54	0.3	22	0.13	49	65.5 x 42.5	185
44	0.3	22	0.2	55	69 x 76	510
32	0.45	22	0.15	55	65.5 x 43	220
32	0.34	22	0.2	49	70 x 45	170
19	0.85	22	0.13	72	81.5 x 72.5	560
12	0.72	22	0.25	77	88.5 x 115	1050
12	0.87	32	0.25	72	80 x 99	730
8.1	2.0	32	0.18	dedicated	122 x 242.5	2310
3.10	4	8	0.13	55	89 x 118	665

Chapter 7
ACCESSORIES

7 ACCESSORIES

The range of accessories made by Sony for your camera can seem bewildering at first. Add to the list accessories made by third parties and equipment made for Konica Minolta cameras that is still available secondhand, and the choice is more confusing still. However, before buying an optional accessory, it is worth thinking hard about how it will improve your photography. Many accessories that seemed a good idea at the time often end up left at the back of a cabinet gathering dust.

» FILTERS

A filter is a piece of glass, gelatin, or optical resin that affects the light hitting the camera sensor in a subtle—or sometimes not so subtle—way.

Filters that were once necessary for film cameras are now no longer needed. Color correction filters such as the 80 series, which corrected for the orange color of tungsten lighting, have been superseded by the white balance settings of digital cameras (see pages 76–8). In many ways, this is a good thing, since adding filters to the front of a lens inevitably leads to some degrading of the final photo. The more filters that are used the more this loss of quality is exacerbated.

However, filters still have their uses, and some have an effect on an image that cannot be duplicated either in camera or later using photo-editing software. Filters vary in price depending on the quality of the materials used. If you think that filters will become an important part of your photographic equipment, it is worth spending time researching what is available and spending more on a good quality set that will delight rather than disappoint.

CONTROLLING THE SKY »
The trick to using filters successfully is to make it look as though they weren't used in the creation of the image. In this photo, I used a polarizing filter and a two-stop neutral-density graduate filter to balance the exposure of the sky with the moorland scene. Too strong an ND graduate filter would have darkened the sky too much and made it look unnatural.

7 » FILTER TYPES

Filters are generally either circular with a threaded frame, which allows you to screw them onto the front of a lens, or square (or rectangular) and designed to fit into a slotted holder attached to the lens. A third type, drop-in filters, are relatively uncommon and are used at the back of lenses that have protruding front elements.

Circular filters are typically made of high-quality optical glass. One disadvantage they have is that you may find that, as your lens collection grows, each lens has a different size filter thread. Unless you were to use step-up or step-down adapter rings, you would be forced to buy the same filter several times, one for each lens. The filter thread sizes for all of Sony's lenses can be found in the lens chart on page 192–193. Sony produces a range of circular filters for the A500 and A550: see the filter chart on page 202 for types and their filter thread sizes.

Filters designed to fit into a holder are typically made of optical resin or gelatin. There are several manufacturers of filter holder systems, such as Cokin, and the highly regarded British company, Lee. Inexpensive adapter rings allow you to use the same filter holder (and filters) on virtually any lens you own, or are contemplating buying. The disadvantage system filters have is that, once you have bought into a system, you may find that only filters made by the same manufacturer will fit into the holder.

› UV or Skylight

Both filters absorb ultraviolet light, which can cause an excessive blue cast in an image. This effect is most noticeable at high altitude and on hazy days. The UV filter is more neutral than the skylight filter, which is slightly pink in color. There is little light loss when using these filters, so exposure will be unaffected. Because of this some photographers also use these filters to protect the front of their lenses. This is done on the basis that an accident that damages the filter is better than one that damages the lens. It's a sensible approach, but bear in mind that the more filters you use, the more chance the quality of your images will decrease.

Sony circular filters »
Top: Polarizer
Middle: MC (multi-coated) Protector
Bottom: Neutral Density

› Polarizing filters

We've all seen the classic tourist brochure scenic photo: a sunny day with white clouds lazily drifting across a deep blue sky. It's more than likely that the blueness of the sky was achieved through the use of a polarizing filter. The filter is most effective when pointed at 90° to the sun, with diminishing effect as you move away from this angle. At 180° to the sun, the polarizer will have no effect whatsoever on the blueness of the sky. The height of the sun will also affect how strongly the polarizing filter appears to work.

MULTIPLE USES FOR A POLARIZER ⌄
The use of a polarizing filter allowed me to deepen the density of the blue sky over this woodland. I had to use a longer shutter speed to compensate for the light loss in using the filter. This captured the sense of movement of the trees swaying in the breeze more successfully.

The glass part of the filter is mounted in a holder that can be rotated through 360°. This allows you to vary the strength of the effect by rotating the holder. It is possible to darken a sky to the point where it is almost black. Unless this was an effect you were looking for, rotating the filter further will reduce the strength of polarization, making the sky look more natural.

Another use for the polarizing filter is to control the amount of light reflected from non-metallic surfaces. This includes water, shiny paint, even the leaves of trees. The effect is noticeable even on overcast days and not just when the sun is shining.

A polarizing filter reduces the amount of light reaching the sensor so the exposure will need to be changed if you are shooting using manual exposure. The amount of exposure compensation will vary, but two stops is a good starting point.

> *Tip*
>
> *Polarizing filters are available as either linear or circular. This has nothing to do with the shape of the filter: for technical reasons linear polarizers are only really suitable for manual focus cameras. If you intend to buy a polarizing filter for your camera, you should buy the circular type.*

There are occasions when the A500 and A550 base ISO of 200 is still too sensitive to use a particular shutter speed/aperture combination. Using a slow shutter speed is particularly difficult on a bright, sunny day, for example.

Neutral density (ND) filters are a bit like sunglasses for cameras in that they reduce the amount of light entering the lens and so allow longer shutter speeds or larger apertures than could ordinarily be used. As the name suggests, they are neutral in color and so do not affect the natural colors in the image. ND filters come in a variety of strengths from 1 stop to 10 stops (resulting in a filter that looks almost opaque) and are available either as a circular screw-in type, or square to fit a filter holder.

An ND graduate is a filter that is transparent on one half shading to neutral density on the other half. ND graduates come in a variety of strengths and are mainly used in landscape photography to balance the exposure when a sky is much brighter than the foreground.

> ### Tip
>
> *A polarizing filter can be used as an alternative to an ND filter, and will reduce exposure by about two stops.*

INCOMING TIDE ⌄

The use of an ND filter allowed me to increase the length of exposure, ensuring that the movement of the waves washing onto this beach recorded as an interesting blur.

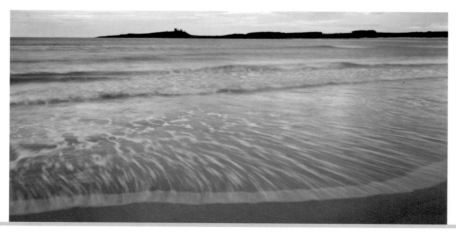

› Special effects filters

There was a fashion in the 1980s for using—or overusing, depending on your taste—special effects filters such as starburst filters, and strong color filters such as the tobacco filter. Like wearing flares and sandals, these filters are now rather unfashionable, although of course that doesn't mean they won't become popular again. Some of the color filters are probably unnecessary now, since their effects can be replicated in photo editing software. However, there is nothing wrong with experimenting with effects filters and, who knows, you may even be at the head of a nostalgic revival.

ROMANTIC HAZE ⌄
Effects filters don't need to be expensive. Here I used a crumpled clear plastic bag taped to the front of the lens to soften the scene and make it more "romantic."

> ### Tip
>
> *It is not necessary to buy expensive filters to have fun. A DIY approach can be even more rewarding, particularly if you can come up with an interesting effect that costs virtually nothing. For example, stretching material from nylon pantyhose over the lens will give a soft-focus effect to an image. Just be sure to ask permission from the original owner first!*

Type	Sony product code	Filter thread size
Multi-coated protection	VF-49MPAM	49mm
Multi-coated protection	VF-55MPAM	55mm
Multi-coated protection	VF-62MPAM	62mm
Multi-coated protection	VF-67MPAM	67mm
Multi-coated protection	VF-72MPAM	72mm
Multi-coated protection	VF-77MPAM	77mm
Circular Polarizer	VF-49CPAM	49mm
Circular Polarizer	VF-55CPAM	55mm
Circular Polarizer	VF-62CPAM	62mm
Circular Polarizer	VF-67CPAM	67mm
Circular Polarizer	VF-72CPAM	72mm
Circular Polarizer	VF-77CPAM	77mm
Neutral Density	VF-49NDAM	49mm
Neutral Density	VF-55NDAM	55mm
Neutral Density	VF-62NDAM	62mm
Neutral Density	VF-67NDAM	67mm
Neutral Density	VF-72NDAM	72mm
Neutral Density	VF-77NDAM	77mm

» CAMERA PERFORMANCE

› Essential accessories

Sony makes a range of accessories for the A500 and A550 that will either make your photographic life easier or help to improve your photography.

› NP-FH50 battery

There are few things more frustrating than a depleted battery during a photographic session. A spare battery is a useful addition to your equipment, particularly if you rely on the Live View option on the A500 and A550. LCD screens are notoriously power-hungry and using them frequently will quickly deplete a battery.

› Bodycap

The bodycap should be replaced when the camera lens is removed to reduce the risk of dirt and dust entering the interior of the camera.

› Diopter adjustment

Although the A500 and A550 allow you to change the diopter of the eyepiece, the range of adjustment may not be enough for your eyesight. Sony produces a series of eyepiece lenses that range between -4 and +3 diopters.

» OPTIONAL ACCESSORIES

› ACPW10AM AC adapter

Used to power the camera from an AC mains source, the AC adapter allows continuous shooting.

Sony ACPW10AM AC adapter

› SH-L2AM LCD protector

Although the LCD screen of the A500 and A550 is reasonably scratch proof, this hinged plastic cover will offer complete protection.

SH−L2AM LCD protector

› VG-B50AM vertical grip

The addition of a vertical grip makes the A500 and A550 easier to handhold vertically —this is particularly useful when shooting portraits. The main controls are duplicated on the grip and two NP-FM500H batteries can be stored internally to power the camera for extended shooting sessions.

VG-B50AM vertical grip

› FDA-A1AM angle finder

This device allows you to look through the eyepiece of your camera from above or from the side, which is useful when the camera is low to the ground. It can also be used as a magnifier to allow more accurate manual focusing, which is particularly useful with macro shots.

FDA-A1AM angle finder

› Remote commander

An electronic version of the traditional cable release, the RM-S1AM and RM-L1AM allow you operate the A500 and A550 remotely from a distance of 1.67ft/0.5m (RM-S1AM) to 16.4ft/5m (RM-L1AM). The RMT-DSLR1 wireless remote commander can also be used with the A500 and A550 for untethered shooting.

RM-L1AM remote commander

› FDA-M1AM magnifier

Increases the magnification of the eyepiece by 2.3 times with a diopter adjustment: -7.5 to +3.1.

» STORAGE

› Memory cards

The A500 and A550 can switch between a Memory Stick and an SD card. If you have both cards fitted in the camera, this will double your potential storage space. However, even with two cards, it is possible to quickly fill the available space, particularly if you are on a long trip. Fortunately, memory cards are relatively cheap and each year larger-capacity types are introduced. It is worth carrying a couple of spare cards; you never know when you may need them.

› Other storage devices

If you are away from home for a long period of time, it is advisable to backup your memory cards. Losing precious images because of a faulty memory card, or even due to accidental erasure, can be avoided if you regularly copy the contents of the card to a laptop or a portable storage device. A laptop is the more expensive and bulky option, but would allow you to review your photos, carry out basic image editing, and burn the files to CD or DVD for increased protection.

A portable storage device, such as the P-6000 Multimedia Photo Viewer made by Epson, is smaller and lighter than a laptop. As with a laptop, the images are stored on a small hard drive, and some of the more expensive devices have a small color LCD screen for basic image viewing. Unlike a laptop, there is no way to burn a disk for extra security. Another option is to copy your images to an MP3 player such as an iPod, if the device supports file transfers from a camera or card reader.

Epson P-6000 Multimedia Photo Viewer

» SUPPORTING THE CAMERA

Recent developments in digital camera technology have gone some way to reducing the need for additional support for the camera. The SteadyShot function of the Sony A500 and A550 can reduce the effects of camera shake by up to 3.5 increments of shutter speed, which will enable you to capture sharp images at slower shutter speeds.

In addition, the Noise Reduction facility, which combats the grainy noise that is a typical bi-product of the long exposure, enables a higher ISO setting to be used, again reducing the need for additional camera support.

However, there are times when there is no alternative to using a tripod or other form of camera support. Very long exposures will only work effectively with additional support, because the camera must be kept still for the shot to be sharp.

You may imagine that using a tripod will be a barrier to your spontaneity and creativity, because of the time it takes to set up the camera on the tripod. However, in reality, this process of slowing down can actually be very helpful. You may find that in slowing down, you take more time to look at your subject and consider more closely the shot you are setting up, leading to more pleasing images.

› Tripods

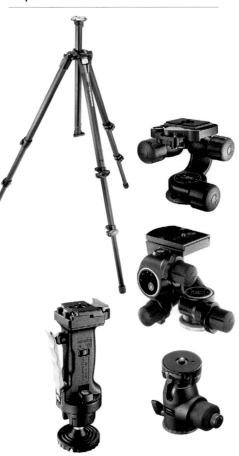

Manfrotto 055 CX3 tripod with a selection of optional heads

The tripod is the most popular and varied form of support for a camera. When choosing a tripod that will be suitable for your needs, you should consider its weight and leg-length, the type of feet you will need, and the leg-angles that are possible.

Weight is important in adding stability to the tripod, especially in the landscape, where you may be exposed to windy conditions that could still cause the camera to shake. You also need to consider how far you will tend to carry your equipment; if you frequently walk for miles to capture fine landscape images, a heavy tripod is likely to become a burden. However, modern materials such as carbon fiber allow for the construction of sturdy, high quality tripods that are surprisingly light to carry.

The type of feet on your tripod is another consideration. Some tripods have spiked feet and others flat rubber feet. Again, you need to consider where you will be using your tripod. Spiked feet do add stability on soft ground, but will make you very unpopular in ancient churches and historic houses, since they may scratch precious floors. Rubber feet will certainly be more suitable in such situations.

The available leg-angle range of the tripod is also important, since the wider the angle that can be achieved, the more stable the tripod will be, resulting in sharper images.

A range of mini and tabletop tripods is now available. These offer an ideal lightweight and compact alternative for carrying around comfortably.

Sony makes a number of tripods for use with the A500 and A550, such as the VCT-1500L. Respected third-party tripod manufacturers include Manfrotto, Gitzo, and Velbon.

> ## Alternative supports

Apart from tripods, there is a myriad of other choices for keeping your camera stable and your images sharp.

The monopod, which has a single leg and can also be telescopic, is very light and easy to carry, and is useful when you might need to move around more easily than a tripod would allow. Other supports include clamps and suction cups, with integral camera mounting screws.

Tip

Although a tripod or other camera support offers a good way to avoid the blurring of an image through camera shake, it will not prevent blurring by the movement of the subject.

Chapter 8
CONNECTION

CONNECTION

To get the most out of your Sony camera, you will need to connect it to an external device such as a computer or printer in order to view, organize, and archive your images as either digital files or as prints. The A500 and A550 have connection options that make this an easy task.

› Color calibration

No matter how carefully you expose your photographs, or how accurate your white balance settings, unless your computer monitor is properly calibrated, you will not be able to see the true colors in your images accurately.

There are several ways to calibrate a monitor. The most precise way is to use a hardware color calibrator. These devices are now relatively inexpensive and are particularly useful if you intend to print your images. Combined with accurate profiles for your printer, calibrators can soon pay for themselves by saving on wasted print paper.

A cheaper way to calibrate your monitor is to use a software calibrator such as QuickGamma (PC), ColorSync *(left)*, or Display Calibration Assistant (Mac OS X). Although software calibration is less accurate than using a hardware calibrator, it is still better than no calibration at all.

› Computer requirements

The A500 and A550 ship with Image Data Converter SR 3.1 and Image Data Lightbox SR 2.1 *(below)*, both of which are compatible with Windows XP (SP3) and Vista (SP2), as well as Mac OS X (10.4/10.5). Also on the disk is Picture Motion Browser 4.3.01, which is Windows XP (SP3) and Vista (SP2) compatible only.

» CONNECTING TO A COMPUTER

› Installing the software

If you shoot RAW files rather than JPEG, you will need software to convert them to a more universally accepted file format such as TIFF or JPEG.

Sony supplies Image Data Converter SR to convert A500 and A550 .ARW RAW files, though other third-party converters are also available.

IF USING WINDOWS:

1) Log on as the Administrator.

2) Insert the Sony CD-ROM disk into the CD-ROM drive.

3) The software installation screen should appear automatically. If it does not, double click on the CD-ROM icon on My Computer and select "install.exe." If you are using Windows Vista, the AutoPlay screen may appear. Select "Run Install.exe" and follow the onscreen instructions to continue with the installation.

4) Select both Sony Image Data Suite and Sony Picture Utility and continue to follow the onscreen instructions.

5) Once the installation is complete, remove the CD-ROM.

6) The shortcut icons to the installed software should now be on your desktop.

IF USING MAC OS X:

1) Log on as the Administrator.

2) Insert the Sony CD-ROM disk into the CD-ROM drive.

3) Double-click on the "IDS_INST.pkg" file in the "MAC" folder.

4) Follow the onscreen instructions to install the software.

5) Once the installation is complete, remove the CD-ROM.

6) The installed software can now be found in the Applications folder of your Mac hard drive.

› Sony software

The A500 and A550 are bundled with
Image Data Converter SR, Image Data
Lightbox, and Picture Motion Browser (PC
only). Although these programs aren't as
sophisticated as professional packages such
as Adobe Photoshop, they will allow you to
view, adjust, and convert Sony RAW files,
and set up a simple database of images.
For an in-depth guide to the bundled
software, consult the comprehensive
online help notes that are accessible when
running the software.

IMAGE DATA CONVERTER SR ⌄

Allows you to make a variety of adjustments to
your photographs.

› Image Data Converter SR

Sony's .ARW RAW files will need to be
converted to a more universally accepted
file format for use with other software
packages. Image Data Converter will allow
you to open .ARW files, apply adjustments
to the image, and then export the altered
file as either a JPEG or TIFF.

Image Data Converter initially uses the
image settings applied to the RAW file at
the moment of capture. However, these
settings are not fixed as they are in a JPEG
and are merely the starting point for you
to make adjustments.

Image options that can applied
in-camera to JPEGs can also be applied to
RAW files using Image Data
Converter. These include
D-RangeOptimizer and the
various Creative Styles such as
Landscape and Vivid.
Adjustments that are not
available in-camera, but can be
made in Image Data Converter,
include the option to adjust the
tone curve of the image, and
the peripheral illumination to
correct for vignetting *(see
page 135).*

› Image Data Lightbox

If you simply wish to view or compare your .ARW RAW files, you will not be able to use Picture Viewer (Windows) or Preview (MAC OS X). Image Data Lightbox *(below)* will allow you to view, compare, and print your RAW files without the need to convert them to JPEG or TIFF.

› Picture Motion Browser

This PC-only software will manage the importing of images for you and add them to a user-friendly database. There are various easy ways to sort and search for images in the database such as the option to apply ratings to images and also tagging

them with simple keywords. Picture Motion Browser also allows you to apply some very basic image adjustments such as red-eye correction *(see page 154)*.

› Connecting the camera

1) On the camera, check that **USB Connection** on ✎ 2 is set to **Mass Storage** and that the memory card with the images you want to copy is inserted.

2) Switch the camera off.

3) Connect one end of the USB cable (provided with the camera) to the camera's ◆➞ USB terminal.

4) Connect the other end of the cable to the USB port on the computer.

5) Turn the camera on.

Warning!

Before connecting the camera to your computer, ensure that the camera battery is fully charged.

8 » COPYING FILES TO A COMPUTER

IF USING WINDOWS:

If the Picture Motion Browser software is installed, this can be used to import your images from the camera, otherwise:

1) When the camera is connected to your computer and switched on, the Autoplay dialogue box will appear.

2) Select "Open folder to view files" and then double-click on the "DCIM" folder.

3) Double-click on the folder containing your images.

4) Right-click on the image file(s) you want to transfer and select "copy."

5) Open the folder on your computer you want to copy to and then right-click inside this folder and select "paste."

6) Double-click on the "stop USB device" icon on the Window's taskbar and select ⟶ (USB Mass Storage Device), then "stop" to eject the camera.

7) Switch the camera off and unplug the USB cable.

IF USING MAC OS X:

1) Double click on the memory card icon on the desktop.

2) Double-click on the "DCIM" folder, then on the sub-folder within it that contains your images.

3) Right-click on the image file(s) you want to transfer and select "copy."

4) Open the folder on your computer you want to copy to, then right-click inside this folder and select "paste."

5) Right-click on the memory card icon on the desktop and select "eject."

6) Switch off the camera and unplug the USB cable.

FILE MANAGEMENT »
It doesn't take long for the photos on your computer to become unmanageable without a logical and expandable file structure. Although it may be tempting to use an arbitrary system only you can understand, there may come a time when you have so many images that even you won't be able to understand where particular files are.

» FILE FORMATS

A file is a block of stored information identified by a file name and an extension specific to a particular file type. Files can be opened, saved, deleted, compressed, moved from one folder to another folder, and transferred to another network device entirely.

A photographer still shooting film is likely to have filing cabinets full of slides or negatives. In a similar way, the digital photographer has virtual folders full of image files. The key to both approaches is to have a logical and expandable filing system. Before you create too many images, it is worth spending time thinking

about how and where all these files are to be stored on your computer. Copying all your images into one big folder is a recipe for disaster. After a while, finding a particular image will be like looking for a needle in a haystack. One possibility is to copy images into specific folders based on subject (e.g., animals), then, as a further refinement, creating still more specific sub-folders (e.g., animals/dogs/labradors).

Once your image collection begins to build, it is also important to create backups on a regular basis. External hard drives are relatively cheap now and are a worthwhile investment, certainly once you consider how valuable your images are to you. For further peace of mind, keeping a second external hard drive at a friend's or relative's house has much to recommend it.

The A500 and A550 can create two different file formats when capturing an image. These two file formats both have advantages and disadvantages, and what format is used will be determined by factors such as memory card space and the ultimate use of the final image.

It would be wonderful to have unlimited storage space on a memory card. Until that day there will always be a compromise of how many images can be captured before a card needs to be emptied.

› JPEG files

JPEG is short for the Joint Photographic Experts Group, referring to the software development team that originally created the file format. JPEGs are compatible with virtually all software that uses image files, including Internet web browsers and email packages.

JPEG file sizes tend to be relatively small and therefore take less room on a camera memory card. The small file size of a JPEG is due to the data contained within the image being compressed. This compression works by reducing the amount of detail in the image, degrading it to a greater or lesser degree. This is generally referred to as "lossy" compression because the image is altered to achieve the compression.

Once your camera has created a JPEG image, it is impossible to recover information lost by compression. However,

a situation may arise where memory card space is an issue. In that case it may be worth the compromise of less detailed images that will fit onto the card, than not being able to capture the images at all.

At the time of capture, the style of the image (such as white balance and contrast setting) are "baked" into the JPEG, making it more difficult to successfully alter these at a later date without the image becoming further degraded.

Once a JPEG has been copied to a computer, the more often it is opened and altered in photo editing software and then resaved, the more the compression will affect the detail in the image. After a few iterations, an image can become almost unrecognizable.

JPEG images are readily identified by the extension .jpg or .jpeg (in either upper or lower case) after the file name.

‹‹ JPEG COMPRESSION
The detail of a heavily compressed JPEG file. At 100% magnification, the blocky artifacts are very visible.

› RAW files

A RAW file is the "uncooked," unprocessed data that is created when a camera sensor captures an image. Before a RAW file can be viewed on a computer, a RAW converter such as Sony's Image Data Converter SR or Adobe Lightroom *(below)* must be used to interpret this data. There is no RAW standard and RAW comes in many versions, with each camera manufacturer using a different variation of the format. This means that RAW is not used as a general file format. It is better to consider RAW as a stepping-stone to a file type such as JPEG or TIFF.

RAW has been described as a "digital negative" in that it is merely a starting point in the creation of an image. Unlike a JPEG, a RAW file retains every detail captured by the camera. It is therefore possible to create multiple interpretations of an image, with little or no loss of quality in the final image.

Because RAW files need to be processed before they can be used, they are more time intensive than JPEG. A press photographer, who may not have time to fine-tune images, would be unlikely to use RAW. However, for a photographer who wishes to create the best possible image, RAW files are worth the inconvenience.

A RAW file will always take up more space on your memory card than an equivalent JPEG file, so you will need to be prepared to empty the card more frequently. Sony uses the extension .ARW for their RAW file format.

› TIFF

TIFF stands for Tagged Image File Format. It is a widely used image format, though less ubiquitous than JPEG. The TIFF standard supports lossless compression, 24-bit color, and Photoshop layer and channel information. Files use the extension .tif or .tiff (in either upper or lower case).

8 » CONNECTING TO AN HD TV

Viewing images on a widescreen television has now replaced the family get-together to watch a traditional film slide show. Using the slide show option on your A500 or A550 will allow you to specify how long the images will be shown and whether the show will repeat once it is finished. With a compatible television, it is also possible to use the TV remote to control the display of images, as well as being able to delete and specify printing options.

The A500 and A550 do not come with the necessary Type C mini-pin HDMI cable, but these cables can be found readily in good consumer electronics stores.

1) Ensure that the camera and TV are both switched off.

2) Open the cover on the left hand side of the camera and insert the HDMI connector into the **HDMI** terminal. Connect the other end of the cable to the TV's **HDMI** slots.

3) Turn on the TV and set it to the correct channel for HDMI input. The camera will detect the broadcast standard of the TV automatically once it is switched on.

4) Turn on the camera—the first photo should now be displayed. Select the desired photo using the ◀ / ▶ control buttons. The LCD screen on the back of the camera will remain blank.

Note:
The A500 and A550 are compatible with Sony's Photo HD TV standard. On a compatible TV, your photos will be optimized by the automatic fine tuning of parameters such as sharpness and the colors.

› Using Bravia Sync

With a Bravia Sync compatible TV, you can control the camera using the TV remote control when it is linked by HDMI cable.

1) Follow the instructions above to connect the TV and camera.

2) Press the Link Menu button on the TV remote control.

3) Operate the camera using the control button on the TV remote.

Tip

Bravia Sync is a Sony standard. Non-Sony TVs may occasionally cause the camera to perform unnecessary operations when operated via the remote control.

If this happens set **CTRL FOR HDMI** in the ✎ Setup **1** menu to **Off**.

› Options for Playback include the following:

Delete

Images can be deleted from the camera either one at a time, or all.

Image Index

Displays the image index screen.

Slide show

Plays back images automatically using Slide Show parameters *(see page 45)*.

Single-image playback

Returns to the single-image screen.

Note:
Use of the optional ACPW10AM AC adapter is recommended for lengthy slide show sessions. Although the camera will not be harmed should the battery become exhausted, it will cut your slide show prematurely short!

Sony BRAVIA EX700 LCD HD TV

The A500 and A550 are designed to connect straight to a PictBridge compatible printer, so that images can be printed without the need for a computer. The printing of images is controlled on the camera's LCD screen. Some printers also have slots for memory cards, again so that images can be printed directly without using a computer. The one limitation of printing through the camera or memory card is that RAW files cannot be printed.

› Setting the camera

1) Turn the camera on and select **MENU**.

2) Select 🔧 **2** and then set **USB Connection** to **PTP**.

3) Turn the camera off.

› Connecting to a printer

1) Check that the camera battery is fully charged before beginning to print. Sony recommends the use of the optional ACPW10AM AC adapter to ensure that power is not interrupted during printing.

2) Ensure that both the camera and printer are switched off. Insert the memory card of images you want to print into the camera, if it is not already installed, and set the memory card switch to the correct position.

3) Connect the supplied USB cable to the camera's USB terminal.

4) Connect the cable to the printer, following the instructions in the manual supplied with the printer.

5) Turn the camera and the printer on. The screen for selecting the images to print should now appear on the back of the camera's LCD.

« **PICTBRIDGE LOGO**
Printers that are compatible with the PictBridge standard will display this logo somewhere on their outer casing.

› Printing options

1) Use the camera's ◀ / ▶ buttons to move through the images on the memory. When the image that you wish to print is displayed, press the **AF/Enter** button. To cancel the selection press the **AF/Enter** button again.

2) Select **OK** on the menu using the **AF/Enter** button.

3) Once the camera displays the "printing finished" screen, press **AF/Enter**.

CANON PIXMA iP4700 ≈
The three major printer manufacturers, Canon, HP, and Epson, produce a range of PictBridge compatible printers. The Canon PIXMA iP4700 is an entry level A4/letter-sized printer.

4) Repeat steps 1 through to 3 to print another image.

5) When you have finished printing, turn the camera off.

6) Turn the printer off.

7) Disconnect the cable.

Note:
Pressing the **AF/Enter** button part way through the printing process cancels printing. Turn the camera off and on again and follow the procedure above to choose further images to print.

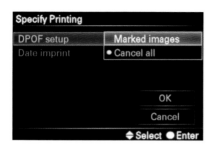

You can use your A500 or A550 to specify printing instructions for images that will be printed either by your home printer or by a print shop. DPOF only works with JPEG images and the instructions will be written to the memory card. These instructions remain on the card after printing so you will need to remove them once the printing is complete.

Print ordering: selected images
1) Press **MENU** and go to ▶ **Playback 1** and select **Specify Printing**.

2) Select **Date imprint** if you want to have the date the image was captured overlaid on the printed image, then press **AF/Enter**.

3) To choose specific images to mark for print go to **Marked images**, press **AF/Enter** again and then select **OK**.

4) Use the ◀ / ▶ buttons to move through the images on your memory card. Press the **AF/Enter** button to mark the displayed image for **DPOF**. A green **DPOF** will appear in the center of the image followed by a number. This number is the number of prints you wish to have made of that particular image. To increase the number of prints, keep pressing **AF/Enter**. The maximum number you can specify is nine. Once you reach nine **DPOF** is deselected for that image.

5) Repeat step 3 to select other images for **DPOF**.

6) When you are happy with the number of prints that will be made from your images, press **MENU** and select **OK**.

7) The DPOF information will be recorded onto the memory card and the memory card can now be used to print from.

Canceling DPOF
1) In Playback mode, press either **MENU** or **Fn** and select **Specify Printing.**

2) Select **DPOF Setup** and press **AF/Enter**. Highlight **Cancel All**, press **AF/Enter** again, and select **OK**.

Setting

> Lens: 100mm
> Aperture: f/11
> Shutter speed:
 1/125 sec.
> ISO: 200
> White balance:
 5600°K

SEASONALITY »

Carrying your camera with you and using it whenever possible will start to change the way you look at the world around you. By looking at your environment more closely you will start to notice how the seasons alter the landscape, both natural and urban. By being aware of these changes you will gain a sense of what they mean photographically, and the different opportunities that are presented throughout the year. For example, this photograph of Victorian buildings in the English town of Carlisle would probably not be as effective in winter when there was no foliage on the trees.

Chapter 9
CARE

9 CARE

As with any digital camera, proper care and a few simple precautions will ensure the effectiveness, and prolong the life, of your camera. Remember, the camera is not dustproof, splashproof, or waterproof, so when you are working with it outdoors, keep it clean and dry. Where possible, avoid exposing it to dust, moisture, excessive heat, and sharp knocks.

» DUSTY CONDITIONS

Dust and sand can easily cause the camera to malfunction, and can even result in irreparable damage. The best way of avoiding this is to keep the camera in your camera bag until you wish to use it.

Take particular care when changing lenses: dust can enter the camera via the lens mounting, and can also cause damage to the lens elements themselves. Sand on the glass of a lens will scratch it if it is wiped off, so it is best to use a blower or blower-brush to remove it.

Be sure to attach the lens cap or body cap when you are not using the camera. Before attaching the body cap, take care to remove any dust from it first.

« HERMIT CRAB
Wind-blown sand can get everywhere. There was a lot of fine sand blowing about when I stooped down low to capture this hermit. Using my body, I tried to shelter the camera as much as possible to stop sand getting in where it shouldn't.

» COLD CONDITIONS

The A500 and A550 are designed to operate in temperatures of between 32° and 104°F (0° and 40°C). Using the camera in temperatures that exceed this range is likely to be detrimental to its effectiveness.

This does not mean that you cannot use the camera in these conditions, but simply that you should take a little extra care. Batteries, in particular, suffer a massive fall-off in performance when they are extremely cold. It is useful to carry a spare, fully-charged battery with you; it's best to keep it in your pocket until you need it, to help keep it warm.

You should also try to keep the camera warm when working in conditions of extreme cold. Store it in your camera bag when you are not using it, perhaps wrapped in an extra layer of insulation, such as a spare woollen scarf. Symptoms of the camera becoming too cold include reduced battery performance, a darkening of the LCD screen, and sluggish operation.

NORTHERN EXPOSURE ⨯
Extreme cold can be bad for both you and the camera, particularly when you're both standing around waiting for the light to change. Several layers of clothing are better than one single layer as each layer will help to trap body heat.

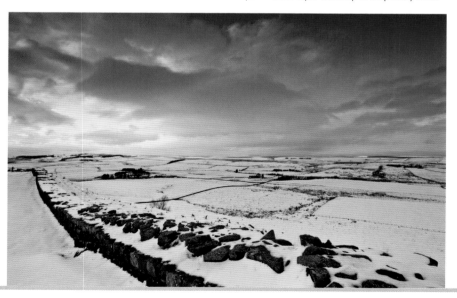

9 » HOT AND HUMID CONDITIONS

Excessively hot conditions can cause a considerable amount of damage to the camera; high temperatures can cause the camera body to become discolored and deformed, which can result in malfunction. Heat can also cause the expansion of non-metal parts, which can be a problem with many lenses, although some newer models do allow for a certain degree of heat expansion.

Never leave the camera uninsulated in a car on a very hot day; temperatures in this situation can easily exceed the 104°F (40°C) recommended as the maximum operating temperature. A food coolbox is one simple solution for storing the camera in these conditions, but do not use freezer packs, as these may create conditions that are too cold and damp.

When working in humid conditions, it is best to store the camera in an airtight plastic bag or container, preferably with a small packet of silica gel, such as the one that is included in the box when you buy a new camera. The silica gel absorbs the moisture, so helping to protect the camera from a buildup of condensation. To ensure the maximum benefit, the silica gel sachet should be stored in a dry place until it is needed.

To avoid the danger of condensation building up inside the camera when you take it from a cold place into a hot, humid one, allow it to remain in its protective bag or container for at least an hour, during which time it will reach the ambient temperature and will be safe to use.

If a moisture buildup does occur, switch off the camera and wait until the moisture has evaporated. If you attempt to shoot with moisture remaining inside the camera, clear images will not be possible.

« SHIFTING SANDS
Starting at first light allowed me to capture the images I wanted before the heat of the desert affected me and my camera.

» PROTECTION FROM WATER

The Sony A500 and A550 are not waterproof, so it is a good idea to take a few simple precautions to prevent the camera getting wet.

You may wish to obtain a camera bag that has a rain cover that can be tucked away when it is not needed. Some makes of bag even have two rain covers, one showerproof cover for the top of the bag, and another that wraps round the whole bag. This has the added advantage of keeping the bag dry when you place it on the ground in damp conditions.

Take special care when you are using your camera near the sea. Salt, as well as moisture, is a threat to the camera in such conditions, and it is worthwhile carrying a small towel or soft cloth as part of your camera kit, to dry off the camera immediately if it does get wet.

« SWIRLING SEAWEED
Though water is potentially damaging to a camera, with care there's no reason why you cannot use it as a photographic subject.

» CARE FOR LENSES

» CLEANING THE SENSOR

A dirty lens will potentially reduce the quality of your images. The glass elements of a lens are easily scratched and so care must be taken when cleaning. If possible, use only a blower to remove dirt or dust to reduce the amount of physical contact with the lens. Grease marks from fingerprints or water spots from rain should be cleaned off with a dedicated lens cloth—not with a T-shirt or handkerchief!

Many photographers attach a skylight or UV filter to the front of their lenses. A filter does not reduce the amount of light coming through the lens and so is an ideal way to protect the front glass elements. When the lens is not in use, it is advisable to replace the lens cap originally supplied.

Care should also be taken when cleaning the LCD screen on the rear of the camera, which is also vulnerable to scratching. Again only a dedicated soft cloth should be used to clean the screen. Sony sells sheets of transparent film (product code PCK-LS7AM) that can be applied over the screen to protect it, as well as a more robust hinged plastic hood that fits completely over the LCD (product code SH-L2AM).

Dust on the sensor (or to be more accurate, the low-pass filter that sits in front of the sensor) can be seen as tiny, slightly fuzzy spots in your images. Although these are generally easily cloned out using photo editing software, prevention is always better than cure.

To clean the sensor, Sony recommends that only a blower be used. The battery in the camera should be fully charged, and cleaning completed as quickly as possible.

1) Press **MENU** and then navigate to setup ⚒ **3** using the ◀ / ▶ control buttons.

2) Select **Cleaning mode** using the **AF/Enter** button.

3) The message **After cleaning, turn camera off. Continue?** will be displayed.

4) Select **OK** with the ▲ button and press the **AF/Enter** button. The image sensor inside the camera vibrates for a short time and then the mirror is lifted.

5) Remove the lens or body cap, if fitted.

6) Holding the camera face downwards, use a blower to remove dust from inside the camera, taking care not to touch the sensor with the tip of the blower.

7) Reattach the lens or body cap and turn the camera off.

> ### Tip
>
> *If the camera starts beeping during cleaning mode, this indicates that the battery is almost depleted. Remove the blower tip from inside the camera and turn the camera off.*

DUST SPOTS　　　**»**
When the sensor hasn't been cleaned for a while, dust can build up and is visible in light areas of a photo such as sky, snow or sand.

It's not just the camera that needs protecting from the elements. You should always try to ensure your own safety and comfort when embarking on a photographic trip away from home.

1) Decide on a route and destination and let someone know that this is where you intend going. If possible, also let that person know the approximate time you plan to return.

2) Take a cellphone, making sure it is fully charged and with sufficient credit. Because cellphones may not receive a signal in hilly areas, carrying a whistle is also recommended. The recognized signal for distress in the USA is three blasts on a whistle (six in the UK) followed by a period of silence. This is repeated until help arrives.

3) Carry an up-to-date map and compass and ensure that you have the knowledge to use them correctly.

4) Carrying a head torch is highly recommended, particularly for pre-dawn or post-sunset walking. Wearing a head torch frees the hands to hold a map or keep balance when you may be clambering over rocks.

5) Wear appropriate clothing for the trip. Weather can change quickly in the hills, so carrying warm and waterproof layers is essential. Comfortable boots that support the ankles are highly recommended, too. For a coastal photography trip, rubber boots may be more appropriate.

6) Carry food and water. It is easy to become dehydrated, particularly when carrying a backpack of camera equipment all day.

7) Check the weather forecast for the day. If possible, use a mountain forecast rather than a more general forecast for the area.

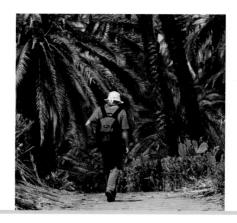

ENTERING THE PALM GROVE »
Heat brings its own problems. Be sure to take water to drink and protection from the sun in the form of sun cream, in addition to appropriate clothing.

Setting

> Aperture Priority
> ISO 100
> 5 sec. at f/14
> Polarizer
> White balance:
 5750°K

WATERFALL »

Fall brings color and the opportunity to photograph leaves as they collect in streams and waterfalls. Take care not to get the camera wet, and if you do to wipe it dry as soon as possible.

Aberration An imperfection in the image caused by the optics of a lens.

AE (autoexposure) lock A camera control that locks in the exposure value, allowing an image to be recomposed.

Angle of view The area of a scene that a lens takes in, measured in degrees.

Aperture The opening in a camera lens through which light passes to expose the CMOS sensor. The relative size of the aperture is denoted by f-stops.

Autofocus (AF) A through-the-lens focusing system that allows accurate focusing without manually having to turn the lens.

Bracketing Taking a series of identical pictures, changing only the exposure, in half or one f-stop (+/-) differences.

Buffer The in-camera memory of a digital camera.

Cable release A device used to trigger the shutter of a tripod-mounted camera at a distance to avoid camera shake.

CCD (Charged-Coupled Device) A micro-chip consisting of a grid of millions of light-sensitive cells—the more cells, the greater the number of pixels, and the higher the resolution of the image.

Center-weighted metering A way to determine the exposure of a photograph by placing importance on the light-meter reading at the center of the frame.

Chromic aberration The inability of a lens to bring spectrum colors into focus at one point.

Color temperature The color of a light source expressed in degrees Kelvin (˚K).

Compression The process by which digital files are reduced in size.

Contrast The range between the highlight and shadow areas of an image, or a marked difference in illumination between colors or adjacent areas.

Depth of field (DOF) The amount of an image that appears acceptably sharp. This is controlled by the size of the aperture: the smaller the aperture, the greater the depth of field.

DPOF Digital Print Order Format.

Diopter A unit that expresses the power of a lens.

Dpi (dots per inch) A measure of the resolution of a printer or a scanner. The more dots per inch, the higher the resolution will be.

D-RangeOptimizer Method used by Sony to control the contrast of an image to avoid or reduce loss of shadow or highlight detail.

Dynamic range The ability of the camera's sensor to capture a full range of shadows and highlights.

Evaluative metering A metering system whereby light reflected from several subject areas is calculated based on algorithms.

Exposure The amount of light allowed to hit the CCD sensor, controlled by aperture, shutter speed, and ISO-E. Also, the act of taking a photograph, as in "making an exposure."

Exposure compensation A control allowing intentional over- or underexposure.

Extension tubes Hollow spacers that fit between the camera body and lens, which are used for close-up work. The tubes increase the lens focal length and magnify the subject.

Fill-in flash Flash combined with daylight in an exposure. Used with naturally backlit or harshly side-lit or top-lit subjects to prevent silhouettes, or to add extra light to the shadow areas of a well-lit scene.

Filter A piece of colored, or coated, glass or plastic placed in front of the lens.

Focal length The distance, usually in millimeters, from the optical center point of a lens element to its focal point.

Focal length and multiplication factor The CCD sensor of the Sony A500 and A550 measures 23.6 x 15.8mm—smaller than 35mm film. The effective focal length of the lens appears to be multiplied by 1.5.

fps (frames per second) A measure of the time needed for a digital camera to process one image and be ready to shoot the next.

f-stop Number assigned to a particular lens aperture. Wide apertures are denoted by small numbers such as f/2; and small apertures by large numbers such as f/22.

Histogram A graph used to represent the distribution of tones in an image.

Hotshoe An accessory shoe with electrical contacts that allows synchronization between the camera and a flashgun.

Hotspot A light area with a loss of detail in the highlights. This is a common problem in flash photography.

Incident-light reading Meter reading based on the light falling on the subject.

Interpolation A way of increasing the file size of a digital image by adding pixels, thereby increasing its resolution.

HDMI High Definition Multimedia Interface.

ISO-E (International Organization for Standardization) The sensitivity of the CCD sensor measured in terms equivalent to the ISO rating of a film.

JPEG (Joint Photographic Experts Group) JPEG compression can reduce file sizes to about 5% of their original size.

LCD (Liquid crystal display) The flat screen on a digital camera that allows the user to preview digital images.

Macro A term describing close-focusing and the close-focusing ability of a lens.

Megapixel One million pixels equals one megapixel.

Memory card A removable storage device for digital cameras.

Mirror lockup A function that allows the reflex mirror of an SLR to be raised and held in the "up" position, before the exposure is made.

Noise Colored image interference caused by stray electrical signals.

PictBridge The industry standard for sending information directly from a camera to a printer, without having to connect to a computer.

Pixel Short for "picture element"—the smallest bits of information in a digital image.

Predictive autofocus An autofocus system that is able continuously to track the progress of a moving subject.

RAW The file format in which the raw data from the sensor is stored without permanent alteration being made.

Red-eye reduction A system that causes the pupils of the subject's eyes to shrink, by shining a light prior to taking the flash picture.

Resolution The number of pixels used to capture or display an image.

RGB (red, green, blue) Computers and other digital devices understand color information as combinations of red, green, and blue.

Rule of thirds A rule of thumb that places the key elements of a picture at points along imagined lines that divide the frame into thirds.

Shutter The mechanism that controls the amount of light reaching the sensor, by opening and closing.

SLR (single lens reflex) A type of camera (such as the Sony A500), that allows the user to view the scene through the lens, using a reflex mirror.

Spot metering A metering system that places importance on the intensity of light that is reflected by a very small portion of the scene.

Teleconverter A lens that is inserted between the camera body and the main lens, increasing the effective focal length.

Telephoto A lens with a large focal length and a narrow angle of view.

TTL (through the lens) metering A metering system built into the camera that measures light passing through the lens at the time of shooting.

TIFF (Tagged Image File Format) A universal file format supported by virtually all relevant software applications. TIFFs are uncompressed digital files.

USB (universal serial bus) A data transfer standard, used by the Sony A500 and, A550 when connecting to a computer.

Viewfinder An optical system used for composing, and sometimes for focusing the subject.

White balance A function that allows the correct color balance to be recorded for any given lighting situation.

Wide-angle lens A lens that has a short focal length and consequently a wide angle of view.

» USEFUL WEB SITES

SONY

Sony US
Home page for the Sony Corporation
www.sony.com

Sony UK
Home page for Sony UK
www.sony.co.uk

Sony User Support
European Technical Support
http://support.sony-europe.com

Sony/Minolta Info
User forum, information, and galleries
www.dyxum.com

GENERAL

Digital Photography Review
Camera and lens review site
www.dpreview.com

Sony Photography Awards
Where to send that potentially award-winning photo!
www.worldphotographyawards.org

David Taylor
Landscape and travel photography
www.davidtaylorphotography.co.uk

Luminous Landscape
Photography technique with a landscape bias
www.luminous-landscape.com

EQUIPMENT

Adobe
Photographic editing software such as Photoshop and Lightroom
www.adobe.com

Apple
Hardware and software manufacturer
www.apple.com

Sigma
Independent Sony compatible lenses and flash guns
www.sigma-imaging-uk.com

PHOTOGRAPHY PUBLICATIONS

Photography books & Expanded Camera Guides
www.ammonitepress.com

Black & White Photography magazine
Outdoor Photography magazine
www.thegmcgroup.com

» INDEX

Contact us for a complete catalog or visit our web site:

Ammonite Press, 166 High Street, Lewes, East Sussex, BN7 1XU, United Kingdom
Tel: +44 (0)1273 488006 Fax: +44 (0)1273 472418
www.ammonitepress.com